Gaudier-Brzeska: Artist and Myth

# Gaudier-Brzeska

## Artist and Myth

Roger Cole

*Sansom & Company*

First published in 1995
by Sansom & Company
an imprint of Redcliffe Press Ltd,
22 Canynge Square, Bristol BS8

© *Roger Cole*

ISBN 1 872971 29 6 [casebound]
ISBN 1 872971 39 3 [softbound]

British Library Cataloguing in Publication Data:
A catalogue record for this book is available from
the British Library.

Typeset by Mayhew Typesetting, Rhayader and printed
in Great Britain by The Longdunn Press, Bristol

# CONTENTS

# ACKNOWLEDGEMENTS

Many people in both private and public capacities have, over many years, given generously of their time in assisting my researches into the life and work of Henri Gaudier-Brzeska.

I should like to thank particularly Gillian Raffles who contributed to the research and structure of this book and who offered encouragement and enthusiasm throughout, and Richard Eastham and Roger Eastman for reading and advising on aspects of the text. My publisher, John Sansom I wish to thank for his patience, tolerance and support, and of course, my family and friends who have endured the several years of my enthusiasm and frustrations in bringing the final text together.

It is impossible to mention everyone by name, but I wish to thank the staff of the Public Record Office, Kettle's Yard, Cambridge and the University of Essex for their help, and the principals of numerous other public and private collections who have made their archives available for study and provided reproductions of the artist's work.

Of the many biographies and studies I have consulted, I would mention the following as being especially useful for anyone wanting to read more on Gaudier-Brzeska: H.S. Ede's *Savage Messiah*, first published in 1931 and currently available in a paperbound edition published by Gordon Fraser; Horace Brodzky's *Henri Gaudier-Brzeska* and *Gaudier-Brzeska Drawings*, both published by Faber & Faber, in 1933 and 1946 respectively; Ezra Pound's *Gaudier-Brzeska* was first published by John Lane in 1916, with a new edition published by the Marvell Press in 1960; *Gaudier-Brzeska* by M. Levy was published by Cory, Adams, Mackay in 1965. My own earlier book on the artist, *Burning to Speak: The Life and Art of Henri Gaudier-Brzeska* was published by Phaidon in 1978.

Of related interest, Enid Bagnold's *Autobiography* was published by Heinemann in 1970, Oliver Brown's *Exhibition: The Memoirs of Oliver Brown* was published by Evelyn, Adams and Mackay in 1968, Nina Hamnett's *Laughing Torso* in 1932 by Constable, and Wyndham Lewis's *Blasting and Bombadiering* by Calder in 1967. *The Book of Lovat* by Haldane Macfall was published by J.M. Dent in 1923 and Edward Marsh's *A Number of People* by Heinemann in 1939. Jim Ede's *A Way of Life: Kettle's Yard* was published in 1984.

# FOREWORD

Nine million young men died in the Great War, many with brilliant careers unfulfilled, but few accomplished as much in a brief life or showed more promise of greatness than the young Frenchman killed in June 1915 at Neuville St Vaast at the age of 23 years and nine months. He lies on a hillside there with 15,000 other French soldiers.

The work Henri Gaudier-Brzeska completed in three years bears witness to what his stolen future might have been. In that time, he created many wonderful and mature drawings and sculptures. Because the life he lived in the years which were given to him was rich in incident and creativity, it has attracted a mythology which, if anything, has obscured his artistic achievement. How this came about is a story in itself. *A Life of Gaudier-Brzeska*, written by H.S. Ede, was published in 1930. It told the romantic story of this young French sculptor and the older Polish woman with whom he shared his life. It was based on the letters between them, the diaries she kept while they were together and her notebooks and diaries after he was killed. An American edition, entitled *Savage Messiah*, followed in 1931. Its title captured the imagination of the reading public and was later adapted for a film by Ken Russell.

This book, *Henri Gaudier-Brzeska: Artist and Myth*, is the biography of that French sculptor, lost so tragically on the battlefields of France. It tells of his life and work, his friendships with artists and writers and of his relationship with the Polish woman, Sophie Brzeska. It breaks new ground in tracing Sophie's tragic life after Gaudier's death, and in telling how Jim Ede came to write his book and to own the sculptor's life work, as well as Henri's and Sophie's letters and diaries. It is also the story of Ede's double creation: the Gaudier myth and his own unique gallery at Kettle's Yard in Cambridge.

The meeting between Henri Gaudier and Sophie Brzeska in January 1910 has become one of the most romanticised encounters of recent times. Henri was a young man, more a boy, gifted and passionate about

life and art, fiery and sensitive, with frenetic energy and great ambition. Sophie, disenchanted, a lonely emigrée convinced the world was against her and consumed with her own unhappiness. Who these two people really were has been lost and overlaid by romance, with even the origin of the name by which the man was to become known obscured in the process. The encounter changed the passage of their lives. What Henri would have achieved without Sophie can only be guessed at, that he would have become a sculptor is undeniable; but as he had so little time in which to succeed perhaps it was as well that he did meet this mother, sister, friend whose character and temperament precipitated his life into adventure, chaos and amazing achievement.

The story of those brief years is not the romantic artistic life that their names conjure up for readers and film goers. It conforms in two ways to the accepted mythology – they lived in dire poverty and he had true creative genius – but the full story is richer, stranger than the manufactured myth.

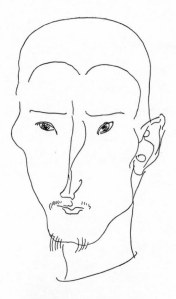

# Henri

# 1

Henri Gaudier was born on October 4th, 1891 in the small French village of St Jean de Braye. Then a few miles from the city of Orléans, but now engulfed by it, it was a quiet place by the river Loire, on the edge of one the largest forests in France. Fewer than two thousand people lived there. Until the plague of phylloxera wiped out the French vineyards at the end of the nineteenth century, the area had been a prosperous wine growing district. At its peak there had been 940 hectares of vines, but by the time of Henri Gaudier's birth this was a thing of the past. Henri's father, Germain Gaudier, was the village carpenter and joiner, a craft that had been the family tradition for generations. His mother, Marie-Alexandrine came from a neighbouring village. Both parents were strict with their three children, in particular their only son. There were two daughters, Henriette, two years younger than her brother, and Renée, born six years later. All three children attended the village school, from where Henri won a scholarship to the Benjamin Franklin Secondary School in Orléans. There he began to show an exceptional talent for languages. His teachers believed that this aptitude would suit him for a career in commerce and he was entered for a scholarship which was held annually for the Merchant Venturers' College in Bristol, England.

Henri was academically advanced enough to sit the exam a year early. His father, although a strict disciplinarian, was happy that Henri should take this route. It would be a means to 'better himself' and escape from a future life as a village carpenter. When, at fifteen, Henri was awarded two scholarships, both of which were for study abroad, Germain was delighted. Henri's teacher, M. Roux, had sent other successful boys to Bristol in previous years and had become friends with one of the masters of the Merchant Venturers' College. It was to George Smith's home in the prosperous suburb of Cotham that Henri went to live as part of the family in August 1907. With his remarkable talent for languages, he rapidly became fluent in English, greatly helped, no doubt, by the fact that Mr Smith's two teenage children were living at home. He got on well with both the daughter, Kitty and her brother, Sedgley but it was Kitty, a year younger than himself with whom Henri became closest. Their friendship endured until the end of his life. They

11

shared many interests, most particularly a love of nature and the countryside. Initially, in this strange country, Henri missed his family and most of all his sister, Henriette. They had shared the pleasure of long walks in the woods around St Jean de Braye, but in Kitty he found a more than happy substitute.

Together they explored Bristol and cycled miles on summer evenings. Henri frequently stopped to sketch anything that interested him. On walks with his father as a small boy he had been encouraged to study nature and draw the birds and insects which his father identified for him. Now he was also discovering an interest in architecture and, fascinated, he filled his notebook pages with sketches of buildings in Bristol and Bath. The Smiths were a happy family and Henri felt at home with them. The atmosphere of those first months sowed the seeds of an affection for England. After his first four months learning English in Bristol, Henri's scholarship took him for business training to Cardiff. His command of spoken and written English was extremely good, although he was never to lose his fairly strong accent and idiosyncratic delivery. In Cardiff he was apprenticed to Fifoot and Ching, a coal exporting firm. He found the work interesting enough and learnt quickly but although his 'digs' at 29, Claude Road were adequate, with a pleasant Welsh family, there was not the companionship of other young people as there had been in Bristol, and he was not unhappy when these six months there came to an end.

From Cardiff, he was to go straight into the second scholarship in Germany without returning home, and on April 12th, 1909 he crossed the Bristol Channel to say good-bye to the Smiths and travelled up to London by train. On April 16th and 17th, he went to the British Museum; by now, his sketchbook was always in his hand and the pages were filled with sketches of everything that caught his interest. He travelled by train from London, took the boat to Antwerp and continued by train to Nuremberg via Cologne. He chronicled his journey with drawings of a huge variety of buildings in great architectural detail, delighting especially in the spires and gargoyles of Cologne Cathedral. He arrived in Nuremberg on April 20th.

He was in Germany to learn the language and gain experience in German business methods. He had lodgings with another of M. Roux's friends. Again he could not have been luckier. Doctor Uhlemayr was a doctor of medicine, in his late thirties, a cultivated man with a charming wife and two small sons. Although there were no companions of his own age in the family, the doctor was a highly intelligent, sensitive man

whose sympathetic understanding was to be of great help to Henri, while he was in Nuremberg and in the future. Their close relationship was clearly based on mutual affection and respect. While he was living with the Uhlemayr family Henri spent most evenings, into the small hours, discussing life and art. Dr Uhlemayr became his mentor and the sounding board for his ideas. He pointed Henri in new directions that widened his horizons, encouraged his obvious gift for drawing and introduced him to a broad view of art and art history.

For Henri, this was his university. His father had been reluctant for him to travel, fearing that he would be led astray. His worst fears might have been confirmed, as during his conversations with the older, more worldly, man the idea began to dawn on Henri that what he truly wanted was to be an artist; that he needed to express the ideas and philosophy which were crowding in on him and that he could do so only as an artist. Dr Uhlemayr was opening his eyes and mind to extraordinary possibilities, none of which would have arisen for a country boy in St Jean de Braye. His father had hoped that the scholarships might open the way for Henri to a wider world, an entry to the field of business, to becoming *un homme des affaires*. That in itself was, in 1910, a tremendous ambition for the son of a village carpenter. Had he had an inkling that his son was even flirting with the idea of being an artist Germain would have been appalled. How could being an artist be a way of earning a living? It was not a respectable profession. Henri's discussions with Dr Uhlemayr ranged over art, literature and philosophy, but the longer they talked the clearer it became that Henri's ideas were beginning to polarise: he could see where his interests were leading and the crossroads that lay ahead, but there was one very real problem: how to break the news to his parents. Dr Uhlemayr could only guide him. The final move, if there were to be one, was up to Henri.

He spent July and August in Munich. He visited the museums – Munich was very much the centre of the Jugendstil movement, the German Art Nouveau – and was excited by the new ideas in painting, design and architecture. He was now seventeen years old, fluent in three languages and learning Russian, experienced in practical business methods in two countries, and well read, with a lively interest in art and philosophy. The moment had arrived for him to begin his career in commerce. He was an eminently employable young man in the commercial European world of 1910. Now that he was on the brink of this career he found himself unable to make the break. He could not

confess to his father that commerce was not what he wanted, that he intended to turn his back on a promising career and go into the completely uncharted world of art. Reluctant to face his father, he put off the confrontation and instead of going home went from Nuremberg to Paris. There on September 27th, 1909, through the recommendation of a professor at the Sorbonne, another of M. Roux's circle, he obtained work as translator with a publishing company, Armand Colin.

The publishing work was poorly paid and boring and he stayed only eight months. Henri was unhappy in a city where he had no friends. His solitary lodgings at 14 Rue Bernard Palissy were in sharp contrast to family life with the Uhlemayrs and the Smiths. His loneliness made him more determined to read and assimilate knowledge and follow the arts in the way that Dr Uhlemayr had led him. Ever since leaving Bristol Henri had kept up a correspondence with Kitty. In March, 1910 he wrote: 'I am involved in trouble just now. The fierce rapaciousness and lust of lying tradesmen made me leave the publishing firm I was working in about twelve days ago – I am looking for other gallows but cannot find them. Let us hope that it will end for the better.' He had little money, and it was important to find another job quickly. He found one with a company called Goerz which he described to Kitty in another letter as 'a firm making gunsights and looking glasses'. It provided work but no more salary than the job at Colin.

Henri spent his evenings after work reading in the local library; it was free and it was warm and there were others there equally lonely and dedicated to the search for knowledge. The library he chose was the Saint-Geneviève, opposite the Panthéon in the 5th *arrondisement*. Here he immersed himself in books on art and artists, architecture and philosophy, reading greedily and making up for what he thought were years lost in following a commercial training. The possibilities ahead began to unfold, to crystalise, and finally become an obsession. The life of a painter was not enough. It seemed too ordinary and to lack vigour and passion. He would model himself on Rodin and Michelangelo. His life was as a sculptor; and only as a sculptor.

He wrote to Dr Uhlemayr on May 24th, 1910:

I have taken a great decision – I am not going to do any more colour work but will restrict myself entirely to the plastic. I have never been able to see colour detached from form, and this year after doing a few studies in painting I noticed that the drawing and modelling were all I had been concerned with. I have put by the

brushes and tubes and have snatched the chisel and bolster – two simple instruments that most admirably second the most wonderful of modelling tools, the human thumbs. This and clay is all I need now with charcoal or red chalk and paper. Painting is too complicated with its oils and its pigments, and too easily destroyed. What is more I love the sense of creation, the ample voluptuousness of kneading the material and bringing forth life, a joy I never found in painting for as you have seen I don't know how to manipulate colour and as I've always said I'm not a painter but a sculptor.

It may surprise you that I am content to confine myself to this branch of art leaving all others untouched; yet sculpture is the art of expressing the reality of ideas in the most palpable form. It makes plain, even to the eyes of fools, the power of the human mind to conceive ideas and demonstrates in cold lucidity all that is fervent ideal and ever lasting in the soul of man. You will have noticed that obligations begin with sculpture and end with it: painting, music, letters are later refinements. For my part I see quite clearly that I do not wish to wield the brush any longer, it's too monotonous and one cannot feel the material near enough, paint sticks well to the hairs of the brush and sings on the canvas, one appreciates its fertile texture, but the sensuous enjoyment is far greater when the clay slips through your hands, when you can feel how plastic, how thick, how well bound together and when you see it constantly bringing forth.

I am now in the midst of Bohemia, a queer mystic group but happy enough, there are days when you have nothing to eat, but life is so full of the unexpected that I love it as much as before I used to detest the stupid regular life of employment.

Although this letter outlines Henri's ideals, it glamourised the day-to-day life he was really following. He clearly felt the need to describe his activities so that Dr Uhlemayer would believe that he was living out the theoretical discussions they had shared in Nuremburg.

The Saint-Geneviève library attracted many of the provincial and foreign students who gravitated to Paris, most of them poor, all intent on educating themselves and keeping warm at the same time. Henri spent every evening there. In January, he noticed one woman who stood out from the rest. She was older, more serious and more self-absorbed. She seemed, unlike the others, not to be studying or taking books from the shelves but to be absorbed in writing. He surreptitiously began to make

sketches of her in the same way that he sketched everyone and everything that caught his attention. Eventually she became aware of this and although at first shy, they found themselves chatting together on leaving when the library closed. Gradually they grew less wary and spent the end of most evenings in the Café Cujas, just down the hill from the library in the street in which the woman had her lodgings. Sometimes they went on their own but most frequently with other students, talking and arguing into the small hours. It was Henri's first taste of student life. He was no longer the scholarship boy working hard for an exam but a young man drinking in the cafés of the city by night and experiencing the stimulation of young minds exchanging ideas. The woman who shared these evenings with Henri and this youthful crowd was Polish, and twenty years older than the other students.

For Henri, meeting Sophie Brzeska at this moment was one of those incidents in life that in retrospect can seem predestined. They had much in common; she too was lonely, solitary and seemingly obsessed, although for her the obsession was with writing. He recognised that she was well educated and articulate, that she spoke, besides Polish, both French and English fluently and that they shared many interests in art and literature. He found himself spellbound by this mature, apparently self-possessed woman and he rushed full tilt into a friendship that seemed to offer so much intellectual support and encouragement.

That Sophie was Polish is the one reliable fact known about her, although at one traumatic moment she later declared to Henri's father that she was Austrian. She told numerous stories about her background which varied according to her audience. The most consistent was that she came from a noble family near Crackow, was one of ten children, not all of whom survived, that she had had a terrible relationship with her mother and that her father – a good-for-nothing spendthrift – had dissipated his estates to the point of bankruptcy. She was the only daughter, and his hopes of restoring the family fortune centred on her making a glittering marriage. One arrangement was contrived, but faced with the elderly bridegroom on offer she fled. She recounted similar stories throughout her life.

Whether one of the stories – that she had been a governess to the daughter of a steel magnate in Philadelphia – is fact or fiction is impossible to discover, but about the time she met Henri she was writing to her eldest brother, Joseph Bresser in America. He had emigrated there and changed his name. The letter sheds a glimmer of light on her background and on her temperament.

There is no wonder that our days are dragging so unhappily – we can shake hands as victims of our mother's tender endeavours, she can be proud of our lot which she so deliberately prepared . . . I am a bundle of nerves, torn like strings in a clavichord. Leaving Crackow in great dejection and irritation I was decided on death.

Which version of her life she chose to tell Henri is not known, but she did confide in him that she was 39 years old, alone with little money and immersed in writing the history of her family: a project that would establish her as a writer, solve her financial difficulties and open up the literary world to her. The book was never to be written, although Henri later drew numerous designs for the bookjacket and the project became a consuming ambition for the rest of her life.

Sophie's veneer of self-confidence, worldliness, aristocratic bearing and romantic background dazzled the inexperienced and naive Henri. He was desperately eager to live life to the full. He was still corresponding with Dr Uhlemayr, and six months after meeting Sophie he wrote: 'I have so many things to tell you, but things quite different from those we have already talked about – I refer to the effect of love on one's will to work.' He had been writing to the doctor about his future, which preoccupied him and which he could not mention to his family. To Uhlemayr's role of mentor, was now added that of confidante and father confessor. 'Would you believe I am in Love? I see that you already picture me with some "backfisch" strolling in the "Boul Mich", or whispering sweet nothings in secluded corners around the Panthéon. You are wrong; the woman I love is thirty years old – you smile – I love her with a purely ideal love, it is a flow of sensation which you must feel since words are too coarse a medium to convey it. She is Polish – Brzeska is her name. I met her at the library where I go to work each evening.'

With Sophie's entry into his life, Henri's frustrated ambitions and soul-searching multiplied. Soul searching had always been part of his life, but now he was in daily contact with someone for whom it was an almost total preoccupation, who would forever think of herself as a victim, ill-used by life and people. Sophie was convinced that success was her due. In Henri she recognised a fellow spirit, and with his talent and ambition she saw a future they could share. His enthusiasm and youthful naivety were refreshing and she encouraged his growing obsession to be a creative artist. At first, he was carried along by her passion as she transferred her own unrealistic dreams to him and began to live through him. Dr Uhlemayr had pointed him towards possibilities; Sophie talked

excitedly about making them realities. It was intoxicating stuff, but it lacked substance and solved none of their practical problems. Neither had the financial resources to cushion them from the hardship of everyday life. Sophie's small savings could be considered no more than an emergency fund for dire needs. They would be used for just such purposes on a number of occasions, but could not offer the prospect for Henri to survive as an artist without other employment. So far he had realized none of his dreams of becoming a sculptor. All he had done was to fill a few sketch-books: he had never had the chance to work with clay or stone. He had no choice but to continue his tedious job and devote his evenings to study in the library.

In his unworldliness Henri must have believed that by some amazing luck everything would be possible. Indeed, things did resolve themselves, and by accident, but not in the way that he would have sought or could have expected. The strain of life in Paris began to tell, and towards the end of 1910 Henri became seriously ill. He was unable to work, he was penniless and desperately frustrated and unhappy. In this predicament and in a distraught state of mind there seemed to him to be only one thing he could do. He would go home to St Jean de Braye to be looked after and fed, regain his vitality and summon the courage to speak to his father about his change of heart. He would be able to persuade him that he was wasting his talent in business and that his real destiny was to be an artist. That accomplished, he could return to Paris with his family's blessing.

Henri returned home in a pitiable state. He was undernourished and shabby, he had neglected to eat and sleep and all his spare money had been spent on books, sketchbooks and pencils. Sophie's physical plight was hardly better, but the mental turmoil about his future was entirely his. Once at home, Henri set about demonstrating his artistic capability to his parents. He made a portrait of his father – the first that he had ever attempted – and then immediately a self-portrait. These were his first attempts at sculpture. To any but simple country people the sculptures would have been impressive. The portrait of his father is strong and vigorous and a striking likeness. Henri had absorbed the lessons of the illustrations and theories in the art books he had pored over at the library. Instead of being amazed by his genius, his parents called in the village doctor. For them, Henri's academic success meant he could have travelled the world and made his mark where it counted: among men of business and influence. What demon had taken possession of him and made him believe that working with his hands in

clay offered an adequate future? He must be in the throes of a break-down. Henri was devastated. For all his brilliance, he saw everything in black and white terms: a trait which would impede all his relationships. This crisis was the first example of his inability to compromise.

Sophie meanwhile decided that she, too, needed a holiday and left Paris to stay in Royan, but she missed Henri's company and began to suspect that his overtures at home had not gone as planned. She had to see for herself. She took the train and, as she thought, discreetly found a cottage to rent near St Jean-de-Braye at Combleaux. She could hardly be inconspicuous in this small closely-knit community; in fact, had she considered it at all she would have known that she would be the centre of interest and curiosity. The gossips there found her irresistible. Rumours multiplied and in no time the gossip reached the Gaudier family. There was a strange middle-aged woman living near the village, who kept a house of easy virtue, had many visitors from far and wide and one of them was their son, Henri. Père Gaudier was horrified, his worst fears realized. What had happened to his son since he embarked on his studies with such high expectations? Henri was equally outraged. He had come to St Jean believing he could persuade his parents that his new goals were reasonable, but instead he found himself in a quite desperate tangle. He felt compelled to take Sophie's side even though this would mean a catastrophic break with his family.

Henri tried to justify himself and restore Sophie's reputation. He wrote to the most important man he could think of, the Conseil General de Loiret, giving a detailed account of the happenings in the village as he saw them. He described how two gendarmes had descended on Sophie, threatening her and producing a letter which claimed that she kept a disorderly house. This letter had made them both ill, he said, and he demanded that the person responsible for the rumours be appre-hended. The Conseil dismissed the incident. Gaudier wrote again. He wanted to meet the Conseil before he and Sophie departed for Paris, so that he could introduce Sophie and show how misguided the rumours were. It was a long and angry letter and his frustration is evident from the handwriting. Whether the letter was actually sent or was simply a draft written to placate Sophie is impossible to determine. But in any event he made the gesture. The rift with his family remained; Henri and Sophie, now forced closer together by events, were driven out of St Jean and returned to Paris in distress.

This contretemps was not the only one between Henri and the Conseil General. Two years later in London Henri received a second

letter, clearly written at the prompting of Gaudier senior. It was a diatribe about his shirking military service and must have been fuelled by the earlier recollections of Henri's last visit to St Jean. It had no effect at the time, although possibly it influenced Henri's later decision to volunteer when war was declared. The Conseil's letter contained the stirring paragraph:

> One must say that military service is a duty, and that one is always happy doing one's duty. So what situation are you putting yourself in? You are closing the door on France, you can never yet again return to Saint Jean de Braye . . . What unhappiness have you caused your family, my poor child. You are putting yourself outside your family and your country.

When Henri and Sophie returned to Paris in December 1910, their circumstances were no better than when they had left. If anything, they were worse. Henri no longer had his job and his health was even more debilitated. The only employment for which he was qualified was in the commercial world and that was the last thing he wanted. With Sophie's paranoiac fears fuelled by the St Jean debacle, Henri was beginning to feel an alien in his own country and to think nostalgically of England and the warmth and friendship he had found in the Smith home. He persuaded himself that the opportunities he needed lay in England, where they would find a more tolerant atmosphere for the life they were intent on sharing. Henri was convinced he could immerse himself in the artistic world of London where fame and success waited to be grasped.

This may seem a strange decision, given the vibrancy of the Parisian art scene of the time, but the world of the Post-Impressionists might have been a thousand miles away for all that it touched their lives. Henry's world of art was in books, dreams and unresolved imaginings. He had yet to meet a real artist. The exciting artists currently working in Paris were completely unknown to him apart from seeing their work in a few exhibitions. But, for all its improbability, the move to London very soon proved to be the right decision.

# 2

Henri and Sophie arrived in London in early January 1911. It was terribly cold, they had nowhere to stay and knew no one. The people whom Henri now thought of nostalgically as his family were a hundred miles away in the West Country. They had the greatest difficulty in finding lodgings at a price they could afford, and had been forced to dip into Sophie's savings for their fare to London. Although they both spoke excellent English, they felt unwelcome. The lodgings they found in Edith Road, Fulham were dirty and miserable, but even for these they were again forced to delve into Sophie's fast diminishing savings. It was March before Henri found employment, but he persisted in his artistic search. He visited London's museums and galleries, sketchbook in hand, making drawings from Hokusai woodcuts in the Victoria and Albert Museum, drawing in the Egyptian room at the British Museum and making studies of birds in the Natural History Museum. This preoccupation could well have contributed to the length of time it took to find work, and probably only their increasing destitution drove him eventually to take a job.

The work he found was no more congenial than his job in Paris. Again it was as translator, but it also included book-keeping. Wulfsberg & Co. were Norwegian timber merchants with offices in St Mary Axe in the City. The wages, £6 a month, barely covered rent and food for them both; there was nothing over for the much coveted art materials or even for clothes. Henri was forced to walk the six miles from Fulham to the City each morning and back again each evening. In many ways, their situation had worsened. At least in Paris they had friends and agreeable companionship in the library and cafés in the evenings. Their relationship was already under strain after the events in St Jean and Sophie decided she must act before things became irredeemably fraught. She began to search for work. Despite their rows, she was far from enthusiastic about leaving Henri, but she found the situation in cramped, squalid conditions intolerable. The best she could find was a position in a private school, with board and lodging in return for teaching. It made no contribution to their financial resources and offered her no future, but it was at least a short-term expedient. Even when Sophie had gone, Henri kept moving: in February to Redburn

Street, Chelsea and again in March to Sterndale Road, Putney in the search for more congenial and cheaper rooms. All these lodgings proved as squalid as each other, and accommodation would remain their overriding problem.

The private school was at Felixstowe in Suffolk. That in itself offered a respite from the tension, and Sophie was lucky to find anything at all, as she must have been without references; it is fair to assume that this was why the post was offered on a no-salary basis. Felixstowe was more than four hours by train and the fare, which would have been paid by her employers on her taking up the job, would have been far too much for Sophie even to consider returning to Henri for weekends.

This first long separation had an unexpected effect. After months of strain and extremes of emotion from high euphoria to the depths of despair, Henri was on his own and able to please himself. He walked to and from work and did his job at Wulfsberg's well enough to keep it, as it had become the cornerstone on which to build his ambitions, but outside those hours he could read and draw all night, visit museums and galleries at weekends and forget everything else including food and sleep. With no restraining influence, he rushed headlong at everything that caught his imagination.

He felt some guilt about his new-found freedom, and wrote diligently to Sophie trying to discuss with her his feelings about art. 'Rodin has written in this book I am reading, "I may be called a dreamer, idealist, Christian, Pagan, etc. I am actually none of these, on the contrary I am an unsociable mathematician, and I have not created a statue which is not at its concept mathematical – I would agree that a geometrical statue stimulates thought, but I have not set out with that intention. I have only set out planes and these give freedom to ideas, that is why I am amazed when faced with my own work, just like the critics, and able to find in it those things which they can see." It is candid and to date undisputed, everyone must have faith and "inspiration"?! He makes no more of this than creation – one observes, one sees and interprets and nothing more.'

He also wrote to her:

I shall always relentlessly hold to the opinion that Michelangelo was wrong in his handling of proportions, which produced 'supermen'. It's an unfortunate figure of speech which I don't like. If a man is imperfect one gives him credit for his qualities, mean, coarse, deceitful, otherwise he is perfect – but if he is a 'superman' that is

to say if he is inhuman then the opposite is true – you reproach him for it less than Rodin for he never knew how to make a single statue. He did not know how to find rhythm in the arrangements of the shapes in one body, but he achieved it by the organisation of a number of bodies. The great sculptors are there to prove this, think of the masterpieces which we like most, all standing or seated and one at a time and it is not in the least monotonous. The gourmet loves a tasty cake but the glutton requires at least six to satisfy himself.

The first thing is:
That sculpture is composed of the placing of planes
according to a rhythm.
That painting is composed of the placing of colours
according to a rhythm.
That literature is composed of the placing of stories
according to a rhythm.
That music is composed of the placing of sounds
according to rhythm, and that deviation from any one of these rules
is not permitted,
that any infringement by one or other is a mistake
in taste and understanding . . .

Sophie did not always agree, and their letters were often querulous, but Henri for his part softened his with endearments and diminutives, calling her 'Mamus', 'Little Mamus', and himself 'Pik' and 'Pikus'. He was well aware that Sophie regarded him, and frequently referred to him, as 'mon fils adoptif': an attitude which contributed to his feeling stifled by her. He was writing at this time to Dr Uhlemayr expanding his ideas and theories, and now that Sophie was absent he resumed his correspondence with Kitty Smith in Bristol. He wrote many letters to her, simple, straightforward and affectionate. He felt no compulsion to explore his theories with her nor the need to tread carefully. Her replies were in the same happy vein. Sophie had no idea that he wrote to Kitty, nor did he tell Kitty about Sophie.

Henri kept a small notebook in which he listed addresses and the routes by which to get to certain galleries. Among the notes he made were 'the Grafton Gallery la plus grande et belle de Londres' and 'Leicester Gallery, bonne clientele mais arrierée'. One of his sketchbooks at this time filled with his explorations of London was inscribed 'le

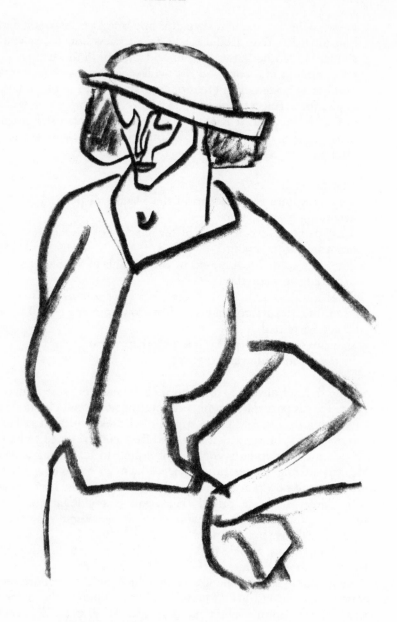

Gaudier sketched in London streets and parks.

chaos'. In his lunch hours, Henri roamed the streets of Whitechapel near Wulfsberg's offices and sketched the orthodox Jews with long kaftan coats and their flowing sideburns under wide-brimmed sable hats. His book was full of sketches with captions such as 'Sale Russe qui peut la Vodka', 'Portrait d'un Etudiant en Medecine'. The London Hospital was nearby and there were characters in plenty for him to relish and sketch. He was fascinated by the variety of people in the streets and parks: workmen, mothers with children, old women, and one Saturday he listened to Keir Hardie, the Socialist pioneer, at a rally in Trafalgar Square and included a sketch of him in a letter to Sophie, describing him as 'this splendid old man'.

Henri was alone and making his own discoveries of London at an exciting time for everyone in the English art world. It was the time of the first Post-Impressionist exhibition arranged by the critic and painter, Roger Fry at the Grafton Galleries. Fry, a member of the wealthy chocolate family, was more aware than most of the new movements in art flourishing on the Continent. In the year that Henri had spent in Paris, his studies at the library had been devoted solely to artists of the Renaissance and nineteenth century. He remained virtually unaware of contemporary art and the modern movement. It was only with his new-found freedom in London that he discovered the work of living artists. The Post-Impressionists was one of the first exhibitions that bedazzled him.

With this exhibition, Roger Fry was introducing into England French artists such as Cézanne, Monet, Degas and Gauguin. The freshness and originality of their work burst upon the conservative English with the impact of an explosion. Not all the reactions were enthusiastic but for painters, particularly the young, it was a revelation. It would have been impossible to be in London and remain unaware of the turmoil the exhibition was creating among artists and critics. Roger Fry and the artists he showed were news, the papers and reviews were full of them, the talk in bars and cafés about little else. The euphoria must have reached Gaudier as he devoured everything that he could see and read about art. This was his introduction, remote as it was, to Roger Fry who, in the spring of 1913, would establish the Omega Workshops and give him commissions.

# 3

Among Henri's voracious reading was a journal entitled *The English Review*. An article by Haldane Macfall in the January 1912 issue convinced him he had discovered someone of influence in London whose philosophical ideas were in tune with his own. With his usual impetuosity he wrote to Macfall. His letter brought a reply that was the best thing that could have happened to Henri, and had repercussions that he could hardly have anticipated.

Macfall was a man of fifty who until the 1890s had served in the regular army in India. On his return to London he embarked on a career as biographer and satirist. In 1912 he was writing *The Splendid Wayfaring*, having previously published two other books, *Whistler* and *Masterful*. The latter was the more successful, a bitter satire on decadent London literary and artistic life. Because he was considered daring and outspoken in his views, he attracted a group of admiring young artists and writers to his 'open house' on Wednesday evenings at his home in Perham Crescent, Kensington. He invited Gaudier to one of these evenings, and Gaudier found himself in an artistic milieu for the first time in his life. Some years later, Macfall wrote *The Book of Lovat*, a memoir of the artist, Claude Lovat Fraser who died in 1921. In it, he recalled receiving the letter from Gaudier:

45, Paulton's Square,
Chelsea, S.W
5th January

To Haldane Macfall, Esq, c/o English Review

Your essay in this month's number of the English Review has awakened in me a craving to make your acquaintance – it is very hard to find here someone who looks at life in the broader sense – in a manner freed from all prejudice and who dares say that Art is a vital need. I came to London a year ago and though I have not missed one single opportunity to come near to any body whom I thought would be worth knowing I have not so far succeeded – you are well able to understand the kind of loneliness and self disgust that has overcome me, the more because I am suffering from

26

uncongeniality – I work hard at my branch of art unfortunately only in the spare-time left me by an every-day attendance to a shipbroker's office – not later than yesterday I was baffled by that puritanism against which you write. I had prepared posters and the editor sent me back – saying they are too original – that people do not want expression character but mediocre prettiness and that my productions were too distorted for his purpose – If I am not mistaken it appears hopeless for any one to do anything original here when necessity is compelling – the man began a lengthy speech to try and induce me not to paint any nude figures or give any expression to any one of them not to frighten his customers. I do not despair because of that neither do I intend to change my own ideas about drawing & decoration – the only thing I wish for just now is to have somebody to talk to in a frank and open manner – too great an isolation spoils me undoubtedly and you would be very kind indeed if you would allow me to see you one of these evenings when you are free –

Yours respectfully,

H. Gaudier

And later, years after Gaudier's death, Macfall wrote to Horace Brodzky:

In the January number of the English Review an article by me had appeared entitled 'The Puritan and the Theatre' in which, as in the address to the Camera Club, I had embodied the main ideas of the book I had been engaged upon for a long time which was to be called 'The Splendid Wayfaring'. Curiously enough it also led to the discovery of a young genius who, like Lovat, was to pass away at the gates of the realm of which he might have become a prodigious master. I got a letter from a young fellow, a Frenchman, or rather of French and Polish stock, who told me he had felt compelled to write as he had read the article and it was the only thing that he had ever read on art that seemed valid and interpreted the artist. I asked him to come and see me but he replied that he was living with his sister in bare garrets in Chelsea, working as a clerk in a London shipping office by day in order to enable him to live so that he might get up at daylight to work at sculpture and at drawing before he went to the office. I begged him to come on Wednesday with his sister; and so it came about that

there walked into our flat one evening the gifted, bright, and wonderful lad whom the world today knows as Gaudier-Brzeska but who we knew better as Henri Gaudier.

The group that assembled on Wednesday evenings included Lovat Fraser, Enid Bagnold, Dolly Tylden, Henry Harding and Macfall's old army friend Major Smythies. Lovat Fraser, an artist and illustrator, and later to be a successful theatre designer, was born a year earlier than Gaudier. He had been educated at Charterhouse School and came from an affluent family very different from Gaudier's. He was exceedingly tall and attractive with a generous, outgoing personality and immediately took to Gaudier, who in every physical and temperamental way was his opposite.

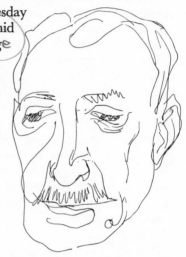

Haldane Macfall drawn by Gaudier.

Enid Bagnold, the daughter of an army colonel, was two years older than Gaudier and would in time achieve fame as a novelist and playwright. She was striking to look at, intelligent and a great chum of Lovat's. Enid had recently left home, a fairly daring thing for a young woman from her background to do and was sharing a flat in Ryder Chambers, Lower Church Street, Chelsea with Dolly Tylden. Enid once described Dolly as 'a circle maker' with the face of a 'a Pekinese with a long cigarette holder . . . cynical without bitterness, amused without shyness, debunking, chuckling, commending, with no ambition for herself'. Henry Harding was a writer and dramatist who was killed in the First World War and whose now-forgotten books included *Carnival, Whirlwind* and *A Bowl of Roses*. He and Major Smythies were the oldest and most staid members of the circle.

At Haldane Macfall's instigation, Smythies offered Gaudier his first commission: to make his portrait bust. So, almost simultaneously, Gaudier was launched into a new intellectual circle and found himself with his first patron. With this circle of young people who worked hard, his life also now took on some of the lighter aspects that had been missing because, inspired by Lovat's exuberant personality, they also

played hard. Even so, Henri found it difficult to respond to people who were more affluent and carefree than himself, leading lives so different from his own. Although talented, and ambitious, they did not have the same tremendous inner force driving them. As a foreigner Henri felt at a disadvantage. He was often out of his depth, and became impatient and petulant. In her autobiography, Enid Bagnold gave a graphic account of him at this time:

> Gaudier shot into our group . . . I shouldn't have said at an evening party at Macfall's I should have said on a station on the Tube Railway . . . like a mechanical wasp, a slight, powerful, steely creature, all stings and ceaseless quiet noise. Within his head the wheels were never at peace and the hum lay on his lips, from which poured talk, invention, criticism, intolerance, jibes, enthusiasm – everything that makes up a mind that can use itself.
>
> Lovat, ambling and soft, and shining in the eye, brought him tucked under his arm. But you couldn't tuck Gaudier under any arm. I remember him at Macfall's, thin and poor like a foreign workman, like one of those slight and burning Italian engineers you find building a Swiss railway, talking, hissing his talk out on the defensive and ready to bite . . . every time I turned towards him I stepped on a thorn . . . Gaudier talking . . . he did not drop a subject when he had added a little to it. He did not throw a word in here and there and make a crisp sentence sum up a bale of thought. What had been talked of a quarter of an hour before at Macfall's was still being followed up. Gaudier, his long front hair hanging in string down the side of his white brow, was throwing his future and his past and his passion into the discussion. Gaudier felt our bodies moving, grouped away from him, and I remember as he talked his eyes and pale face shone, he put out his thin arms and surrounded us and held us fast in the wind so that our edging movements should not distract him.
>
> Lovat was the first to have the wit to be excited about him. But they soon quarrelled. His young vanity could not stomach Gaudier's blows. I did not really like him. But that is no judgement on either of us. Gaudier never seemed to like anyone. He rushed at people. He held them in his mind. He poured his thought over them, he burnt his black eyes into them, but when in response they said ten words they were jabbed and wounded and blood flowed.

It must be some reflection on the strength of Gaudier's conviction of his own genius that despite his prickliness these sophisticated young people welcomed and encouraged him. They had seen none of his work, as there was none to be seen. And yet, they either gave him commissions, if they had the means, or tried to find some for him. He still could not afford clay or tools and he boasted 'the thumbs are best for modelling, tools are unnecessary'. He was utterly convinced from the moment he had decided on being an artist that his genius would be recognised. The thought that he might struggle in neglect indefinitely had never been a serious worry. It would only be a question of one bold gesture and he would have arrived. The fact that he had no sculpture to his credit other than the two portraits in St Jean did not shake his confidence, nor that he still had to fulfil arduous hours of meaningless book-keeping at Wulfsberg's.

*Promenade*, one of nearly two thousand ink and pencil drawings completed by Gaudier in his short life.

Life now became frenetic. On top of the Smythies portrait, Haldane Macfall decided he would sit for Henri, and Lovat bought some drawings and persuaded a few wealthy ladies to buy. Lovat was a great enthusiast who loved to encourage others, and he asked Gaudier to decorate his studio in Roland Gardens. Henri described the studio as 'a palace, a great room with two walls entirely glass, a gallery and above two rooms all lit by electricity'. The initial discussions centred around the idea that Henri would copy some tiles and primitive designs and paint the staircase in stunning colour, but this plan rapidly grew more ambitious and exotic. As well as decorating the space, Henri made an over-life size mask to hang from the gallery balustrade above the main studio. The character of the mask was without doubt based on Lovat: a huge circular plaster sculpture of a satyr-like head which Henri painted in black, gold and red. It was the first time he had sculpted a head that was not to be a portrait. Here he was free to make of it what he would. He could well have put into practice all the theories he had been preaching, but in the event the finished piece bore no overtones of Rodin or Michelangelo. If

30

*and Oriental ?*

anything, he turned his back on the past masters he had religiously followed. The Lovat sculpture showed primitive influences and anticipated the work that he would make in the future.

Henri and Lovat must have talked enthusiastically and at length, exchanging ideas about the form the mask would take. Lovat was not the kind of man to stand by and watch; he would have found it impossible not to be involved. The finished work uniquely reflects Lovat's personality and the vivid colours must have owed a great deal to his own bold way of working with colour. Henri had never used colour in sculpture before, and the other's enthusiasm must have fed his confidence. Lovat was delighted. It was exactly what his beloved studio needed. Henri received his fee of five pounds, and in celebration made Lovat a cheetah in plaster painted yellow with black spots. Lovat was a member of the London Zoological Society and only members were allowed access to the Regents Park gardens on Sundays, when they were closed to the general public. Henri asked Lovat for tickets and all the animal drawings, with the exception of the deer and some birds, he made there were thanks to Lovat. Henri took this privilege for granted and frequently sent postcards to Lovat asking for tickets.

Haldane Macfall continued to seek commissions for Gaudier; he suggested he tried again to make designs for posters. Henri made a series of gouache studies he thought would be suitable as advertising material but the printer whom Macfall had suggested was not interested. Gaudier persisted in his assertion that he was really a sculptor. Macfall encouraged him in this. He persuaded Leman Hare, a publisher and, later in the twenties, editor of *Apollo*, to ask Gaudier to make a sculpture of Maria Carmi. She was appearing as the Madonna in the great Max Reinhardt pageant, *The Miracle*. Gaudier wrote to Macfall about it:

Mrs Hare came down to Paulton's Square while we were packing things up and all dusty, telling us that Mr Hare wanted me to make a statuette of Maria Carmi as the Madonna at Olympia. Off we went towards 8pm tired as well could be, after a day's work, made about sixty sketches of the subject, came back after having had discussion at Pembroke Road, at 1 o'clock yesterday, and spent the whole morning putting up the clay for the thing . . . Mr Hare gave me a very good idea: he suggested that I should indicate (on the plaster cast) the different colours; gold red and blue – and this I will do. My impression of 'The Miracle' is that neither music nor the drama interest me, but I find good character in the actors:

31

Carmi, Riddle and the one who acts the Devil's part, but I fail to see much unity of thought in it, and I detect a good deal of lower taste such as the fire on the stage, the different processions, many costumes, several mechanical effects treated with too much stress – in all it is to my eye, a most spectacular effect with only three personalities not very strong.

I roughly sketched the statuette yesterday and should very much like to get it finished by tonight, but I am enervated, tired, and discontented with nearly everything. I am wild and not fit to be talked to – and I do not know what I do so excuse these tiresome lines.

He wrote again to Macfall realising that it was wise to keep him involved in the excitement of his new activities.

26.2.1912.
Dear Mr Macfall,
I am very sorry that I have not seen you for such a long time but that statuette has given me such a lot of trouble that I have hardly been able to take a few hours rest a day. The mould is finished and I trust to cast it tonight. That plaster business puts my rooms into such a state of filth that it is simply disgusting to look at and never more will I undertake getting such a thing ready in so short a space of time.

I had an invitation from Major Smythies to go to his last night. I met Simpson and Fraser there and was disappointed to learn you had not been able to come. Lately I have been digesting all the observations I have made for a year or so and drawn some marks in the way I mean to sculpt them: painted so as to give the absolute characteristical complexion modified by the occasional expression but just as simple and bright as can be – I use for that the optic mixing of the colours putting them in pure pigments side by side so as to give the resulting tone – I will fix some of them and bring them for you to see on Wednesday the 28th evening if convenient.

Mrs Hare as well as her husband became Henri's patron. She suggested that he make two plasters of Maria Carmi, and told him that Lord Northcliffe, the newspaper proprietor, had asked to be 'put down for fifty pounds'. Gaudier set to work eagerly on the clay model of the figure, working in the evenings and at the weekend, and by February

26th had completed the clay and made a plaster from it. He was ill-equipped to handle the clay in their two small rooms, and even less to handle plaster which smothered everything in dust and infuriated Sophie who had by now returned to London from Felixstowe. However, the two casts of Maria Carmi were completed, one for Mr Hare and one for Lord Northcliffe. Northcliffe was not happy with his and gave Leman Hare only five pounds to 'pay off' Gaudier. The plaster Madonna was painted by Gaudier in contrasting primitive colours not unlike the colours on the Lovat mask. This idea, probably suggested by Lovat Fraser, had pleased Gaudier without his realising how innovative it was. This unconventional treatment must have been partly responsible for Lord Northcliffe's lack of enthusiasm, but in any case the work, although having a certain presence, was in many ways a static form and not what had been anticipated. It was the first of several instances of Gaudier being given a subject rather than making a choice of his own. He was never to be happy under these conditions and the commissions were seldom successful.

By February 1912, Henri had made four commissioned sculptures. For the portrait heads he received ten shillings each; five pounds for the mask from Lovat and for the two casts of Maria Carmi, five pounds each from Hare and Lord Northcliffe. Lord Northcliffe later sold his cast at the Gaudier memorial exhibition at the Leicester Galleries. Enid Bagnold was to sit for Henri, but was busy with her own affairs and kept stalling. When eventually they did start they seem, from her description, to have been ill-at-ease with one another. But whatever the tensions between them, they were probably caused by Gaudier's resentment of her middle-class manners. In the strength of the posture of the head, and the slightly haughty position of the chin which conveyed the confidence of the sitter, it was unlike any sculpture he had previously attempted. It was an important work in the development of his portrait sculpture, and by far the best portrait he had yet made. It remains remarkable today.

Enid's account of him at work is unique. In her autobiography she gave a vivid and evocative description of their sessions in his rooms in Chelsea:

When I went for my sitting his sister . . . we called her his sister . . . was ill and lay in the next room. They had two rooms and I sat for him in the front one, looking on the street. There was a wooden table, a dirty clothes bag on a nail, a lot of clay, a dresser and some chairs. It must have been a winter afternoon for it got dark at half

past four, and I think there was a red foggy sun dropping fast behind the houses. I sat still, idle and uncomfortable on a wooden chair. And Gaudier's thin body faced me, standing in his overall behind the lump of clay. We talked a little and then fell silent as he worked. I think he realised the light was fading faster than he had allowed for. From time to time, but not very often, his black eyes shot over my face and neck while his hands flew round the clay.

Then blood began to drop from his nose. At first in beads, but soon in a dark stream that reached his chin and fell down his overall. He made not the slightest effort to staunch it, nor even twitched a lip that must have tickled. He appeared insensible to it. Unable to stand it any longer I said 'Your nose is bleeding. Aren't you going to stop it?' 'If you look in that bag,' he said, pointing without looking at it to the dirty linen bag which hung from a nail, 'You will find something you can tie round.' I crossed the room and undid the bag. It was full of the underclothes of Gaudier and Sophie, and I chose something, long legged drawers I think, and tied them round his nose and mouth behind his neck. 'Lower!' he said impatiently, wrenching at it, unable to see properly. I re-adjusted it, and went back to my seat. The room went dimmer, but before he ceased work I saw the dark blot of blood spread on the folds of the thing I had tied round his neck.

As he threw down his little wooden stick and a sort of flat knife, the violence and the brutality of a dog fight broke out in the street beneath the window. We went to look. We could just see down in the street, which was lighter than the room, a large dog pinning another by the throat, spread his murderous legs over it, his bent shoulders hot with crime. The noise raged up and down the street. Gaudier watched it to a finish with dark and interested eyes, his head against the curtain and the gas lamp shining on his bloody bandages.

By an odd twist of memory, in the radio broadcast of 1965 which commemorated the fiftieth anniversary of Henri's death, Enid remembered the story exactly as this except that the protagonists, herself and Gaudier, were reversed and it was her nose that bled.

It was arranged that she should pay £3 for the finished portrait and Gaudier took it in a wheelbarrow up the King's Road to the flat she shared with Dolly Tylden. When he arrived Enid was out, and he left it in the flat. By the time she got back, Dolly and Lovat Fraser in sheer

devilment had put lipstick on the lips and blued the eyes, and hung a dress under the chin. She was so angry that she burst into tears, but when Henri returned he easily removed the damage for her. She was obviously delighted with the head, because she asked Epstein to have it cast in bronze and she still owned this unique cast when she died in 1980. She had considered bequeathing it to the Tate Gallery, but had not done so. When she tried to speak to Sir John Rothenstein, then curator, he had snubbed her. '"Excuse me," he said with the waspish irritation of an interrupted man, "but I am talking to my director." So I didn't give it to the Tate.'

Henri was deeply involved with this new group of friends, and very conscious that as yet he was only producing sculptures to the demands of others. He had yet to discover his own style and intent. Macfall was so enthusiastic about his work and eager to establish his protégé that he suggested an exhibition. Henri's answer made it clear that he was under no illusions about his achievements so far and he was clearly setting his sights high:

I have reflected on it and I find it is much wiser to wait till next autumn before having a show – I will have much more then, I shall select out what is best – and there are many more people in town then than now, when they go away to the country. As I told you before I wish to exhibit when what I have is of some value – two or three portraits is not enough by a long way – I must have a full length statue at least, and half a dozen high reliefs with about a hundred statuettes, a score [of] portraits and vases – I have just finished a vase and am portraying Miss Bagnold next Sunday 12th inst.

# 4

In 1912 Filippo Marinetti came to London. It was the occasion of the Futurist exhibition at the Sackville Gallery. Marinetti was the motivating spirit of the Futurist Movement in Italy, and although Boccioni, Carra, Russolo and Severini were also exhibiting, Marinetti was the artist most concerned to promote Futurist ideas through lectures and manifestos.

On November 20th Percy Wyndham Lewis assembled a group of friends including Henri for supper at his Greek Street flat, and after a fairly vivacious meal they 'shuffled bellicosely round to the Dore Gallery' to one of the much publicised public meetings at which Marinetti and C.R.W. Nevinson, a staunch supporter of the Futurists, were due to speak. It was a packed audience and whipped into a frenzy by drum rolls and other sound effects before any of the speakers had even arrived on the platform. Marinetti appeared and mounted a raised dais specially constructed on the stage and in Italian hurled staccato slogans from his Manifesto at his audience. It was a totally novel experience for London. Almost from the start of the performance Gaudier became agitated. In *Blasting and Bombardiering*, Wyndham Lewis gave a vivid account of the evening:

> I assembled in Greek Street a determined band of anti-futurists. Mr Epstein was there, Gaudier, T.E. Hulme . . . about ten of us. At the Doré Gallery Marinetti had entrenched himself upon a high platform. Gaudier went into action at once. He was very good at the parlez-vous, in fact he was a Frenchman. He was sniping him without intermission, standing up in his place in the audience all the while . . . the Italian intruder was rousted.
>
> Gaudier was spoiling for a fight. He threatened at Ford's to sock Bomberg on the jaw, and when I asked him why, he explained that he had an imperfect control over his temper, and that he must not be found with Bomberg for the manner adopted by that gentleman was of a sort that put him beside himself. I had therefore to keep them apart.

Marinetti's visit to London sowed the seeds and style of the manifestos that two years later were to appear with such passion in *Blast*.

# HENRI

Henri had received no news from Dr Uhlemayr for some time. Then unexpectedly he received a letter which prompted him to reply immediately, giving a long account of everything that had happened to him in the last year, telling of his new circle of friends, justifying his friendship with Sophie, describing his successes in London. The letter gives such a vivid insight into his perception of his life at this moment that it must be read in its entirety:

18th June 1912: *is this date correct?*

Dear Doctor Uhlemayr,

It was because of my friend Zofia Brzeska that I thought you were hurt. I had told you about her, in one of my last letters, and as you did not reply, I wondered: 'Well, he thinks Gaudier ran away from his parents to have fun with an ordinary woman and it is not very honourable − he is not worth the trouble to write to.' I realise now that this supposition arose because of a letter I did not receive, as I left Sterndale Road exactly a year ago. I must say that I was surprised by this thought as I have always known you to be different − so I am pleased to have made a mistake and to know that our friendship is all the more precious today. Zofia Brzeska is more than my friend − this is certain − without her financial and moral help in Paris, I would have been dead long ago and her help is even more valuable as Brzeska herself was also poor and ill. For two years now we have lived together − we pooled our efforts and together keep up the struggle against life. For eight months now our finances have improved by sheer energy and we actually live together in a little flat in Redburn Street.

Our mutual influence from an artistic point of view is admirably productive. If I have developed quickly it is because of a certain amorous inspiration which matures one a great deal, and then on account of a jealous artistic emulation which drives you to do better. The same phenomenon happened to her. She is writing much better now than when I first met her − we are certainly very happy − but our happiness is peculiar − not sentimental − we do not spare ourselves and work incessantly. Nature has created Man and Woman in order to complete themselves and know how to fight better; the worst thing to do is to obey, and this is what we have done and will continue to do. Brzeska is 40 years old − I am 20; therefore each one of us is 30 − you will not be surprised to see that I have made considerable progress in three years. Most men

37

waste their youth running after 'cocottes' and wittily playing on words. It would be better to steel oneself and adjust one's armour and lance for the tournament, than to dance, laugh and do silly things, arriving at night when the fight is over, the victors proclaimed. I can only congratulate myself to have met Z. Brzeska and to have decided immediately to join my fate to hers. She is very energetic, serious, and as a writer she possesses amazing power and technique; she is very experienced, understanding good and true feelings, but very particular about cleanliness (hence our little discussions and arguments about my plaster etc); she can feel a deadly

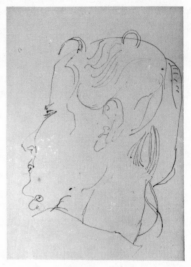

Sophie, 1913.

hatred to anyone who offends her. She does not represent 'Eternal Femininity' but a new feminine type – made of steel – strong as a man – having the same temperament and each forgiving the other's faults to love one another gradually more, with a love built on friendship, giving sexual passion second importance, and not with a common love born simply from passion, with friendship and therefore more lasting.

I can remember that once you spoke to me about help from the French government. This is hardly desirable. First, it is impossible because if I accept something from them I must join their army, and that means death. I will never be able to bond my character to the commands of an officer, and they would probably send me to a disciplining company in Morocco. My health is not very robust and I would return feet first, if however, jackals and hyenas did not fight over my meagre carcass – moreover help from whatever direction brings despondence and laziness. If I am left to myself and my life is worthwhile, that is to say, if I have enough energy, self control and talent, I will always find the means to pull myself out of the rut. I have found a rather good job with a firm designing carpets, fabrics, silks, etc., 'Art Products', and using this as a basis I did my

38

utmost to foster friendships with rich people. I have succeeded in knowing some of them, I have made portraits, statuettes, I am still doing some and one day I shall leave the fabric manufacturer and I shall work freely, on my own.

About Canada, I have discussed at length with the President of the Canadian Arts Club – it seems the country is just opening its eyes and there is a good demand for portraits etc. – sculpture for buildings – I am still in touch with him and he will put me in touch with a sculptor – the only one in Toronto who is forced to refuse work. The English group who know me exhort me, naturally, to remain in London, and everyone is doing his best to find me the most advantageous work. I shall certainly remain where there is the most money. I think the hardest times are over for me and now everything must absolutely contribute to the success of my efforts. I am not 'a little Frenchman indolent and elegant', I have a will of my own and it must win or else I shall perish with it. As I have said it to Mrs Uhlemayr, I shall probably take a trip to Germany next year if everything goes well and then we shall meet again with pleasure.

I am going to South Kensington on Thursday night, to read Art reviews – I am lucky as the English do not speak a foreign language, and I have a whole table to myself – covered with the best magazines in French, German, Italian and Spanish. From time to time I also read a Dutch review but seldom do I find anything worth reading. The review is called 'Oude Holland', 'The Old Holland' and I am deeply interested in modern art. Old Masters interest me a great deal until the end of Giotto and Fra Angelico, but I detest the remainder since Botticelli, as far as the true modern art – that is to say the Impressionists as the whole of their art conveyed only towards bad photography – and the Dutch masters, except Jan van Eyck – all are included.

I would like to see Paul Lehmann's colour, I seem to have seen black and white reproductions of his pictures as his name seems familiar. What I wanted to know is if Klimt has a great influence in Vienna and if Hodler is altering a little as he seems to become increasingly affected. The Czechs have an interesting movement but I can't lay my hands on any of their reviews; neither the Russians nor the Poles. The Slavs seem to have formidable reserves of energy, slightly entangled by corrupted bureaucracy. I am very interested to see how all this is developing. The Spaniards also are

moving forward firmly, naturally the Italians – buried as they are in their Renaissance – have only a few names, among them Severini the man admired the most by them is the brightest star, his colours have a sun-like splendour, as clear as the spectrum and he uses it with tremendous feeling. He reminds me of Seganta by the feeling and treatment of colour itself, but he surpasses him by a head. There is also a good movement among the Scots. I know two of them, Peploe and Ferguson [sic] who are also gifted in the handling of colour and form which is captivating – but they both live and work in Paris. Ferguson [sic] even publishes an art review in English and French, very often it includes some of his drawings. The text is edited by a certain Murray [sic] and most of the time is very stupid. Even in England there is only 'Frank Brangwyn' and yet, although crowned as a master by the Gods of France and Germany, he repeats himself too much to be taken seriously. I have a friend, Lovat Fraser, who handles colour well, but he is only just beginning, and am not sure, but his English hypocrisy is transmitted in a certain way to his works, and in a certain measure affects me unfavourably.

A Russian sculptor, Jacob Epstein also works here – he has just finished a tomb (sarcophagus) for Oscar Wilde in Paris. The thing will be erected in the Père Lachaise Cemetery next July. I saw it in the studio last Sunday – Oscar Wilde is flying slowly into space, his eyes closed. The whole work is treated strongly filled with insuperable movement and delicate feeling, in the expression and the medium – a piece of sculpture which in a word will live for ever only the total effect seems to be too small. The whole thing is large – you understand what I mean – but the statue seems to be delicate, too small, the whole cut from the stone without modelling.

I have written to Ferguson [sic] and sent him some of my drawings for publication in Rhythm; if he publishes any I will send you a copy.

Does Herr Graumann paint better things now? What he showed me in Dachau when I saw him was not very good, perhaps in Munich he had better works – he was with a certain Kerzen – or something like that – a person whom I did not like very much and who seems presumptuous and scornful. I rather like Graumann, a little Jew, intelligent and open. Remember me to him when you see him – but naturally you need not tell him I called him 'a little Jew'.

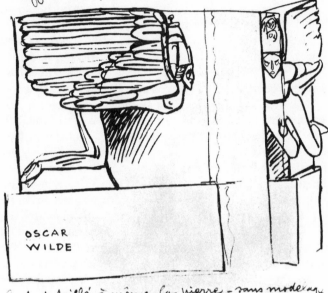

Extract from Gaudier's letter to Doctor Uhlemayr with sketch of Epstein's tomb of Oscar Wilde.

Zofia Brzeska (whom I usually call 'my sister' or Matka to simplify things) joins me in sending you our kind regards,
Yours,
H. Gaudier Brzeska.

The question that arises from this letter is whether Gaudier was trying to boost his own morale or simply wanting yet again to impress Dr Uhlemayr? Either way much of it was fiction. Certainly the Canadian episode seems fictitious, and the 'rather good job with a firm designing carpets' equally has little, if any, foundation that can be traced from

41

Gaudier's notebooks or other letters at this time. The 'fostering of rich people' was also an exaggeration to bolster his ego. The defensive references to Sophie suggest that he could already perceive their difficulties. His disparaging remarks about Lovat are something of a betrayal. This is the time when he was working on Lovat's studio, his first exciting commission, a commission that gave rise to many new ideas. Henri was again biting the hand that fed him.

There were at the time a number of small bookshops in London whose owners encouraged young artists to display their work, pass the time of day and gossip. One was Harold Munro's in Charing Cross Road. Epstein rented a flat above, and it was here that Epstein and Gaudier first met. One of the most significant passages in the letter to Uhlemayr is that about Jacob Epstein. It is interesting that Henri thought of him as a Russian when in fact he was born in New York in 1880 of Jewish parents who had fled from Poland. Epstein was the first sculptor with whom Henri had come in contact. His influence was to be crucial, as Epstein was at that time working directly in stone, and was developing his ideas of sculptural form from African primitive art. He had been in Paris before settling in London and was familiar with Paul Guillemot's collection of primitive art which was exhibited in Paris in 1904. In 1912, Epstein was well established in London where he was considered an avant-garde artist and, as Henri said in his letter, was working on the Tomb of Oscar Wilde, his first major international commission. It was the first of a number of stone carvings that would shock a conservative public in the following decades.

Gaudier was immediately stimulated by this 'real' sculptor and from his descriptions of seeing the carvings in Epstein's studio it is not difficult to comprehend the impact the visit made on him. He recounted how Epstein, surrounded by blocks of stone, and covered in dust, was carving in a way that personified everything he aspired to. There is an apocryphal story that Epstein asked if he worked in stone, to which Gaudier replied, 'most certainly'. Epstein was doubtful and challenged him by replying, 'very well, I'll come on Sunday and see.' It is an amusing anecdote and probably has an element of truth in it. Certainly, seeing Epstein's work would have galvanised Gaudier into appropriating some stone and launching into carving without further thought. His first work in stone was *Head of Christ*, and, the story goes, when Epstein arrived on the Sunday, the piece was ready for inspection.

Henri was immensely flattered by Epstein's interest. He was well aware of the older man's connection with Paris and the young artists

working there. Epstein must have talked to him of Picasso, Brancusi and Modigliani and the controversial work they were producing. He fed Henri's thirst for information and introduced him to T.E. Hulme, the philosopher, who became one of his champions. After Epstein's return to Paris in the early summer to the furore over the Wilde Tomb, his impact on Gaudier remained profound and enduring. He, and later Brancusi, were the contemporary artists who most significantly influenced Gaudier's sculpture.

Although Henri consistently expressed anti-semitic sentiments (he had this in common with Ezra Pound), like much in Henri's life, his actions contradicted his words. The two men to whom he was closest in London were both Jews – Horace Brodzky and Alfred Wolmark – and the sculptor who most influenced him, Epstein. Where he imbibed these prejudices is difficult to assess. France was still alive with the Dreyfus Affair when he was growing up, Germany a hotbed of Aryan culture when he was studying in Nuremberg, and Sophie expressed similar sentiments which she had undoubtedly brought with her from Poland. Her childhood would have been spent against a background of recurring pogroms and virulent anti-semitism. Anti-semitism was widespread in Europe and America at the turn of the century and the kind of comments with which Henri peppered his conversation were not exceptional. Pound was brought up in an America with an underlying intolerance among the middle classes which was further heightened by the great influx of Jews fleeing the Russian and Polish pogroms of 1870 onwards. It has to be remembered that many of the people already settled in the States had originated from the same countries as the refugees. Their prejudices had come with them.

It seems plausible that Henri's derogatory remarks were merely an absorption of the attitudes prevalent at the time, because his behaviour belied them so completely. His lunchtime sketches of East End Jews when working in the City are not caricatures or cruel jokes, but sympathetic observations. Brodzky became his closest friend – they spent hours together in the railway arch studio — and Alfred Wolmark and his wife took him under their wing and fed and helped him. He made portraits of them both and was influenced in his pastels by Wolmark's Fauvist colour sense. It was another facet of his personality which showed that here was a precocious young man with a complicated mixture of immaturity, bombast and a bravura that his friends attributed to genius.

43

# 5

ohn Middleton Murry and J.D. Fergusson were editor and art editor respectively of *Rhythm*, a magazine launched in 1911 and concerned with art, music and literature. The title was taken from the current over-usage of the word rhythm to describe all things artistic. Henri had met neither man, but encouraged by the success of his approach to Haldane Macfall, which had led to his drawings being included in *The Splendid Wayfaring*, he wrote offering drawings for the magazine. Fergusson immediately accepted some for publication. Henri met both Fergusson and Murry and was also introduced to Katherine Mansfield, the New Zealand writer with whom Murry was living and whom he later married.

These were important meetings for Henri, and that with Murry and Katherine Mansfield rapidly blossomed into a friendship which, on her return to London, also embraced Sophie. As a foursome, it was a mixture of alarmingly explosive material. In a very short time the friendship fell disastrously apart because of what Murry called Sophie's 'Dostoievsky' character. Murry himself was a difficult, self-opinionated, arrogant man, and Katherine was highly strung and neurotic. Katherine had a certain beauty which was heightened by her fragile health but she also had a reputation for being spiteful and difficult, which might have been partly due to her illness and excused by her increasingly prolonged stays in sanatoria. They called each other 'Tiger' and were known amongst their circle as 'The Tigers'. On a postcard to Sophie on September 20th 1912, after their friendship had split apart, Henri referred to them as 'les sales tigres'.

In the first flush of their friendship, Sophie and Henri invited Katherine and Murry to Redburn Street and Gaudier began a head of Murry in clay. Later, when Murry and Katherine rented a cottage at Runcton near Chichester, Sophie and Henri were invited to stay. It was this invitation, for the last Saturday in August 1912, that caused the split between the volatile couples. Sophie had been unable to go and Henri, arriving alone, approached the cottage from the rear and overheard what he thought was a derogatory remark about Sophie by Katherine. Gaudier, as was typical of him, took instant exception and turned on his heel and went back to London. When *Rhythm* was published a few days

later with six of his drawings in it, he confronted Murry, asking for payment. Murry countered that the magazine was supported solely by himself and Katherine and no one received money for work published. Gaudier, with assumed outrage, used this as an excuse to row with Murry and threatened to throttle him. His antagonism was fuelled by another contributor, a Scottish woman writer who used the name 'George Banks'. She had earlier 'wiped the floor with Murry' and she encouraged Henri in his confrontation. They went to visit Murry at home. Murray wrote to Katherine after the row: 'G. and Gaudier have just been. Of course, I am not worth a twopenny damn now. I've been crying out of sheer nervous reaction. The old story shrieked at me, plus some Gaudier lies and venom. I can't do any work now. I'm just good for nothing. I love you – but suddenly this beast has fouled everything. Either of these antagonists alone could have filled me with apprehension, in alliance they struck panic into my heart.'

Years later, Murry recalled the incident in vivid detail:

I was scared to be alone. In retrospect it seems fantastic; but there is no doubt that at this time, the spring of 1913, I was really horrified of what Gaudier might do to me. His malignity had caused a sort of convulsion within me, and I believed him to be the kind of man who might do anything. And now, to complete my consternation, I learned that he had formed an offensive alliance against me with the woman artist G. who I had known in Paris. I had been the witness of her hostility towards an artist who had been her friend, and I knew what to expect.

'You are a dirty liar, as well as a thief!'

We glared at one another, and the next moment I was aware that two drawings hanging framed on the wall had been suddenly snatched down. 'Are you going to pay?' said Gaudier.

'Certainly not. I haven't any money to pay you with. And, if I had any money, I would never dream of paying you.' Then I felt a stinging slap on the face. Gaudier laughed. I tried to look as though nothing had happened. 'Have you finished?' I asked.

'That's enough for tonight,' said Gaudier. 'But we've only begun.' And they went away.

The origin of Gaudier's grievance against me, I knew and understood; the cause of G's animus was a mystery. But the basis of their present alliance was a common pretence that I had exploited them as artists. Since I could not suppose that they seriously

believed this to be true, their behaviour to me seemed to proceed from a motiveless malignity. I am not surprised that I was scared by it. Indeed, it is only after many years and much experience that I have come to a full understanding of this incomprehensible episode. Within a few years, it is true, I had a glimmering of the emotions that were working in G., but the case of Gaudier remained mysterious. For why was his hatred directed against me? On his own confession it was not I, but Katherine who had dealt the blow. Yet his hostility towards Katherine was merely theoretical and perfunctory. In the same breath he made her responsible for all that I had done, or left undone, and proclaimed that all my iniquities were committed at her instigation; yet it was me, and me alone, that he threatened revenge. It was me he proposed to kill.

Every now and then I would receive from him some mysterious and menacing epistle to say that he was preparing his revenge. I forget how he signified to me that he had entered into an alliance with G. for this purpose, but I knew that I was given dire warning. And, I confess, now that I was alone, I lived in fear and trembling; I felt that they were capable of anything – quite capable, at least, of creating an uproar in the block of offices where I lived, and accusing me of all manner of excesses for all the world to hear. I locked and bolted the door in the evenings and refused to open it. They came once or twice together and hammered in vain. But late one afternoon they took me by surprise. Unsuspectingly I answered the knock. They were there. They brushed past me.

'Now we've got you,' said Gaudier.

'So it seems. What do you want?'

'All sorts of things. We've come to pay you out.'

'Very well. Fire away.'

'I should like,' said Gaudier, squeezing his fingers together round an imaginary throat, 'to throttle you. But you're not worth murdering. But you're going to pay me for the drawings of mine you published.' At that my indignation got the better of fear. I was trembling, but I managed to speak quietly.

'You know perfectly well, there never was any question, or possibility, of your being paid for your drawings. And what is more you know that you were only too anxious to have your drawings published for nothing. You know that *Rhythm* has never had any money at all. It's been Katherine and I who have paid for *Rhythm* – two hundred pounds.'

46

This episode highlights Gaudier's frequently irrational behaviour and illustrates how, with his often cruel and vindictive outbursts, he lost a number of friends, some of whom could have helped him. He would never admit how poor he and Sophie were and kept up a facade of insouciance, giving the impression that it was because material comforts were of no account to him that they lived in such extreme discomfort. The Macfalls and others would have helped more had they been allowed to get closer.

Dolly Tylden in her unpublished memoirs wrote:

At that time, to save bother, they called themselves brother and sister, but Miss Brzeska looked at least twenty-five years older than he. She was obviously an 'exaltee', and she talked of philosophy and poetry in the grand manner, but without being in the least ridiculous. He, when asked to show us some of his work, gave us a pile of drawings to look through. They were so good that I at once made up my mind to buy one, but at the same time one of my irritating double-crossing sensibilities began gnawing at me. I have always hated asking someone I know what a thing costs if they want to sell it. How much more difficult it was going to be here, with this frightful poverty hitting me in the face. I was poor, too, but that was relative compared with them, and I dreaded that he might think I wanted to 'help' them. Although I had only met him half an hour ago, I realised what I was up against. At last I said as naturally as I could, 'Can I buy one of your drawings?'

He answered quickly. 'Oh, no. These are only sketches, but if you like them, please take the one you like best.'

I made no effort to argue. I knew at once that that would be impossible. In my mind I had already picked out two or three of the best to choose from. Now I felt constrained to take one of those I thought inferior. I pretended to look through them again with care, and asked him if I could have a small head in charcoal. By the way he said 'Yes' I knew that my choice had nipped any faint hope he might have had that I understood and appreciated his work. But as I couldn't pay him, I threw him a little of my vanity – out of vanity. .

On another occasion, I was walking along King's Road one cold winter's afternoon; we stopped and talked for a few minutes. He was almost in rags, unshaven and shabby looking, with such an intense atmosphere of defiance of what he knew I must think his

appearance suggested, that I was too frightened even to ask him to come round to my flat and have tea. It was one of the few times in my life that I was a moral coward (as I have said, I am nearly always a physical one), and I have often regretted that I didn't risk a snub – however cutting – and try at least to give him something to eat.

I walked home feeling miserable, thinking what a fool I'd been; with a little tact I might perhaps have wangled an imaginary 'commission' for him. But his terrific personality had always rather unnerved me, and, thinking it over, I realised that 'tact' and 'wangling' had nothing to do with him. He was a force outside those well-meaning shop-keeping qualities.

# 6

A t about this time, Henri made a friendship that proved to be one of his most enduring. Horace Brodzky was an Australian-born Jew whose family had originated in the Ukraine but who migrated through Europe to East Prussia, Vienna and Paris. His father, after serving in the Franco-Prussian war, emigrated to Australia in 1871 where he became a teacher and journalist, finally owning his own magazine. As a result of a court case and over-borrowing, he was declared bankrupt in 1904 and the family left Melbourne for San Francisco. There they were caught in the great earthquake of 1906 and so travelled on to New York, but after two years the family finally moved across the Atlantic to London. Horace had been born in 1885 in Melbourne. By the time he and Henri met in 1911, he had already mounted his first solo exhibition at his studio in Manresa Road, Chelsea, which had received a favourable review from the critic Paul Konody. He had also become one of the group of painters who visited Sickert's 'Saturday afternoons' in Fitzroy Square. His meeting with Henri came about as a result of Henri seeing a woodcut by Horace on the cover of a magazine called *The Art Chronicle*.

Brodzky was slight in build with an unusually proportioned head and a striking countenance. He stooped when standing, as if his head were too heavy for his small frame. Their friendship grew rapidly and he seemed, unlike everyone else, to thrive on Henri's outbursts. In his eyes, Henri could do little wrong. Brodzky was six years older than Henri, more mature and a great deal less impetuous and ambitious. He frequently modelled for life drawings, his lethargic posture making a contrast to the usual professional models to be found at Henri's evening classes. Their friendship must have been based on the attraction of opposite temperaments. Brodzky seems to have enjoyed Henri's outbursts of vituperation, possibly because they were so unlike his own behaviour. Sophie described their relationship as 'like a dog running in and out of Henri's legs', while Brodzky said later that he was 'really the only friend Henri had'. When in June 1912 Henri persuaded Brodzky to sit for a portrait bust, he modelled a head that was larger than life-size and the most powerful and original portrait he had yet conceived. It remains a major work of strength and redolent of the sitter's personality.

Shortly after the incident with Middleton Murry, Brodzky participated with Henri and Sophie in a brick throwing competition in the studio. The target was Henri's portrait head of Murry. Horace recalled that after several misses it was his brick that succeeded in destroying the head and any possible relationship between Henri and Murry.

After Henri's death, Brodzky went to New York with an introduction to John Quinn from Ezra Pound. He seems not to have liked the American collector, but nevertheless became 'Clerk of Works' for his 1917 Vorticist exhibition. Brodzky wrote a memoir of Gaudier which was published in 1933, and compiled a book of reproductions of drawings in 1946. In *Henri Gaudier-Brzeska 1891-1915*, he gave an amusing account of the portrait head:

> Brzeska had already decided to model my portrait, and he often expressed the desire to commence. At last we arranged a sitting. He was full of enthusiasm, and insisted on my stripping to the waist, as he wanted to do the chest as well. My head was tilted back, with the chin prominently forward.
>
> He worked in the most alarming fashion: jabbing all the time. He did not appear to go at it methodically, although I suppose he had a method, but he thumped the clay about, gouged out furrows, and all the time he was telling amusing stories. He seemed to get fun out of the work. He was full of devilry, and I am sure that his idea of my being bare-backed was to add to my discomfort, for at later sittings – or rather standings – even if he was only concerned with an eye or the upper part of the head, he would still insist on the removal of my shirt. I knew he was tomfooling, but as he got on with the work and really produced something I gladly put up with it. The weather was hot and a bare back was no great hardship.

Later describing the sittings Brodzky said:

> It was not necessary for me to strip to the waist as I did. Brzeska knew enough about anatomy to know how the head and neck were attached to the chest. It was good fun for him to have me disarrange my clothes.
>
> This bust, to use his own words, was 'cubic', and in many respects is very like his over life-size pastel portrait of myself. In each of these works, bust and pastel, he has emphasised the planes

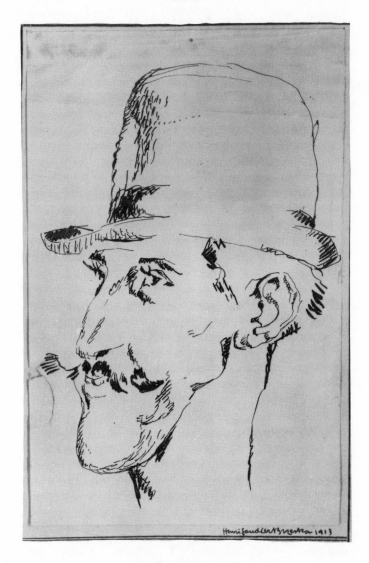

Horace Brodzky, 1913.

Gaudier's drawing of Brodzky with bust.

and exaggerated the asymmetrical in my head. Both, I think, are good character portraits and interesting examples of his work. The modelled portrait bust of myself I consider his most interesting portrait bust.

At the back of the bust he signed his name with a dedication in shorthand. In front he scratched a male nude, and a girl's head. He did not explain the significance of these incised drawings. And I am quite sure there was none. They were done in a moment, on the cast before me. Put it down to his youthful fun.

52

One benefit from the all-too-brief friendship with Middleton Murry was an introduction to Edward Marsh. In 1912 Marsh, a professional civil servant, was Under-Secretary to Winston Churchill at the Admiralty. He was an avid collector who until about 1910 had bought solely Old Master works. He was now making a remarkable collection of Impressionist and modern paintings and had gathered round him a group of young artists and writers. He was a dilettante in the true sense, and his literary interests had led him to compile and edit a selection of the work of young poets under the title *Georgian Poetry*. He was planning to follow it with a complementary volume, *Georgian Drawings*. Everyone of note in the political, literary and artistic world was a friend, or at least an acquaintance. Marsh entertained widely at his rooms in Raymond Buildings, Gray's Inn, and among the painters who were frequent visitors were Mark Gertler, John Currie, Stanley Spencer and Paul Nash. Henri met all of them there at one time or another. It was intended that the book should include the work of these artists and William Roberts, Elliott Seabrooke, Gilbert Spencer, Isaac Rosenberg, Christopher Nevinson, Rudolph Ihlee, Wyndham Tryon. The project came to nothing, because of a combination of lack of money and the outbreak of war, but it brought Gaudier into yet another of those concentric circles of young creative people thriving in pre-war London. Had *Drawings* been published his work would have been included, quite an achievement after so short a time both as an artist and a member of the London art world.

Murry had suggested that Edward Marsh write to Henri. He received a reply by return:

25/9/12
15 Redburn Street
Chelsea
Dear Marsh,
I shall be very pleased to go and see the pictures you have and I most heartedly accept your kind invitation, I shall turn up in Soho at the appointed time and place this Friday.
  Your envelope bearing the Admiralty Seal gave me a sort of fright, I had a vague idea I was going to be arrested for something or other – the look of governmental authority is always more or less frightening to people not accustomed to it.

It had been Henri's good luck that he had not provoked his quarrel with the 'Tigers' earlier; Murry had been generous in his praise and in

suggesting to Marsh that Henri merited his consideration alongside the other young painters who attracted his patronage. But the quarrel did happen; and this, together with the cramped and damp living conditions of their new rooms in Paulton's Square, Chelsea, depressed Sophie even more. In a fit of ill humour she left London for a cottage she had found in Frowlesworth in Leicestershire. As soon as he was on his own again, things became easier for Henri and invitations to the Macfall Wednesday evenings were renewed; Sophie had made herself unwelcome with her moodiness and jealous outbursts. Almost immediately Anthony Lousada, another of the Macfall circle, offered Henri a commission to create a portrait of Bohm and Karsavina, who were dancing *L'Oiseau de Feu* with the Ballets Russes then taking London by storm. This was Henri's first attempt to make a sculpture of two related figures. It was his biggest challenge to date and presented a number of technical and design problems. Gaudier posed the two dancers in such a way as to convey a feeling of counter-balance between the figures. The sculpture is an advance in his realisation of the interpretation of movement in the human form, and Henri must have considered it his most significant achievement so far.

Enjoying the freedom and friendships that resulted from Sophie's absence, Henri wrote long, involved letters to her. Most were about his theories on art and his future schemes but one written at the end of October went to the heart of their relationship:

24/10/12

Zosik,

Your letter upset me a great deal. From one end to the other you do everything you can to find fault with me, there is no depth to your assertions and what is more you support them with inaccurate historical quotations. Take Rodin for example. My anxiety is caused by your stupid 'moral attitude' rather than by your attacks against me. I certainly have many faults, in fact like everyone else I have every fault in a greater or lesser quantity. To the accusation that I am a spendthrift, yes, but conceited, no, you need to put together a spiteful letter to prove that against me. Since you are such a good supporter of the old mystical philosophies which search into the reasons and consequences of things why don't you meditate on what you are saying. You accuse me of being conceited and in the following line you say that I am continually changing my ideas and opinions even about Art etc. Doesn't this show that I am not

conceited? . . . The conceited person is one who stops at one aspect of his work or thought and who like you shouts out. I am not like that at all, I look at things a great deal and I do a lot of drawing so that I can see how things differ, inter-relate and clash with each other. I am never certain that what I say or think is true, and even less certain that what I have said or thought is true and that I am able to sacrifice some new ideas, which are completely different from those I had yesterday, just because they had the good fortune to come into my head and whilst there I relentlessly advocate them.

Say what you like but Art has no moral aims . . . Morals are of secondary importance but an awareness of change is very important for without it work cannot be renewed.

When you have realised once and for all that I am a poor Pikus, a very poor Pikus, and that the only country where I can work during the next few years is just England you will perhaps be able to see things more clearly. Do you realise that I have to be in a filthy office all day and that every minute I am subjected to torturous desires to be cutting stone, painting walls and casting statues? You always seem to be forgetting this and it is very rude of you. I only know stupid people but through them may be able to extricate myself from this hell of shipbroking etc. and of course I am not going to change course in search of some vain glory because my pride has been hurt. I am of the same opinion as Machiavelli that when you want to obtain an objective you must use every means available, for when everything is considered and analysed, the misery I put up with at work is far greater than the insignificant troubles of the soul, mind and understanding which I put up with in my dealings with these pigs that I know.

You have a good example of this in front of you, me too, this example is yourself. Through your pride, you have ruined all the best part of your life, which you put above the work which you could and ought to accomplish. This is the inevitable conclusion of a narrow minded egoism, which puts the individual on a pedestal labelled 'don't touch', and confuses the primordial concept of an individual living within a society in harmony with other people.

All the complaints you have about me infuriate me since none of it is my fault only yours: the falseness of your principles about life. My love for you is entirely intuitive, yours for me is the result entirely of reason and that is the first obstacle from which all our differences of opinion stem. Since you are determined to be alone

stay alone, I will, for my part manage as best I can. You insist that I am not sufficiently interested in your work that I don't ask questions about it – that I haven't read anything of yours since people said it wasn't worth bothering with. That is a hideous lie. What questions can I ask about it? During the two years that we have been together your work has always been in a state of preparation and, apart from slight alterations is always practically the same – except of course that it gets more drawn out and amplified.

You never set yourself a limit or speak about the final form you want it to take and since I know the story from A to Z, what's the point in asking you questions about it. I have, in fact, read all the little notes you have put in the margins and that is more than you can say for yourself about my drawings which you never dream of looking at unless you want me to give you one, and then you go and hide it.

The whole fuss is, of course, a triviality but you seem entirely oblivious to the fact that I work hard to earn our living and don't want to stop my artistic activity. You exaggerate every little fault, never try to understand why I do this or that expecting me to accommodate all your arbitrary behaviour, which is conceited, self-centred and irrelevant. This upsets me more than anything else and if it goes on too long it will destroy my love for you. I can't see why you don't modify your behaviour to suit the circumstances. You reproach me for not having written to you which is absolutely untrue since I wrote you three letters at the end of last week. You even say that I never tell you about what I have been reading, what time have I got to read? You know quite well I hardly have the time to work . . .

I have seen a lot of people who know Murry and they all say that he was quite a different person a year ago lively, outward going . . . in spite of what you say I am sorry for him, I don't hate him at all. As for 'Rhythm' no one knows exactly what's happened . . . Macfall has produced an awful publication 'The Splendid Wayfaring' which you will find in 'Art Chronicle'. He asked me to provide drawings to illustrate it and I gave him about sixty but the stupid editors made such a fuss about a monkey I had drawn with only three legs that Macfall had to go back to them three or four times to convince them that it should be included. Actually I believe he wished I had put in a fourth leg.

# HENRI

Gaudier self portrait, 1913.

It is clear that Henri was confused about his relationship with Sophie. Although suffering some feelings of guilt, for she made it clear that her life was dull and she was lonely, he had no intention of admitting to the guilt and turned it into aggression and vituperation. The immaturity of his intellectual grasp of complex ideas is apparent, and he takes refuge in attacking Sophie. When, in 1929, Raymond Smythies was asked for recollections of Gaudier he recalled him being 'cutting in his criticism and furiously abusive of most of those with whom he came in contact'. Henri was not unaware of this capacity to hurt although he was rarely known to apologise, but following this particular letter he wrote to Sophie, 'I regret many things I have said and done, you must realise, Zosik, that I have only just opened my eyes to the world and I am dazzled. My feelings are not aligned with my reason, my words fail to express exactly what I want to say. My understanding is scanty and the primitive qualities in my nature take the upper hand.'

Gaudier attended evening life drawing classes to work direct from the model.

In the evenings and at weekends he was socialising and having a thoroughly exciting and stimulating time. His output of drawings was prodigious and he was going to an evening class for life drawing so that he could work directly from the model. In November he wrote to Sophie that 'I went to the class again on Friday, they had a man again, but old, brutal, with a great belly. I worked well, and asked the old woman when we were going to have a woman to draw. She promises one for this week, I am anxious to see if the old bitch will make her wear a rag as she did the boy – just as if she were in her "suiski czerwone" – for all I know they'll hang another over her breast. The people in the class are so stupid, they only do two or three drawings in two or three hours, and think me mad because I work without stopping – especially while the model is resting, because that is much more interesting than the poses.'

Many of the drawings Henri was making at this point show a change of interest, away from architecture and minute detail, to a simplification of form and a single fluid line. He was continually searching out form and his drawings are unmistakably those of a sculptor. But they are not drawings for sculpture – he seldom made a preparatory drawing for sculpture – but drawings which in their directness expressed the form the line contained. He was also doing some painting, although he was never truly seduced by colour. He worked on a large canvas of a Jew selling trash but abandoned it, and when a little later he needed a support for the relief plaster of *The Wrestlers* he put it to practical use. His frenetic work programme was developing against a background of discussions in London arising from the first translations into English by Romilly Fedden of Rodin's *L'Art*. Rodin's theories about the figure and its interpretation in movement were familiar to Henri from his Paris reading, but they took on a new life now that he was in a position to explore them in practice. He fluctuated between accepting them wholesale and rejecting them out of hand. The Rodin influence was still apparent in the modelling of Henri's relief, *Workman Fallen from a Scaffold* which is reminiscent of Rodin's *Daughter of Icarus* and *Broken Lily*.

Until now, all the commissions Gaudier had been offered were based on portraiture. Even *L'Oiseau de Feu* was a portrait, albeit full length of two specific dancers. As a gesture of independence Henri made a head for his own satisfaction. He gave it various titles: *Self Portrait*, *Head of an Idiot* and, curiously, *Head of a Jew*. It was certainly a portrait, and it was certainly satirical. The influence it reflected, if any, was Daumier. It was small-scale, barely half life-size, with strength and integrity, and in the

59

modelling there is an indentation in the forehead that in a mysterious way foretells the bullet which would kill him.

In Cecil Court, off Charing Cross Road, was a bookshop-cum-gallery run by Dan Rider, a rumbustious 'fat little man who roared with laughter the whole time' and who, like other book dealers, encouraged his friends and artist customers to bring pieces of work to show in the shop in the hope they might sell. Henri made use of this opportunity and one of the two plasters of *L'Oiseau de Feu* was displayed in the window where it was seen and bought by Leman Hare. The other plaster Anthony Lousada paid to have cast in bronze, and promised Henri that he would use his not inconsiderable influence to have it exhibited at the International Society. Henri had been paid £5 each by Enid Bagnold and Major Smythies for the plaster casts of their portrait heads. They then had the bronze casts made and paid for them themselves. *L'Oiseau de Feu* was Henri's first completed commission in bronze and on the strength of this success, he asked Haldane Macfall if he could persuade Frank Harris 'to put in a good word for him', and thereby not only get Lousada's sculpture exhibited but also Macfall's portrait bust. Gaudier was also hoping that Harris would be prompted to resume arrangements to sit for his portrait as he had promised. Henri had met Harris through Lovat, and for a short time Harris and Rider were running a magazine together called *Hearth and Home* to which Enid Bagnold contributed. Henri managed to persuade Frank Harris that Brodzky was the right man to be his assistant editor. Henri and the artist Joseph Simpson both had drawings published in the magazine, but although it showed every sign of becoming a success it was short-lived. Harris said he wanted to sit for Henri, but he continually postponed the dates.

Henri was also hopeful that another commission would come his way. At Rider's shop, he had met an actor called Ewart Wheeler. Wheeler had a brother who suggested that Henri make small sculptures suitable for mascots on motor car radiators, which were becoming popular at that time. He liked the idea of having one for himself of a swimmer and another of a wrestler. With this new project in mind, Wheeler took Henri to St Bride's School where two wrestlers trained. Henri found the spectacle tremendously exciting. 'Last night I went to see the wrestlers, My God, I have seldom seen such a wonderful sight – two athletic types, large shoulders, taut bull necks, small in build with firm thighs and slender ankles, feet as sensitive as hands and not very tall.'

Henri was carried away by the speed and excitement of the two bodies entwined in combat. 'They fought with tremendous vivacity and

w & Co.                    2n.

7/11/12

Dear Maifall.

Lousada has promised me to try and get
his bronze exhibited for me at the International
I should very much like your portrait to be seen
there at the same time - Can you not get
Frank Harris - (who apparently likes the coloured
nijinsky now in Riders shop) - to put in a word for
me if he thinks the portrait would compare
with the rest of the exhibition?

Please do what you can towards this,
if you succeed I'll pay your trouble with
drawings.

I had some business at Hares last night
so I could not come and see you - next
Wednesday I am going out, so I will only
be able to come along on the 20th

Many kind regards to mrs Maifall
with best wishes for thorough recovery
I am yours sincerely
H Gaudier Brzeska

15 Redburn St
Chelsea. SW

Gaudier often paid for favours with drawings 'in kind'.

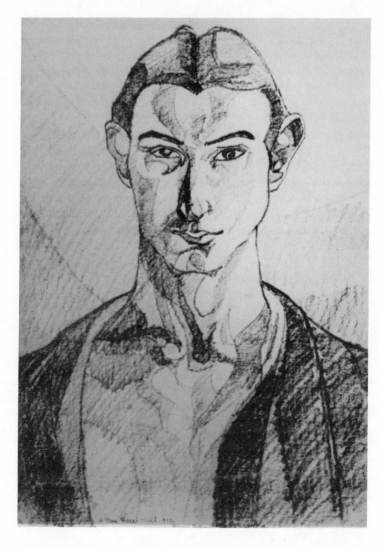

Self-portrait, 1912.

vigour, turning through the air, falling back on their heads and almost at once were up again on the other side. Absolutely unbelievable, they have reached such a stage of perfection that one can take the other by the foot and without exaggerating can spin him vertically round and round five times, then let him go so that he fell like a ball on his head, but he is up immediately and continues with more temper to the fight. Pik believing that he would have been smashed to pieces.'

Typically, Henri's enthusiasm far outreached what was wanted of him. One of the two wrestler brothers recalled that 'Gaudier came to St Bride's School and sketched us. The statuettes Wheeler wanted were never done, you see he wanted something 9 or 12 inches high and Gaudier did something in plaster about 2 or 3 feet.' It is difficult to believe that the sculpture *The Wrestler*, a solid rather massive figure, arms thrust forward but rooted firmly to the ground and lacking any of the vivacity and spin that Henri described so enthusiastically, is the result of these bouts. He made a great number of drawings of the Bacon brothers and in the drawings captured the movement and poise of the two men and the feeling of tension and strength of their bodies. The drawings have a vitality totally lacking in the sculpture. Four casts were made of the figure much later, and one, appropriately in lead, is in the Hirschorn Collection in the Smithsonian Museum in Washington D.C.

The theme itself, however, did capture his imagination and although Wheeler did not get his 'statuette', Henri also produced a large relief sculpture in plaster of two figures wrestling, bent at the waist, one clasping the other round the middle with his leg apparently round his neck. The work is stylized and has a formality unusual in Henri's work. It could be that he knew that the first sculpture of a single wrestler was unsatisfactory and static, and hoped with a relief that was simplified and balanced he would be able to instil more tension to do justice to such an exciting subject. It is without doubt more successful, but it was a formidable concept in the first instance for a sculptor with so little experience.

Henri's *Head of an Idiot* was not the only self-portrait he made at this time. He drew a head in pencil, the largest drawing of any subject he had yet contemplated, and in the simplification of the handling it foreshadowed the abstraction that was to develop in the following months. It is a striking, unequivocal statement of unparalleled honesty: a full-face study of such penetration that the character and determination of the artist stare directly from the paper. It was the most important and successful work he had yet achieved, albeit a drawing not a sculpture.

Inscribed to 'Mrs Hare, Christmas, 1912', it is now in the National Portrait Gallery, London. The drawing was given to Mrs Hare as a 'thank you' for her perseverance in trying to find a studio for him.

Mrs Hare had found a studio in Fulham Road. 'What infinite peace after the hellish din of Redburn Street! Ideas keep rushing to my head in torrents – my mind is filled with a thousand plans for different statues, I'm in the midst of these and have just finished one of them, a wrestler which I think is very good. I'm also doing sketches for a dozen others, God! it's good to have a studio. It's disgusting that so fine a hole should remain empty while I am at this filthy 'business', Zosik could be quiet here, and would write better than while stowed away in the country . . .'

'This filthy business' was his continuing need to work at Wulfsberg's. In December he had signed a new contract increasing his salary to £10 a month. The newly acquired affluence made him feel sufficiently optimistic to send Sophie four gold sovereigns and suggest she return to London. She was currently living at Dodford in Northamptonshire, having moved yet again, and was still writing her family history. But it was mid-February before Henri managed to persuade her to return on the strength of the promises of commissions from Frank Harris, who had now returned from America. She arrived in Fulham to find a dilapidated mess of a studio and a solicitor's writ to the effect that the studio should not be used for living purposes. The shock of the writ, added to the dirt, noise and draughts was too much for Sophie. Within a week she had taken to her bed suffering from cold, influenza and worry. Her return to the menage had not been a good idea.

With Frank Harris' return the portrait bust of him, postponed so many times, was taken up again and finished in March, but although Harris had spoken of influential friends who would commission work from Henri, nothing materialised and he had no major commission or other help from Harris.

At Lovat's suggestion, Henri removed his *Head of an Idiot* from Dan Rider's shop and put it in Lovat's studio. Lovat thought that it would be bound to catch the eye of one of the many visitors to his studio and that he would be able to interest them in purchasing it. He was absolutely right; it was remarked on within weeks by a young poet friend, John Cournos. He was a Russian-born American who had recently thrown over his job as art critic on *The Philadelphia Record* to travel in Europe. Cournos admired the *Head* and Lovat followed it up by introducing him to Gaudier, who in turn invited him to Fulham. When Cournos

returned home to America he also took with him *Boy*, a bas relief 18 inches high, but whether he bought it from Henri or it was a gift is uncertain.

Another Jewish artist now came into Henri's life. The painter Alfred Wolmark, a very different personality from Brodzky and somewhat older, had been born in Warsaw in 1877 and came to London as a boy in the 1890s. A success-ful first one-man exhibition at the Bruton Galleries in 1905 led to his becoming a member of the Allied Artists' Association. He was married and he and his wife welcomed Henri and Sophie to their home. Gaudier made a portrait bust of Wolmark which, as with the Brodzky bust, was over life-

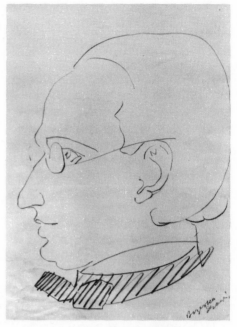

Pencil drawing of Alfred Wolmark, whom Gaudier sculpted in clay in 1913.

size. It came about because, in the course of talking about portraiture as a subject in painting and sculpture, they had decided to each make a portrait of the other. Henri worked in clay and Wolmark in oils, dressing Henri in a scarlet Russian tunic, heavy black cloak and sombrero: a theatrical pose of considerable panache. Gaudier's bust of Wolmark is also theatrical and as vigorous as the one of Brodzky. Both sculptures were highly original and unlike any other contemporary works. Apart from the strength in the modelling that intimates a new confidence in his own ability, they convey a directness of interpretation not previously seen in Henri's work. Some of this must have been due to the rapport he felt with his two friends; both heads were the first portraits that he had made of fellow-artists and contemporaries that were not commissioned. This gave him greater freedom to experiment and exaggerate.

Another friend of Macfall's who kept open house for young artists was Sidney Schiff, a kind, sensitive man, very involved in the literary world

in London, who wrote novels under the pseudonym 'Stephen Hudson'. Much the same group met at his evenings as at Edward Marsh's. Sidney Schiff was immediately enthusiastic about Henri's work. He became a great supporter and even after Henri's death maintained a concerned regard for Sophie and kept in touch with her by letter.

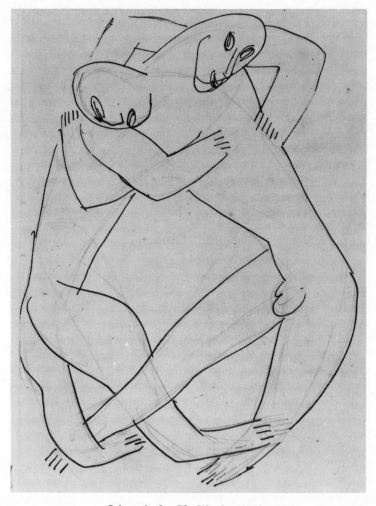

Ink study for *The Wrestlers*, 1913.

# 7

The highlight of the summer of 1913 was the Allied Artists' exhibition in July at the Albert Hall. It was an annual show, modelled on the Salon des Indépendants in Paris, which Henri first heard of from the painter, Walter Sickert. Artists working in England could submit and both Macfall and Leman Hare, feeling that Henri was ready to exhibit, suggested that he sent work. It was his first venture into official circles. Invitations to exhibit were extended to chosen overseas artists. This excited Henri and persuaded him to risk the chance of refusal in the hope that he might be included in a show in which Brancusi and Zadkine would be exhibiting.

Six of Gaudier's sculptures were accepted:

| Catalogue No | | | | |
|---|---|---|---|---|
| 1212 | 'L'Oiseau de Feu' | bronze | Loaned by A. Lousada |
| 1213 | 'Wrestler' | plaster | The artist |
| 1214 | 'Maria Carmi' | plaster | Loaned by Leman Hare |
| 1215 | 'Haldane Macfall' | plaster | Loaned by Macfall |
| 1216 | 'Horace Brodzky' | plaster | Loaned by Horace Brodzky |
| 1217 | 'Alfred Wolmark' | plaster | Loaned by Alfred Wolmark |

It may have been due in some part to Lousada's keeping his promise to speak for him that Henri's work was accepted, but whatever the reason it was a major step forward. The six sculptures made an impressive group of work as a first submission in any exhibition.

P.G. Konody wrote in *The Observer* on July 13th that 'M. Henri Gaudier-Brzeska is somewhat difficult to follow in his busts of Brodzky, Wolmark and Haldane Macfall, the first two of which are executed in a kind of frenzied cubism that is certainly calculated to attract attention, but fails as much in conveying a sense of the sitter's character and appearance as the more normally treated head of Macfall. The artist's failure in portrait is the most surprising as his Madonna, a portrait statuette of Maria Carmi in the 'Miracle', provides unmistakable evidence of rare ability.' The *Daily Telegraph* commented, 'As bold and recklessly defiant M Henri Gaudier-Brzeska presents himself to us, in his busts of Wolmark and Brodzky, the too frequently astonished and no longer very astonishable citizen will hardly be startled from his calm by

the fierce uncouth versions of the human encumbrance, perhaps because he cannot quite bring himself to behave in the agitated mood of either the portraitist or the portrayed.'

These notices could not have been considered entirely favourable by even the most biased reader, but Henri must have felt they were praise indeed when he compared them with the criticisms of the three heads of children exhibited by Brancusi, one of which was described in the *Illustrated London News* as 'more like a motor lamp than a human head'. It is interesting that Konody praised the more conventional sculpture of Maria Carmi, and denigrated the two portraits that are now considered so superb. His reaction shows how original Gaudier's work was already becoming.

Besides placing Gaudier's work before the public for the first time, the exhibition led to his meeting yet another influential person who would become central to his work and life. Although Cournos claimed to have bought them together, Pound's recollection was that he first met Gaudier at the Allied Artists' exhibition. There is some doubt whether he was with Osbert Sitwell or Olivia Shakespear at the time, but whoever it was, they toured the rooms and came upon *The Wrestler*.

Pound, making several humorous attempts to pronounce the name of the artist, was confronted by a young man who put him right and introduced himself as the artist. Having successfully put down Pound for his 'impudent manner' Henri turned on his heel and left. Pound was impressed, perhaps as much by the display of bravura as by the sculpture. He sought out his address and promptly invited him to dinner. It was probably one of the most important encounters in Henri's life, and Pound from then on became a great champion of his work. At this time Pound had been in London since August 1908, when he had arrived 'with three pounds knowing no one'. Initially he had been drawn to

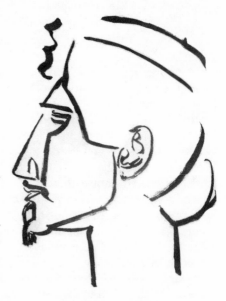

Ezra Pound, 1913.

London by W.B.Yeats' reputation, but had rapidly gained a foothold in the London literary world gathering a circle round himself. He dressed flamboyantly and was altogether a striking figure with a shock of reddish hair and idiosyncratic manner. Although of only medium height, he had a singular presence and must have made a considerable impression on Henri. Henri was twenty-one, Ezra twenty-eight.

When he received Pound's letter of invitation to dinner Henri prepared to go but Sophie, as she so frequently did when he was invited out, precipitated a row and he failed to arrive. Next day he wrote a letter of apology addressed to Madame Pound, the 'a' on Ezra obviously confusing him, thinking he had been written to by a lady which in itself could account for Sophie's tantrum. Pound felt this was a poor beginning which if not salvaged and restarted would never mature, and so asked John Cournos to bring them together. They went to the Putney studio. Pound was very impressed with the work, although he was forced to admit that he did not understand what he was looking at. But, nonetheless, with one of his not infrequent grand gestures he bought two small pieces, a marble group and a torso at 'what would have been a ridiculous figure had it not been that he had next to no market and I had next to no income'. In fact the money, £40, was a gift from Yeats and part of a £50 prize Yeats had received from *Poetry* magazine. As he was expressing interest in this young sculptor, Pound presumed that Gaudier in his turn would be interested in his work, and there and then recited some of his own poetry. Cournos told the story. 'The sculptor was enthusiastic because Ezra had dared to use the word "piss" in a poem. When I told this to Ezra, he was delighted; actually, however, Ezra did not use the word in his poem, but some other quite innocent word which had a similar sound! This slight episode throws light on the robustness of Gaudier and reflects the revolutionary temper of his curious mind.'

Their relationship was colourful and complementary. Pound found the Brzeska part of his name a source of amusement and referred to him as Brzx, 'a sort of modern Cellini, the only person with whom I can really be Altaforte'. Gaudier enjoyed talking to Ezra, sounding his anarchistic ideas off him and taking small sculptures to his rooms in Church Walk to explore and discuss. He would loan them for a week or two, so that Pound said his room became 'rich as a palace'. Pound did not respond naturally to sculpture and he was not truly at ease with Henri's work. Although words were his own medium and it was some time before he could talk or write about Henri's work, he recognised

69

that here was someone of extraordinary talent, energy and conviction. 'It is no use saying that Epstein is Egyptian and that Brzeska is Chinese,' he wrote in *The Egoist* in March, 1914. 'Nor would I say that the younger man is a follower of the elder. They approach life in different manners.'

Pound saw in Henri a relatively unformed but lively intellect, with a ready response to new ideas. He had found someone capable of developing sculptural ideas from his avant-garde poetry, not as an interpretation but as a complementary art form. He regarded Henri's intellectual striving as a reflection of himself, with similar headstrong enthusiasms. Pound's inclination all his life was to surround himself with less mature artists and writers whom he believed he could influence and shape, before he grew bored and charged on with his great rush through life. Henri, with his eclectic enthusiasms, was well suited to this role. It was an encounter between two highly talented and creative minds which, with others, gave birth to Vorticism in Modern British Art. Once again, Henri had found a friend and patron who introduced him to a new circle where he might find those adventurous enough to buy his work. And Ezra Pound, having once adopted Gaudier, remained loyal to both his ideas and his work. He wrote his memoir of Gaudier almost immediately on hearing of his death, and it was Pound who was invited by Brown and Phillips to write the foreword to the memorial exhibition in 1918 at the Leicester Galleries. He was instrumental in shaping the formidable collection of Gaudier's sculpture and drawings and other Vorticist work assembled by the American collector, John Quinn.

Another exhibitor in the same Allied Artists' show was attracted to a lean young man who was closely studying her work. Nina Hamnett had heard about Gaudier from Epstein and thought she recognised him from his description. They exchanged smiles but neither took the initiative to speak. Nina left the exhibition determined to find a mutual friend who would introduce her to this striking young sculptor. Eventually it was Dan Rider who arranged their meeting and Nina, aware of his frugal life, invented a lady who wanted lessons in sculpture and would pay 5/- for an hour's session. Having met Henri at Rider's shop, Nina invited him back to her flat. They walked up Charing Cross Road together and she recalled that he asked her:

'What do you do, Yes, of course, I remember it, you are the young girl who sat with my statuettes; my sister and I called you "La Fillette".' We walked on. He gave my friend lessons, and one day he came to my rooms and said 'I am very poor and want to do a

70

torso, will you sit for me?' I said 'I don't know, perhaps I look awful with nothing on,' and he said, 'Don't worry.' I went one day to his studio in the Fulham Road and took off all my clothes. I turned round slowly and he did drawings of me. When he had finished he said 'Now it's your turn to work.' He took off all his clothes, took a large piece of paper and made me draw, and I had to. I did three drawings and he said 'Now we will have some tea.'

As a result of his friendship with Nina, Henri produced three pieces of work in quick succession which were outside the line of his development as a sculptor. The three works are two torsos in marble and *The Dancer*, modelled in clay. They were all representational works and were, again, examples of Henri drawing his influence and inspiration from the sitter. The torsos are classical in concept and illustrate how he had absorbed so much from his reading and looking and was able, at will, to draw on his unique interpretative skills. They reflect a tenderness not often found in Gaudier's work, other than *Maternity* and *Sepulchral Figure*, and there is a synthesis between the subject and the material. The torsos have a gentle, seductive quality derived in part from their scale, itself partly governed by the stone he could 'obtain' from the mason's yard.

In *The Dancer* the whole figure is poised in motion, a delicately balanced, captured moment. As an interpretation of the dance it achieves a level of expression which is completely original. Gaudier had been enthusiastic about Rodin's terminology. This work shows that he not only understood it, but could express its content by producing sculpture which exceeded natural representation to achieve a direct expression of the transition of movement. It is interesting to consider this work in relation to the earlier Bohm and Karsavina sculpture, a more static and altogether heavier piece. It was the second of the three dance studies he would make. *The Dancer* was later bought by Sidney Schiff for £5. Henri's usual price for a work, it included the making of a round pedestal for the figure. He wrote to Schiff on December 1st, when he received the second part of his payment, 'I am naturally glad that Mme Schiff liked the statuette. It is a sincere expression of a certain disposition of my mind, but you must know that it is by no means the simplest or the last. The consistency in me lies in the design and the quality of the surface – whereas the treatment of the planes tends to overshadow it.'

Henri's confidence was boosted by his success at the Allied Artists' and although he had sold nothing there, he promptly gave up his job at Wulfsberg's. His full-time occupation now sculpture, he spent much of

Design for furniture for Roger Fry's Omega Workshops, 1914.

August working on an alabaster figure. It was a direct development of an earlier carving, *Statuette Funéraire*, the first carving that he made in Bath stone. *Alabaster Figure* is best described as a carving in which Gaudier came closer to understanding the interpretation of his subject through his material. This female figure reveals significant simplifications of form and surface design, with a Maillol-like rotundity in its treatment of the softness of the female figure. It also explores principles that appear again in a number of carvings, particularly *Figure* of 1913 in grey granite which he exhibited at the Whitechapel exhibition in July 1914.

Henri's career developed further when Nina Hamnett introduced him to Roger Fry. It was an acquaintance he was eager to make; he was already familiar with Fry's critical writings and his championing of contemporary art and artists, and had been enthralled by the Post-Impressionist exhibition. Fry had become fully involved in the running of his Omega Workshops, which, with other Bloomsbury artists, he had founded in Fitzroy Square in 1913. Their aim was to produce a complete decorative concept that reflected their ideas of modern domestic living. The principal adherents to the philosophy –and the most active participants – were Vanessa Bell and Duncan Grant. Commissions were sought for artists to make or decorate functional objects for the home. In the next few months Fry employed Henri in various ways; he was asked to make a number of designs for trays, some

of which were carried out in marquetry, others in varnished tempera. He also modelled a cat from which casts in clay were made, painted, fired and glazed in several colours, painted boxes and garden ornaments. Some of these commissions show a significant development in Henri's ideas: in particular the two trays, the larger of which is taken from the drawing of one of his dancing figures and adapted to a design, the other more closely related to an experiment in the abstract forms of analytical Cubism. That the designs were circumscribed by the standard shape of the Omega Workshops tray makes any stylistic comparison difficult. However, it is significant that in his last dancing figure the design of the fingers and toes is a direct development from his abstract treatment of the hands of the *Mermaid*, a marble he carved that year.

The Omega concept of art and utility imposed certain restraints on the work, and led Gaudier to compromise in the creation of maquettes for commissioned vases and garden ornaments. These he made out of clay while continuing to explore his abstract ideas. Henri's most successful garden object was commissioned by Roger Fry as the focal point for the garden created for him by Gertrude Jekyll at Durbins, Fry's house near Guildford. It was a commission for a *Bird Bath* and Henri produced a maquette to 1/6th of the finished size. Its design owes much to Epstein's ethnographica and the collection of African art in the British Museum, and takes the form of two entwined figures supporting a bowl above them. This piece and *Two Men Holding a Bowl*, both made in 1914, are clearly the works most closely derived from African art in Gaudier's entire oeuvre.

# 8

rank Harris returned to London from America in August 1913 and contacted Henri to tell him to collect the portrait bust and have it cast. Henri was delighted: he would have the satisfaction of another piece cast in bronze. But as seemed so often to be Gaudier's fate, Harris proved too mean when it came to the point to pay for the bronze casting. Harris was full of promises to buy other work and, convinced of his good intentions, Henri saw his finances about to get another boost. Having thrown up his job, 'to devote myself entirely to my art', he was anxious to think the best of everyone who suggested they could find him work, but nothing was forthcoming from Harris.

The studio in Fulham was expensive and by September 1913, without his job at Wulfsberg's, Henri began to find it impossible to make ends meet. He heard of a stone-mason called Aristide Fabrucci who wanted someone to share the cost of his workshop in a railway arch next to Putney Bridge. Henri went to see him. They decided that the space could easily be split by a partition. With much excitement, Henri agreed to build the partition and pay Fabrucci £20 a year. It was a magnificent improvement in every way on anything he had previously been able to afford. Fabrucci was an Italian stone-mason and sculptor who had come to London some time between 1880 and 1885. He had exhibited some terra-cotta busts in the Royal Academy exhibitions of 1903-5 but his living was chiefly earned as a monumental mason. Nina Hamnett described how Fabrucci employed 'a band of Italian workmen who came and did the dirty work for him, that is to say, they hacked out the stone. When Fabrucci was out, Henri would buy the workmen Chianti and learn from them how to carve stone. He bought a forge cheaply and put it in the backyard. There he used to forge the tools that he sculptured with. It was a wonderful machine with large bellows and made a great noise. Henri said to me, "Don't mind what people say to you , find out what you have in yourself and do your best, that is the only hope in life."'

Henri could not afford to buy chisels so he begged, borrowed or made them. In November – at the same time as he acquired his studio and forge – Henri had met Raymond Drey, art critic on *The Westminster Gazette*, who gave him steel weaving spindles which were ideal to shape

into tools on his forge. Drey commissioned a sculpture to be based on a clay figure of Gaudier's that he had seen, a sleeping fawn, for which Henri asked his customary fee of £5. Drey remembered Gaudier arriving at his London hotel, dishevelled and dirty, carrying the carving wrapped in an old sack inside his coat. *The Fawn*, one of several that Henri produced over the next year, was based on the deer he had seen in Arundel and Richmond Parks. His love of animals was a constant source of subject matter throughout his life, and reflects not only the sympathy he felt for the subject but also the importance of those early formative country years of his childhood.

November was the beginning of Henri's tenancy of the railway arch – not the best time of year to take up abode in a cavernous space – but to Henri it seemed heaven. He was impervious to the discomfort and cold. He paid the rent in advance with scrupulous regularity. The amount, £1.13.4d, was entered in a rent book each month and duly signed by Fabrucci. But Henri still struggled to buy materials. With commissions, the material was provided by the client but for his own work, in which he was free to experiment, he had to search out marble and stone. Fabrucci gave him small pieces garnered from some of his larger blocks. These, together with pieces raided from a stone-mason's yard at the water's edge near the bridge, were free and practically his only sources of material. Over the following months Henri cut small toys and talismen for Pound and Lewis and Kate Letchmere to put in their pockets, much in the manner of Japanese netsuke. These he fashioned from the small off-cuts of stone; he used larger off-cuts to create *Duck* and *Dog*. He also cut straight into small pieces of brass, forming and filing toys, knuckledusters and doorknockers.

The studio appeared wonderfully spacious to Henri and he could work there without interference. As if to establish his ownership, the first thing he did was to paint the inside of the huge doors with a six foot phallic monogram in heavy black lines. There was some warmth to be gleaned from the blazing forge, and he soon moved in all his meagre belongings and made it both a working and a living space. He was happier here than he had been in any of his London lodgings. Among the possessions that made their appearance were two old deck chairs, into which Henri would frequently collapse exhausted in the early hours of the morning rather than walk back across Fulham. Brodzky often stayed there when their discussions had continued long into the night. With a large stockpot bubbling away on the forge in its extra guise of heater and stove, there was everything he could possibly want. He was

totally oblivious to the fumes and the odour of stale cooking. The atmosphere in the workshop became notorious. Sophie found the dirt and smell insufferable, and friends and possible clients only tolerated it as there was no alternative if they wanted to talk and see what he was working on. It was the one place where he could always be found.

Henri's new happiness released a flood of creativity. The space and freedom to work were true luxury. He had found this studio at a moment when his work was entering a new phase. The work he began to develop under the railway line at Putney was directed towards one major objective: simplification of form. His drawings closely reflected his thinking, and the interdependence of the two processes of drawing and sculpture emerges more strongly at this time than any other. However, Gaudier's sculptural development was littered with distractions forced on him by financial necessity. One was a commission to carve a casket for the poet and writer Wilfrid Scawen Blunt. It was to be a presentation 'in token of homage' from a group of admirers. Blunt was in his seventy-fifth year and the gift commemorated his vehement opposition to the British Empire and its institutions. Eight poets including Richard Aldington, W.B. Yeats and the young Australian, Frederic Manning, commissioned Gaudier, at Pound's suggestion, to create a small reliquary box in marble in which were placed manuscripts by each of the group. It gave no scope to Gaudier's invention and is of little significance in his work. On one side was a low relief carving of a female nude, with the inscription on the other. He put scant effort into the work, and in the same month he carved *Redstone Dancer*, probably his most significant sculpture.

*Redstone Dancer* was the third in his dancer series. It was the first carving in his new studio; his first complex, abstracted sculpture; and, exceptionally, he made exploratory drawings before he began to carve. Abstract concepts of the sculpture were developed in a series of studies, a process repeated when he embarked on the *Hieratic Head*. Although there are elements in *Redstone Dancer* which reflect earlier sculpture, it is a totally new statement which extended Gaudier's language of abstraction further than he had yet dared. It also anticipates much that he was to produce in the next year. The many drawings for it are explicit in demonstrating his search for movement in the figure. Again it was the stone in which it was carved that determined its proportions. The figure is designed with a spiralling thrust within the form of the figure, and owes its success entirely to the continuous movement of the form and to the minimal detail carved in the face, breasts and hands. The triangular design of the face is the first example of Gaudier's use of symbols to

interpret forms and the first directly drawn from primitive African art. *Redstone Dancer* was his most important work to date and, in an overview of his entire oeuvre, it stands equally alongside any of the major pieces which were to follow. It was exhibited with the Grafton Group at the Alpine Gallery in January 1914. Pricing it at the highest figure by far that he had yet dared to ask, he was confident that it was the most exciting and original work he had done.

The exhibition was organised by Roger Fry and as well as *Redstone Dancer* − at the audacious price of £500 − Henri showed another four sculptures:

| | | | | |
|---|---|---|---|---|
| Catalogue | 45 | 'Vase' | marble | £20 |
| | 46 | 'Boy' | alabaster | £25 |
| | 47 | 'Fawn' | stone | £15 |
| | 49 | 'Cat' | marble | £20 |

and a portfolio of drawings.

It seems that Fry permitted Henri to show *Redstone Dancer* only provided he exhibited the other more popular and saleable pieces. Fry looked for a commission of 25% on sales and Henri, who had made a number of 'sweet' sculptures of fawns, considered them no more than a means of producing some money to finance the acquisition of larger and more interesting stones from which he could carve his 'real' sculpture.

Sophie was critical of *Redstone Dancer*. In defence, Henri likened it to one of Pound's poems, and saying peremptorily, 'Well, if you can't understand it, I can't explain it to you. I just feel it and there's an end of it.' It is now in the Tate Gallery collection. At the same time as he was working on this, Henri carved another, less successful piece. It was a more complex and challenging subject, a group of three figures in a *Maternity*. The figure of the mother was directly developed from *Dancer*, but the stone was of poor quality and its colour accentuates the differences rather than the similarities between the carvings. *Maternity* has an unfinished feel and the original concept was clearly not satisfactorily resolved in the carving. The head repeats the drawn line on the head of *Redstone Dancer*, but the work is in every way more derivative and less a personal interpretation.

In his self-appointed role of champion and enthusiast, Pound suggested that Henri make a head of him. Initially they discussed a plaster bust, but their mutual exuberance led to the decision that it should be carved in stone. Pound undertook to provide the material.

Abstracted preliminary drawing for the sculpture, *Redstone Dancer*, 1913.

Recalling the discussions years later he said: 'He had intended doing the bust in plaster, a most detestable medium, to which I had naturally objected. I therefore purchased the stone beforehand, not having any idea of the amount of hard work I was letting him in for. There were two solid months of sheer cutting, or perhaps that counts spare days for reforging the worn-out chisels.'

When it arrived, the stone was manhandled into the studio. Henri was transfixed by the immensity of the challenge it presented. Pound had not considered the nature of the stone he chose, merely its proportion. It was huge, measuring more than three feet by two and of such extraordinary density that the task confronting Henri was Herculean. Ezra Pound began to sit for Henri in February and Epstein came to see its progress. 'Brzeska is using up to a ton of Pentilicon for my Head,' Pound wrote to his father. The concept of the sculpture and its arrogant simplification owe something to the portraits Gaudier had made of Brodzky and Wolmark. 'It will not look like you,' Henri said. 'It will be the expression of certain emotions which I got from your character.' Ezra commented that the head was 'eternally calm – which I ain't', and later he wrote: 'Some of my best days, the happiest and most interesting were spent in this uncomfortable mud-floored studio when he was doing my bust . . . There was I on a shilling wooden chair in a not over-heated studio with the marble on its stand, and bobbing about it was this head "out of the renaissance". I now and again had the lark of escaping the present and this was one of those expeditions.'

The scale and proportions are similar to other portraits, but as the Pound head was carved, rather than worked in clay, the planes emerged stronger, the effect more monumental. Ezra told his future wife, Dorothy Shakespear that 'Brzx's column gets more gravely beautiful and more phallic each week.' It was the most abstracted portrait and the largest work Gaudier would achieve. Pound and Henri together referred to it as 'The Hieratic Head'. When finished, it was exhibited in the exhibition of *20th Century Art*, at the Whitechapel Art Gallery in May 1914. The only reason that Henri was able to exhibit this huge work was that, unusually, the gallery paid for the transport. The organisers must have been taken aback when faced with its size and weight. Henri also sent *Figure*, *L'Oiseau de Feu*, *Cat*, and *Fawn*. The fact that, yet again, no sales resulted was of secondary interest to Henri. It was almost as if he did not expect to sell his work. He had never equated success with selling since he regarded himself as a pioneer and innovator.

After the Whitechapel exhibition, the *Hieratic Head* was delivered to

*Camden?*

the front garden of Violet Hunt's house in Campden Hill, as no other site could be found for it. It remained there getting 'weathered', with Pound occasionally visiting to scrub away the lichen, until he and Dorothy went to live in Italy in 1925. They took an apartment on the top floor of a six-storey building overlooking the sea at Rapallo where the lift never worked. The sculpture could not be manhandled to their apartment and, presumably in the hope that the lift would eventually work, Pound persuaded the owner of the café on the ground floor of the same building, and where they took most of their meals, to let him place it in the corner near the door. Later, possibly at the insistence of the proprietor, it was manhandled up to the sixth floor and onto the terrace where it gazed out over the sea. It stayed there until after the war. Then it was taken to Pound's daughter's *schloss* in Brunnenberg, to be sited in the garden when he arrived. There it remained until its sale to a private collector in the United States in the 1980s.

# 9

Henri was such an individualist that it is surprising he became involved with the artists who formed the London Group, but when there was an election for membership in February 1914 he was one of ten candidates. Four were elected. The other successful candidates were Paul Nash, James Hamilton Hay and Fanny Eveleigh. Amazingly, Henri won overwhelmingly more votes than any of the others. Paul Nash came second. The result says much for Henri's personal attraction and talent. Among the members voting were Gilman, Lewis, Epstein, Wadsworth and Spencer Gore.

Wyndham Lewis had long been in conflict with Fry about the ideas on which Omega theories were based. Finally, with a group of friends,  he formed the Rebel Art Centre. This break-away group consisted of Wadsworth, Etchells, Bomberg, Roberts, Hulme, Letchmere and Henri. This left Henri with one foot with the Rebels and one with the London Group. Meanwhile, he still proposed to accept any possible commissions  from Omega. Much of the Rebels' thinking was based on the Futurists' manifesto. T.E. Hulme became their spokesman. A year older than Gaudier, whom he had met through Epstein, Hulme came from a middle-class background. His father was a Staffordshire businessman. After Newcastle-under-Lyme High School, Hulme went to St John's College, Cambridge but was sent down for a misdemeanour during a Boat Race Rag in 1904. He went to Canada, returning to Cambridge in 1908 and attending lectures in philosophy, although he did not enrol as a student. He then gravitated to London and the literary milieu, where he became part of Ezra Pound's circle. A large, brawny man with great bravura, he was immediately impressed by the ebullient, voluble young Frenchman and encouraged Henri to make small cut brass 'toys' and knuckledusters, which he said he would use to 'tame' his women. He wrote poetry, was secretary of the Poets' Club and expounded philosophical ideas, mainly those of Bergson. 'In the new art there is a desire to avoid those lines and surfaces which look pleasing and organic, and to use lines which are clean, clear cut and mechanical. You will find artists expressing admiration for engineers' drawings, where the lines are clear, the curves all geometrical . . . you will find a sculptor disliking the pleasing kind of patina that comes in

time on an old bronze and expressing admiration for the hard clean surface of a piston rod.'

Hulme and Pound were the paramount influences in Henri's life in 1914. Wyndham Lewis was editing and producing *The Egoist*, which had been founded by Dora Marsden in 1911 as *The New Freewoman*. Ezra Pound became its literary editor and Richard Aldington, the sub-editor. By 1914 it had been renamed, Pound considering the original title too restrictive. Lewis and Pound were using it to promote the Vorticist ideas of the Rebels, and Pound persuaded Lewis to reproduce photographs of Gaudier's work to support an article in the magazine on 'The New Sculpture'. This article discussed the content of a lecture given by T.E. Hulme to the Quest Society on 'Cubism and the new art at large'. Hulme had been lecturing in London during 1913 on other subjects, but in this lecture he was championing Epstein, among others. As part of a series of articles on contemporary drawing which he was writing for the *New Age* magazine, Hulme included an ink wash study for *Redstone Dancer*.

Hulme supported Lewis' art with theoretical argument and not un-naturally Gaudier felt sympathy with him. Gaudier's own philosophical comprehension was inferior to Hulme's, although earlier in 1911 and 1912 he had grappled with the ideas of Bergson himself. His own style of work had sought an ordered form of expression, and he found in Hulme an exponent of logic whose philosophical ideas were founded on principles he had searched to understand. Although, again, he had sold nothing from the London Group exhibition, Henri felt his long struggle to interpret his own ideas justified. 'So long as I have tools and stone to cut, nothing can worry me, nothing can make me miserable,' he said. 'I have never felt happier than at this moment.' He was not only happy, but arrogantly confident. Gaudier now found his first opportunity to appear in print, entering into a debate on sculpture in *The Egoist*. He fired off salvoes in characteristic fashion, concluding:

> The modern sculptor is a man who works with instinct as his inspiring force. His work is emotional. The shape of a leg, or the curve of an eyebrow, etc etc, have to him no significance what-soever; light voluptuous modelling is insipid – what he feels he does so intensely and his work is nothing more nor less than the abstraction of this intense feeling, with the result that sterile men of "Auceps"' kind are frightened at the production. That this

sculpture has no relation to classic Greek, but that it is continuing the tradition of the barbaric peoples of the earth (for whom we have sympathy and admiration) I hope to have made clear.

Lewis rented No 38, Great Ormond Street for the Rebel Art Centre with financial help from Kate Letchmere. There were no official meetings of the group, but Wadsworth, Roberts, Etchells and Bomberg were all frequent visitors in the early months, and Hulme was in constant contact with Lewis and the others. At the time Lewis was having an affair with Kate Letchmere and guarded her jealously, but Hulme succeeded in stealing her. An account by Wyndham Lewis of this incident vividly illuminates the passions and excesses of the group. Lewis had threatened to kill Hulme. 'I seized Hulme by the throat but he transfixed me upon the railings of Soho Square. I never see the summer house in its centre without remembering how I saw it upside down.'

On Saturdays Lewis painted in the small back room at the Centre. He kept the room locked as he was obsessed with the fear that his work would be imitated. Pound, knowing this, would visit at the weekends and Lewis would reluctantly allow him to see his recent paintings. Pound involved himself with Lewis' work in much the same way as he did with Henri's, seeing himself as a kind of artistic entrepreneur. His was the driving force that led to the three planning yet another means of expounding their theories. They announced the new venture on the back cover of the April 15th issue of *The Egoist*. It was to be a new quarterly journal to commence publication in June: it would be entitled *Blast* and would contain: 'Story by Wyndham Lewis, Poems by Ezra Pound. Reproductions of Drawings, Paintings and Sculpture by Etchells, Nevinson, Lewis, Hamilton, Brzeska, Wadsworth, Epstein, Roberts, etc. etc . . . NO Pornography. NO Old Pulp. END OF THE CHRISTIAN ERA.' The first number appeared on June 20th, 1914 with the one-word title printed large and running diagonally down the puce cover.

BLAST, subtitled REVIEW OF THE GREAT ENGLISH VORTEX, was printed on paper so thick as to be almost card with black type in varying faces and size. The copy blasted off the page. The opening statement was LONG LIVE THE VORTEX, and was followed by manifestos of BLASTING, CURSING and BLESSING. It was unlike any journal that had previously been produced in England. It owed much to Russian Suprematist

manifestos, and its idea of printing cursing and blessing lists was copied from Marinetti's magazine *Lacerba*. The finance for *Blast* came from Lewis' mother and from Kate Letchmere, Lewis obviously having exercised his great persuasive powers. It created exactly the stir in literary and artistic circles they had hoped for.

A launch dinner was held for all the contributors. Kate Letchmere remembered Henri arriving at the dinner. 'I was sitting near Ezra Pound, I think, on my right and he came in rather late; we'd almost started, and he put in front of Ezra's plate a darling little faun, and gave it to Ezra Pound. Ezra Pound was very generous and kind to all these young artists, writers and poets and painters and sculptors, and so I don't know whether it was a gift to show that he was already cutting in stone and modelling, I don't know, but this gift was suddenly put in front of Ezra's plate.'

Richard Aldington reviewed *Blast* in the July issue of *The Egoist* in a piece three columns long with a cartoon by Horace Brodzky of three trumpeters with a small top-hatted figure in the corner reading the *Times*. It was captioned 'The Lewis-Brzeska-Pound Troupe Blasting their own trumpets before the walls of Jericho'. Aldington's piece is fairly ambivalent as befits a critic-contributor, but he says of Gaudier's contribution, VORTEX [see Appendix]:

Mr Gaudier Brzeska is really a wild, unkempt barbarian, with a love of form and a very clear knowledge of the comparative history of sculpture. He is the sort of person who would dye his statues in the gore of goats if he thought it would give them a more virile appearance; if he were a naturalist he would chain slaves to rocks in order that he might reproduce their contortions. Fortunately he is not a Naturalist, and his worst crimes consist in a somewhat terrifying abuse of all Greek sculpture whatsoever, and everything which is not tremendously virile and cannibalistic and geometric. His 'Vortex' is extremely good reading, even if you don't understand it; though I see no reason why any reasonably intelligent person should not understand it. He thinks in form – abstract form – instead of in things or ideas. He is perhaps the most promising artist we have. If he ever becomes civilised he will lick creation.

Despite its novelty, *Blast* survived for only two issues. The second, published in July 1915 (it had been planned as a quarterly), was dated

84

No. 1.   June 20th, 1914.

# BLAST

Edited by WYNDHAM LEWIS.

---

## REVIEW OF THE GREAT ENGLISH VORTEX.

---

2/6 Published Quarterly.

10/6 Yearly Subscription.

London :
JOHN LANE,
The Bodley Head.
New York : John Lane Company.
Toronto : Bell & Cockburn.

# Long Live the Vortex!

Long live the great art vortex sprung up in the centre of this town !

We stand for the Reality of the Present—not for the sentimental Future, or the sacripant Past.

We want to leave Nature and Men alone.

We do not want to make people wear Futurist Patches, or fuss men to take to pink and sky-blue trousers.

We are not their wives or tailors.

The only way Humanity can help artists is to remain independent and work unconsciously.

WE NEED THE UNCONSCIOUSNESS OF HUMANITY—their stupidity, animalism and dreams.

We believe in no perfectibility except our own.

Intrinsic beauty is in the Interpreter and Seer, not in the object or content.

We do not want to change the appearance of the world, because we are not Naturalists, Impressionists or Futurists (the latest form of Impressionism), and do not depend on the appearance of the world for our art.

WE ONLY WANT THE WORLD TO LIVE, and to feel it's crude energy flowing through us.

It may be said that great artists in England are always revolutionary, just as in France any really fine artist had a strong traditional vein.

Blast sets out to be an avenue for all those vivid and violent ideas that could reach the Public in no other way.

Blast will be popular, essentially.  It will not appeal to any particular class, but to the fundamental and popular instincts in every class and description of people, TO THE INDIVIDUAL.  The moment a man feels or realizes himself as an artist, he ceases to belong to any milieu or time.  Blast is created for this timeless, fundamental Artist that exists in everybody.

The Man in the Street and the Gentleman are equally ignored.

Popular art does not mean the art of the poor people, as it is usually supposed to.  It means the art of the individuals.

Education (art education and general education) tends to destroy the creative instinct.  Therefore it is in times when education has been non-existant that art chiefly flourished.

But it is nothing to do with " the People."

It is a mere accident that that is the most favourable time for the individual to appear.

To make the rich of the community shed their education skin, to destroy polite-ness, standardization and academic, that is civilized, vision, is the task we have set ourselves.

'War Issue'. The war and the dispersal of its contributors hurried its demise. Had the war not cut its life prematurely short *Blast* would inevitably have run out of steam. Its bombast would have been impossible to sustain and much of what the contributors had to say was said in the two issues.

# 10

In June Sophie went to Littlehampton. Their rooms in Fulham had become infested with bugs and Henri was spending much of his time, day and night, at the railway arch studio. Sophie was yet again finding life intolerable, and she made life equally bad for Henri. Between October 1913 and March 1914, Henri earned £47.19.0d and spent £24.12.0d on materials, tools, rent and exhibition fees. This left £4 a month on which they both had to survive for lodgings, food and clothes. In spite of this, their relationship had recently been less strained. Henri had ignored many of her demands and they had effectively gone their separate ways. When she left, Henri found himself with no money at all and he had to write to Sophie almost immediately to beg something with which to buy food. 'Send me ten shillings . . . since you left I have only had three pounds, and most of that I have had to spend on things for my work, so for the last four days my cat and I have lived on milk and eggs given me on credit, and it isn't enough; my stomach is already dreadfully upset, and I haven't a halfpenny.' Fortunately, and exceptionally, Sophie managed to send him something to tide him over.

In Littlehampton Sophie met a French woman who was working as a governess and teaching French. They became friends and Sophie introduced her to Henri when he visited Littlehampton. On her return to London in August, Sophie invited Mlle Borne to stay and she and Henri struck up an instant rapport. He asked her to sit for him. The result was the powerful portrait known as *Mlle B*. For a long time Sophie had been talking about returning to France as she was unhappy with England and the English. Her new friend suggested she return with her and stay with her family, but Sophie had become jealous of her friendship with Henri, and when she went back to France Sophie was only too pleased to see her go.

Henri had been certain that France and England would eventually be at war with Germany. He had resolved that when that happened he would return to his homeland and enlist, even though he had not returned to do his military service and had vowed that he would never go back. Despite his dread of the advent of war he was still enjoying life, dining with Edward Marsh and Rupert Brooke and afterwards joining Lady Ottoline Morrell at the Drury Lane theatre. Marsh, on another

occasion, visited Henri's Putney studio. He bought nothing, but Henri made him a present of some drawings which he admired, conceivably Henri's way of saying thank you for Marsh's kindnesses, aware that he would leave for the war should it break out.

On the eve of the declaration of war, on August 4th, Henri had dinner with Ezra and Dorothy Pound and other friends at Leber's Restaurant in Holland Park Avenue. Pound had married Dorothy Shakespear in April after a long on-off courtship. Dorothy herself was a great admirer of Henri's work and had bought some drawings independently of Ezra. She was an amateur draughtsman and her work showed Gaudier's influence. She and Henri were good friends and he would write to her frequently when he was in the trenches. To everyone's astonishment, Henri announced his intention to go to France. They were all well accustomed to his changes of mood and extravagantly impetuous acts but this seemed unnecessarily profligate in view of his previous attitude to military service and his disenchantment with his native land. But Henri had given a great deal of thought to the threat of impending war. When war was declared, he drew up his will, handwritten on a small piece of green paper, leaving everything to Sophie and signed over a 1d. stamp: H. Gaudier. The document – a slip of paper – is interesting, not least in trying to assess exactly what Henri believed he was doing.

It appears to be a will, and has been referred to as such by many who have written about Henri and Sophie, but unwitnessed it would not have been so in English law. As both Henri and Sophie were resident in England and it was written there, it is by English law that it would have to be assessed. Nor was it a 'deed of gift', although it is signed over a stamp, because to be so this, too, would require a witness, and there was none. It is not a *donatio mortuis causa*, a document expressing an intention to make a gift in anticipation of death, as that would require specific references to that eventuality, which there were not. And it is not a soldier's will on a number of counts, not least because a soldier's will would require the signatory to be serving in the British forces, not merely expecting to enlist, and it was not the British army that Henri joined. Because it must be judged by an English interpretation of the law, it seems to have been an 'inter vivos' gift from Henri to Sophie, and could only be overturned by very strong evidence to the contrary.

However, in French law the only formal requirements of a legally enforceable will, provided that the property concerned consists only of chattels – as it did in this case – and provided that it is written in

89

but it was witnessed -- ?

1 dancer red stone
with Cosmos
(O church walk
Kensington

1 singer hand stone
with Wolmark
47 Broadhurst gdns
Hampstead

1 relief marble £20
several drawings ...£2..10
Cheril gallery
Kings Road Chelsea

1 boy alabaster    £12.12
1 torso marble    £15.15.
1 vase marble    £12.12
many drawings 2 portions

1 paper weight bras
with Roger Fry
33 Fitzroy Sq.
London W.
also 1 design in plaster

all drawings + works
& tools & furniture
(except 2 ladders 2 plasin
stands and 'turning table'
belonging to A. Hallowin)
at 25 and
Winthorpe Road
Putney SW

I hereby give to Zofia
Brzeska
H Gaudier
aug. 1914

Part of Gaudier's 'will' leaving his work and effects to Sophie Brzeska. This was found by the author in the late 1960s among a portfolio of Gaudier ephemera for sale in a gallery close to Kettle's Yard, Cambridge.

manuscript, are that it be signed and dated. There is no need for witnesses or any other formalities. Henri, one must presume, knew this and believed that he was in fact making a formal will making Sophie his sole beneficiary. Although in English law this was not what he was doing, however the document is interpreted, the entire estate did legitimately become Sophie's property.

Henri left for France soon after writing this 'will', but on arrival was immediately arrested as a deserter for not having returned in 1911 for military service. This account of his sortie by Ford Madox Ford appeared in the October 1915 issue of *The English Review*:

He had gone to France in the early days of the war – and one accepted his having gone as one accepted the closing of a door – of a tomb, if you like. Then, suddenly, he was once more there. It produced a queer effect; it was a little bewildering in a bewildering world.

But it became comic. He had gone to Boulogne and presented himself to the recruiting officer, an NCO, or captain, of the old school with moustachios, cheveux en brosse. Gaudier stated that he had left France without having performed his military duties, but since la patrie was en danger, had returned like a good little piou-piou. But the sergeant, martinet-wise, as became a veteran of 1870, struck the table with his fist and exclaimed: 'Non, mon ami, it is not la patrie, but you who are in danger. You are a deserter; you will be shot.' So Gaudier was conducted to a motor-car, in which, under the military escort of two files of men, a sergeant, a corporal, and a lieutenant, he was whirled off to Calais. In Calais town he was placed in an empty room. Outside the door were stationed two men with large guns, and Gaudier was told that if he opened the door the guns would go off. That was his phrase. He did not open the door. He spent several hours reflecting that, though they manage these things better in France, they don't manage them so damn well. At the end of that time he pushed aside the window blind and looked out. The room was on the ground floor; there were no bars. Gaudier opened the window, stepped into the street – just like that – and walked back to Boulogne. He returned to London.

Henri was drawn back again to France by the opening of the bombardment of Rheims Cathedral. This time he had a safe-conduct from the Embassy. I do not know the date of his second joining up or the number of his regiment.

At any rate he took part in an attack on a Prussian outpost on Michaelmas Eve, so he had not much delayed, and his regiment was rendered illustrious, though he cannot have been given a deuce of a lot of training, he did not need it. He was as hard as nails and as intelligent as the devil. He was used to forging and grinding his own chisels; he was inured to the hardships of poverty in great cities; he was accustomed to hammer and chisel at his marble for hours and hours, day after day. He was a 'fit' townsman and it was 'fit' townsmen who conducted the fighting of 1914 when the war was won. It was Les Parisgots.

Henri no doubt embroidered his prison adventure and the story improved with the telling. But, in essence, this account cannot have been far from the truth. It is easy to imagine that he would have been somewhat embarrassed to find himself back among his friends so speedily after making the great heroic gesture. A certain amount of dramatisation would be understandable. According to Pound, Henri was back in London for only about three weeks before he set out again for France. Horace Brodzky said that he worked on some vases for Lady Hamilton which she had commissioned much earlier. 'Long grass was growing around the base of the stones when Gaudier returned from France and worked on the stones to ease his frustration.' Pound further described how Lady Hamilton had wanted two huge stone vases for her garden. Gaudier, he recalled, went so far as to model the plaster maquettes, but when he came to translate the designs into stone 'got very much bored with it, finding the stone much harder than he expected'. The carvings were abandoned, unfinished, but Gaudier was undeterred, offering to start another carving of his erstwhile acquaintance and friend of Pound, Richard Aldington. In his memoirs, *Life for Life's Sake*, Aldington described how they 'walked together across Hyde Park and Kensington Gardens on his last day in London and he told me how being in prison had entirely changed his views on art – he was going to abandon the modern style entirely and follow "the Greeks". He even offered to do a classical statue of me as Hercules. If this had ever happened, I suspect I should have emerged in stone as a prize fighter afflicted with microcephaly, elephantiasis and superb appendages.'

Henri finally left London to enlist in the French army in the first week of September 1914, only a month after hostilities had begun. Hulme and Wyndham Lewis accompanied him to Charing Cross station to wish him farewell. In his autobiography Lewis described the scene:

Gaudier, though I knew very little, I always liked. This little sharp-faced, black-eyed stranger amongst us, whose name was a Polish city, but who for some reason was a French subject, or had a French name, was an extremely fine artist.

And I amongst others saw him off. Hulme and I believe Epstein were among those who did so. I remember him in the carriage window of the boat-train, with his excited eyes. We left the platform, a depressed, almost a guilty, group. It is easy to laugh at the exaggerated estimate 'the artist' puts upon his precious life. But when it is really an artist – and there are very few – it is at the death of something terribly alive that you are assisting. And this figure was so preternaturally alive.

Gaudier has been written about under the heading 'Savage Messiah'. There must be some claptrap about that. To be brave is not to be savage, not what the French describe as *exalte* – and that he certainly was – messianic. He was gentle, unselfish, and excitable, and probably struck some people as fiery, uncouth, and messianic. No artist so fine as Gaudier could be a Messiah, as a matter of fact. Messianic emotionality and Art are incompatible terms. But the stones that he carved are there to prove that Gaudier was a placid genius, of gentle and rounded shapes, not a turbulent or 'savage' one at all.

So many people who knew Henri, who worked with him and were his friends in London, remained confused about his name and his relationship with Sophie. Some, like Wyndham Lewis, recalled him as Polish with a French name. Sophie and he appear to have sown confusion far and wide and it can only be assumed that this was their intention. They referred to each other as 'brother' and 'sister' and yet when Gaudier wrote to Haldane Macfall, and made his will, he signed himself H. Gaudier. He was obviously ambivalent about it – whether it varied with his mood and affection for Sophie is impossible to conjecture – but he certainly felt very conscious of his own separate identity.

Back in France for the second time, Henri had been drafted into the 129th Regiment as an infantryman, received training, and was *en train* for the battle by September 28th. His attitude to the war was optimistic and buoyant. He shared the common belief that it would 'all be over by Christmas'. In volunteering, his motives were purely patriotic; he seemed almost enthusiastic and expressed no regrets at leaving London, which he saw as a necessary interruption to his work. As early as 1909, at the

age of 18, he had written to his father from Nuremberg: 'if ever the English go to war with the Germans I shall be on their side and will be delighted every time these "pointed helmets" get the worst of it. Everything seems to be pointing that way.'

One unhappy incident at this time came to light only fifteen years later when Dr Uhlemayr recalled in a letter how he had intended to see Henri again. 'I wanted to visit him at the end of July. I left Paris for London on 29.7.1914. I planned to stay in London for a few weeks. However, fearing war, I left on the very day of my arrival, after a mere four hours stay. Then war broke out and letters were prohibited; so I was cut off from Gaudier. I never heard from him again and I often wondered what had become of him in time of war. Now, the news that he fell in 1915 has devastated me. The folly of war has killed one of the best and one of the most valuable of human beings.'

# 11

The few weeks before his abortive adventure at the outbreak of war were the busiest and most successful period in Henri's sculpting career. His contacts began to bear fruit, he exhibited, wrote reviews and criticisms, sold work and was generally, if not on the crest of a wave, at least on the way to success. Frank Rutter, who was secretary to the Allied Artists' Association, gave Gaudier a founder's share and he was successfully proposed and sponsored by Harold Gilman. Gilman and Spencer Gore both canvassed for his election. The AAA exhibition of 1914 opened on July 15th in the Holland Park Hall. Richard Aldington invited Gaudier to review it for *The Egoist*. He was hardly gentle in his appraisals, dealing with each of the exhibitors in turn. He began the piece by declaring himself 'in a perilous position. I am on this year's staff of the association, an exhibitor and the personal friend of many of the artists who show their works. In some quarters I am supposed to write an official whitewashing account; many readers will accuse me of self-adulation and praising of a sect – for all these people I have the greatest contempt.'

Under 'Sculpture', he wrote, 'I specially begin with this virile art. The critics as a whole ignore it – place it always last – excusing themselves by the kind sentence: "It is not lack of good-will but lack of space which prevents me from etc etc."' He then went on to praise Epstein and Brancusi but their works were not included in the show . . . 'The number of people who are at all furthering their sculptural expression is thus reduced to Zadkine and myself.' He did not pull his punches, with comments like: 'offers the worst instance of feelingless abstraction – no emotions; no art' . . . 'A really poor kind of abstraction half-way between Kandinsky and Picasso of the early stages' . . . 'I am very sorry to say that I don't agree with these two painters' ideas of realism – and grieved to see no hope for them', this last comment about Gilman and Ginner. No wonder his friends found him difficult. Another important event of the 'Season' was the London Group exhibition held at the Albert Hall. Gaudier exhibited six pieces and again wrote criticisms of the show which were also published in *The Egoist*. The six works he exhibited were *Insect, Bird, Ornament, Boy with Coney, Doorknocker* and another piece variously called *Doorknocker* and *Ornament*.

# HENRI

In *Vorticism and Abstract Art in the First Machine Age,* Richard Cork devotes the main part of the chapter 'Vorticism in Practice, Synthesis and Decline' to Gaudier and in particular to *Bird Swallowing Fish.* He conjectures on the origins of the work and describes Gaudier's attempts to:

> meet the challenge of translating this transitory event into perma-
> nence of sculpture in an elaborate ink drawing, where the
> precarious poise of pencil study has given way to a firmly based
> object, rendered in its full three-dimensional solidity. The thrusting
> legs have been dispensed with, folded neatly back along each side of
> the bird's body, doubtless because they interfered with the integrity
> of the main mass; and the two warring halves of the sculpture are
> freed to rise up into the air, unrestricted by any formal props.
>     . . . Gaudier set to work on a plaster model, and produced a
> remarkable synthesis of all the best qualities outlined in the studies.
> This masterpiece of Vorticist sculpture formalizes the anatomical
> properties of its two protagonists with such rigidity that most of
> their recognizable features have completely disappeared. The fish
> slots into the bird like a key that can only fit one particular lock,
> and they are wedged together into a single dynamic entity. It is
> hard, at first, to realize that two separate creatures are depicted
> rather than a macabre amalgam containing the characteristics of
> both: they seem indistinguishable from each other, as if the fish was
> a sinister malignance growing out of the bird's extended beak.
>     . . . He has selected the moment of deadlock, when each party is
> still fighting for survival, and the outcome of this eerie stalemate is
> still undecided. But despite the tension, there is no hint of a hectic
> struggle. The dispassionate dictates of Vorticist art ensure that bird
> and fish have a detached air about them: no emotive expressions,
> either of fear, greed or hate, are permitted to disturb the unruffled
> impersonality of the performance. What would normally be a trivial
> incident, a callous fact of nature, has been metamorphosed through
> a strait-jacket of stiff contours into an intractable ritual. And the
> belligerence of the formal language found its match in the materials
> employed: although the original model was carved out of plaster,
> the catalogue of the 1914 AAA Salon states that *Bird* was first cast
> in gun metal. Nothing could have been more appropriate for a
> sculpture which shows above all how Gaudier managed to reconcile
> his dual involvement with nature and the machine.

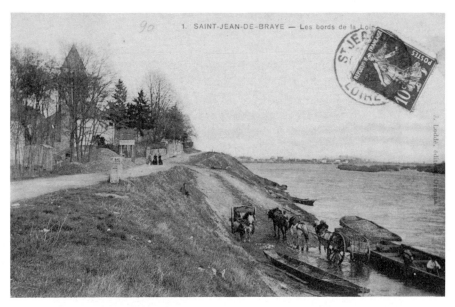

1 & 2. Henri's birthplace, St Jean de Braye.

I

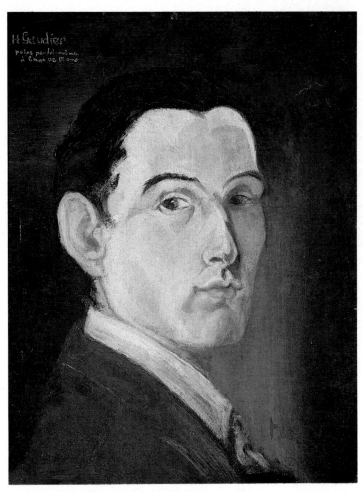

3. A rare oil painting: self-portrait at the age of eighteen.

4 & 5. Early drawings at Bristol and Cardiff, 1908.

III

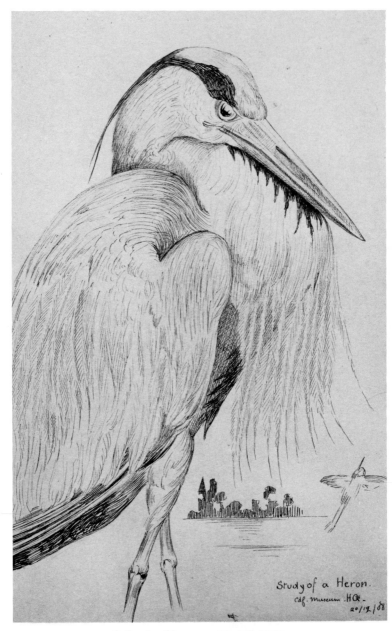

Study of a Heron.
cdf. museum .HG.
20/17/08

6. Study of heron at Cardiff, 1908.

IV

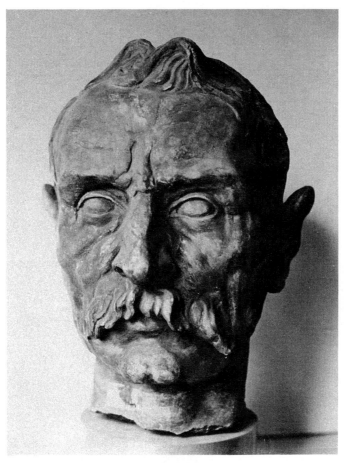

7. The sculpture of Henri's father, 1910, which did not impress
the family.

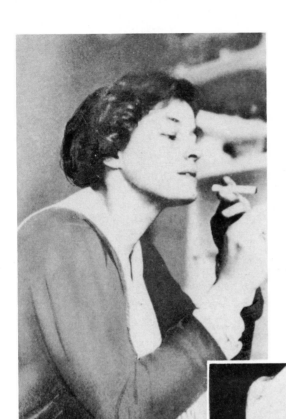

8 & 9. Enid Bagnold and
Henri's portrait bust of her,
completed in 1912.

10. Claude Lovat Fraser.

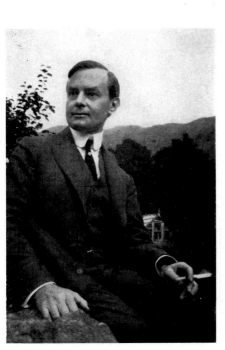

11. Horace Brodzky.

12. Edward Marsh in 1912.

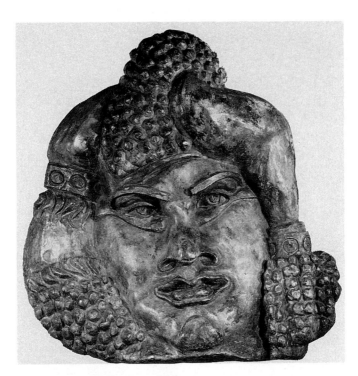

13. *Ornamental Mask*: plaster relief created for Lovat
Fraser in 1912, and based on Henri's study of
primitive carvings in the British Museum.

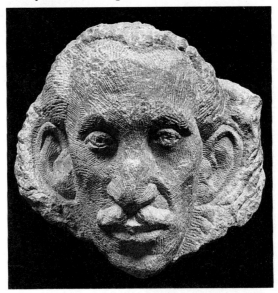

14. Relief stone carving of Horace Brodzky,
1913.

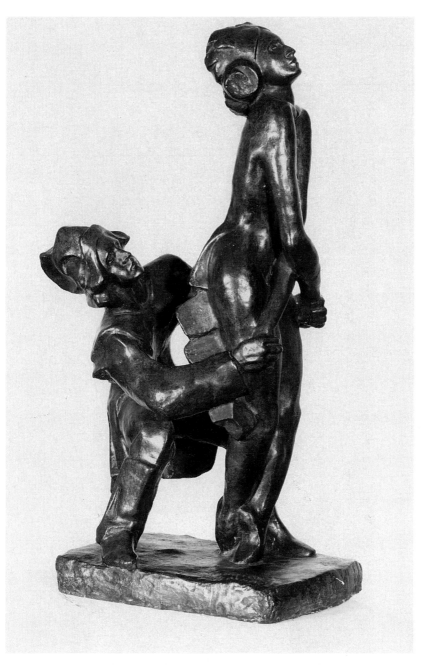

15. *Firebird*, 1912: portrait of Adolph Bohm and
Tamara Karsavina in the Ballets Russes' production of
*L'Oiseau de Feu.*

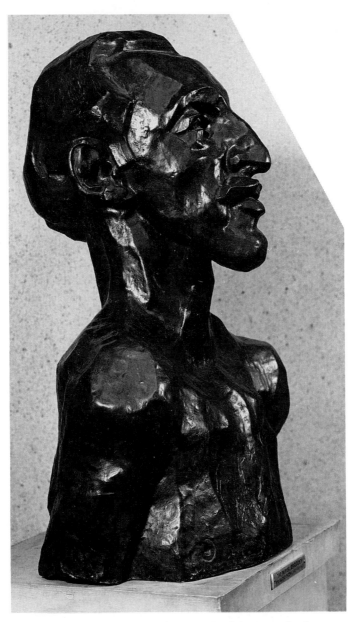

16. This powerful portrait of Horace Brodzky created a furore when exhibited in 1913, failing, according to one critic, to convey a 'sense of the sitter's character and appearance'.

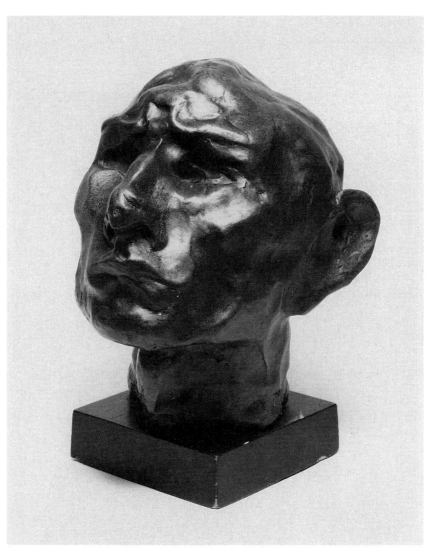

17. *Head of an Idiot*, 1912, a satirical self-portrait.

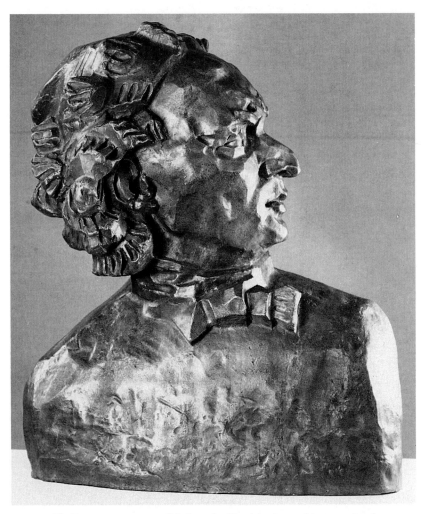

18. Even more purposeful than the Brodzky bust, this portrait of
Alfred Wolmark, 1913 was a major advance.

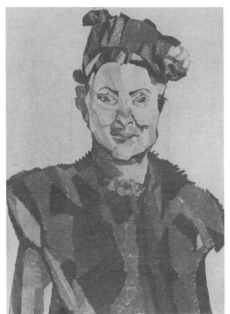

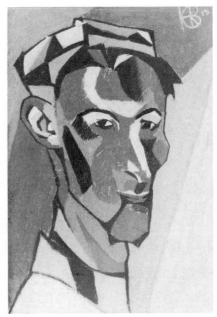

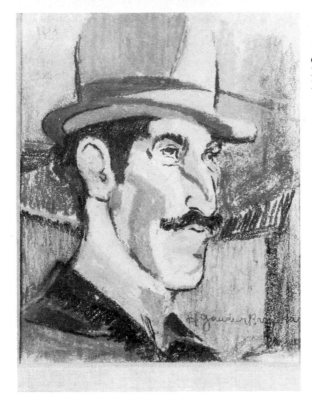

19, 20 & 21. Pastel
drawings of Sophie,
Henri himself and
Horace Brodzky.

XIII

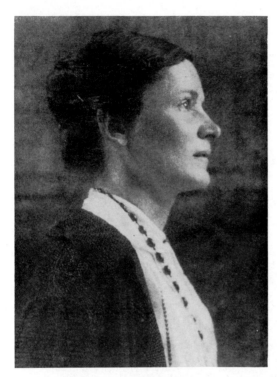

22 and 23. Sophie Brzeska and the Gloucester asylum where she died insane in 1925.

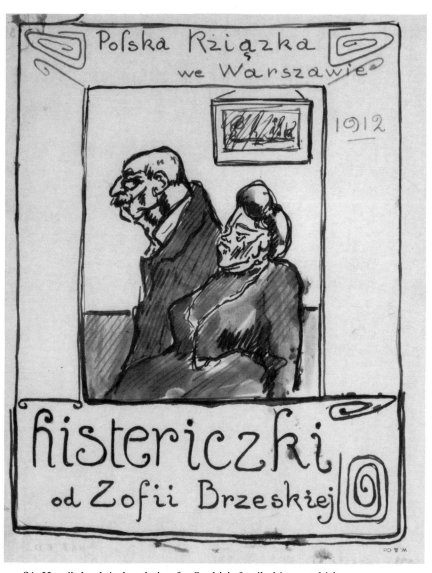

24. Henri's book-jacket design for Sophie's family history which was never to be completed.

XV

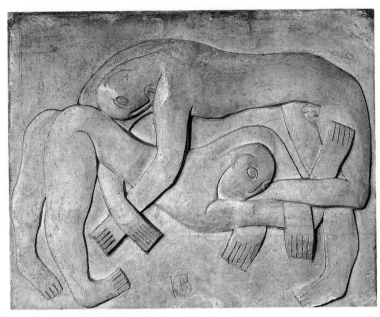

25. *The Wrestlers*, 1914 plaster relief.

26. Drawing of man and horse, 1914.

# 12

From September 1914, Gaudier's life was primarily that of a soldier. He did manage to produce some sculpture and drawings in the trenches, most notably the carved toothbrush he sent to Karlowska, Robert Bevan's Polish wife. All through his life he had thrown all his passion and enthusiasms into every undertaking; war was no exception. However, he returned to his old habit of letter writing. He wrote over eighty letters in the following nine months, corresponding with all his friends and renewing contact with his family for the first time since his flight from St Jean de Braye. These letters are the complete and only record of this later part of Henri's life; some of the most lyrical descriptions of this harrowing time are to be found in them. One subject Henri wrote about was his fundamental difficulty in relating to others. His earlier arrogance was put behind him and he revealed a sincerity and intellectual depth in his discussion of death, war and the beauties of nature. His experiences at the front, in close companionship with other men, were changing this still immature boy as they were to change so many others in the next four years. He wrote from the trenches, 'Life is the same strength. It could be folly to seek artistic emotions amid these little works of ours, this war is a great remedy. In the individual it kills arrogance, self esteem, pride.'

Gaudier's style varied with each of his correspondents. His closest friends before he left were Dorothy and Ezra Pound, T.E. Hulme, Eddie Marsh and Mr and Mrs Robert Bevan. In September he wrote to each of them telling them that he was in the trenches. He also wrote several times to his parents, who responded affectionately and were clearly delighted that he had made the rapprochement; he for his part was glad to know they forgave him and offered him support. It must have helped to justify his gesture in offering himself to fight for France.

9 November 1914
Dear Father,
Thank you for your card – I have already told you that I am in the front of the town sacred to the kings, that I should explain and cannot say more. The cathedral burnt in front of my eyes, now you will understand. I had a good laugh last night. My lieutenant sent

97

me to repair some barbed wire between our trenches and the enemy's. I went through the mist with two chaps. I was lying on my back under the obstacle when pop out came the moon, then the Boches saw me and well! PAU PAU PAU! Then they broke the entanglement over my head which fell on me and trapped me, I took my butcher's knife and hacked at it a dozen times. My companions had got back to the trench and said I was dead so the lieutenant in order to avenge me ordered a volley of fire, the Boches did the same and the artillery joined in with me being in the middle. I got back to my trench crawling on my stomach with my roll of barbed wire and my rifle. The lieutenant was dumbfounded and I'll never forget his face. When things had quieted down I went out again, did my job and got back at 5 a.m.

Henri Gaudier Soldat

le Section 7e Cie 129e de Ligne

3e corps au front par Le Havre.

12 November 1914

Dear Father,

Thank you for your letter of the 6th. The day before yesterday I wrote you a card telling you of my adventure in a barbed wire entanglement. At the time I hadn't noticed it but I find that I have 2 wounds, one tear in the right leg made by the wire and a bullet wound in the right heel. I put some iodine on it when I was in the trench and yesterday I had it bathed, but it doesn't prevent me from walking as well as before.

Everything was all right in your parcel nothing was pillaged. You must not send me any more clothes – every week I get some from London and I'm expecting another parcel even now. The only thing I want is tobacco at 50 centimes.

I'm not at all bored in the trenches. I am doing some little pieces of sculpture. A little while ago I did a small Maternity statue out of the butt-end of a German rifle, it's magnificent walnut wood and I managed to cut it quite successfully with a simple knife. The captain had asked me to do it to give as a present to someone. I can't tell you the names of the officers etc. – anyhow there's no need you will know later on and they are most sporting fellows.

Love to you all and thank you for your good wishes.

Henri.

As the novelty of war lessened and the days became tedious, the content and attitudes of his letters changed. In October, art and sculpture are mentioned for the first time. Jokingly he suggested to Pound that 'I do not despair of ever reaching Dusseldorf and bringing back the finest Cézannes and Henri Rousseaus to be found up there' and ten days later he told Karlowska that he had done some sculpture: 'A dancing woman in stone'. This sculpture vanished in the mayhem. Three days later, on October 24th, he was promising Pound an essay on sculpture for the Christmas Number of *Blast* and added, 'Please let them reproduce in it a photo of your bust. I shall send the essay as soon as finished, but all depends upon the fighting, if we have a few quiet days you'll have it soon.'

The weather in October and November was quite mild, apart from occasional frosts at night, and although conditions in the trenches were far from comfortable, Henri had not as yet experienced the horrors of knee-deep mud and intense cold. He had more time to himself in November and it proved to be an artistically productive month. On November 3rd he had the news of his friend John Currie's suicide. He was upset to hear of it, but the reality of his own situation coloured his letter to Sidney Schiff in February: 'I learnt of Currie's death while in the trenches near Rheims, some time in November I believe, and of course I was not surprised, he had tried once when I was at his place. He was a great painter and a magnificent fellow. In ordinary times I should naturally have been more afflicted, but as you may imagine, death is here a daily happening and one is expecting it every minute.'

Writing to Edward Wadsworth on November 18th, he was 'greedy to see much Vorticism', and had posted an article the previous day. This is interesting in the light of his comments to Richard Aldington during his last days in London. In suggesting a return to classicism, had Henri merely been baiting his friend for effect? In fact, he was still deeply enmeshed in Vorticism. He also wrote to Karlowska, 'I have carved a maternity out of the butt of a German rifle, the captain has it.' It is obviously the same one as he wrote about to his father. Henri sent Karlowska a small carving from the trenches. Although there is no exact record of when she received this, it seems likely that it was carved at about the same time, and before the onset of the severest weather. It was made from the handle of a toothbrush and was yet another instance of Gaudier using whatever materials came to hand. Because of its original function, this small carving is in effect a totem piece and relates most closely to the toys he had made for Hulme and Mrs Kibblewhite.

Henri also began to correspond with John Cournos from the front. In one letter written on December 27th he appears extremely optimistic, managing to ignore the horrors which must have surrounded him:

It is with pleasure that I received news from you. You must have heard about my whereabouts from Ezra to whom I wrote some time ago. Since then nothing new except that the weather has had a change for the better. The rain has stopped for several days and with it keeping the watch in a foot deep liquid mud, also sleeping on sodden ground. The frost having set in we have the pleasure of a firm, if not warm bed and when you have turned to a warrior you become hardened to many evils. Anyway we leave the marshes on the 5th January for a rest behind the lines and we cannot but look forward to the long forgotten luxury of a bundle of straw in a warm bed in a loft – also to that of hot food. We are so near the enemy and they behave so badly with their guns that we dare not light kitchen fire within 2-3 miles – so that when we get the daily meal at one in the morning it is necessarily cold but like the Chinese bowmen in Ezra's poem we had rather eat fern shoots than go back now, and whatever the suffering may be it is soon forgotten and we want victory. In between we have time to busy ourselves with art, reading poems etc. – so that intellectually we are not yet dead nor degenerate.

If you can, write me all about the Kensington colony, the neo-Greeks and the neo-Chinese. Does the Egoist still appear? What does it contain?

With my best wishes for a prosperous & happy 1915.

Now, at the distance of eighty years, only photographs and flickering film footage remain to recall those horrors of 1914-18, but every letter of Henri's during the next two months vividly bring to life the intolerable discomfort of it all. 'We have to stand in ditches with a foot of fluid mud in the bottom for four days at a time . . . there are 800 Germans dead on the ground behind the trench which we cannot bury. When we took the trenches, it was a sight worthy of Dante . . . the close vicinity of 800 putrefying German corpses . . . I got a sore throat in this damned place.'

He was clearly in the thick of the fighting and as a soldier he was daring and determined. In the normal course of events, death brings rapid promotion in war but Henri's rapid progress through the ranks

was due more to his ability and example than the misfortunes of his fellow soldiers. Sophie wrote in her diary of January 1st that Henri had been promoted, but there is no surviving letter to her reporting this. On January 8th he wrote to Edward Wadsworth, 'News! I have been promoted to the high rank of corporal for service in the field.' He also gave the good news to Dorothy Pound and Karlowska. He was obviously pleased with himself, seemingly delighted as he had been with his success in London with his sculpture. He had thrown his energies into new activities in his usual dedicated way.

In a letter to Wadsworth, as well as telling his 'news', he talked of sculpture and exhibiting. 'The only thing I can prey upon for my own work of sculptor are putrefying corpses of dead Germans which give fine ideas to sculpt war demons in black stone once the fight is over. The butt end I gave to my captain long ago. I have done nothing since, in the trenches, but you can send from Hulme's a singer in hard stone and a smaller statuette in alabaster like this [he made a small sketch]. I tell you this now though we are far from the exhibition yet because as you say the invulnerable Gaudier might jump into Hell any day. As prices you'll put up 30 pounds for the singer and 8 for the other one – though the smallest is the best. If I can send a drawing I will.' Four days later, Henri despatched 'the two less worst drawings I have done since I have been in the trenches'. Wadsworth was already preparing to include some of Gaudier's work in the London Group exhibition and Henri in his next letter told Karlowska about it.

Most of March was taken up with a further promotion, Henri was withdrawn from the front lines and sent to an officers' training camp for three weeks. Many letters survive from this time. One, written to Dorothy Pound on March 19th, explained: 'We shall have fellows able to take command of the section in case the officers are hit.' In the same letter he mentioned the cat that Spencer Gore had given him and which he had intended to sculpt.

Three weeks' break from the front was a release from the pressure of the fighting and gave Henri a breathing space. He took the opportunity to sort out his affairs at home and wrote to Pound telling him the price he wanted for one of his sculptures. 'There is a big marble, a sleeping woman, which you have never seen.' And later in the same letter '. . . for the present I am quiet, still and happy . . . but I have some presentiment it is the great calm preceding violent storms, for which we are now well prepared.' This letter was written on March 20th, three months before he was killed.

Shortly after he returned to the lines, Henri sent Kitty Smith a photograph of himself. 'Perhaps you will recognise me in the back row of the group I send, the sun was strong and I could not look straight.' The return to the front was as bad as, if not worse than, he had anticipated and the fighting was ghastly. Somehow, amidst it all, Henri managed to retain his real interests and when he wrote to Mrs Pound he returned to talk of sculpture. He gave hints of misgivings about some of his earlier work: 'I am getting convinced slowly that it is not much use going much further in the research of planes, forms, etc.,' but he expressed affection for the sensuous carving of *Mademoiselle G.* 'If I ever come back I shall do more "Mlle G." in marble. For the present I should like to see some love poems: seven months' campaign give desires which seem very commonplace in usual times, and sensualists have for once my whole sympathy . . . Ezra has sent me the Chinese poems, I like them a lot, I keep the book in my pocket . . . I shall never be a colonel but I expect to be promoted lieutenant very soon, and that will be the end of the carriers; sixty men are quite enough for my strength.'

He sent a photograph to his parents. It is later than the one sent to Kitty and is the last known pictorial record of Gaudier. It was almost definitely sent to them in the middle of May. He had written a great many letters to various friends during the month.

Many letters were to Kitty, at least four between May 10th and 29th. They contained general news about his progress and life, but they were also concerned with nature, an interest they had always shared. 'Our woods are magnificent. I am just now quartered in trenches in the middle of them, they are covered with Lily of the Valley, it grows and flowers on the trench itself. In the night we have nightingales to keep us company . . . Today is magnificent, a fresh wind, clear sun and larks singing cheerfully, the shells do not disturb the songsters. In the Champagne woods the nightingales took no notice of the fight either. They solemnly proclaimed man's foolery and sacrilege of nature. I respect their disdain.' The mention of larks is poignant as at about the same time Siegfried Sassoon was writing, 'The larks still singing bravely fly, scarce heard amid the guns below.'

In his letters to Kitty, Henri revealed his nostalgia for his boyhood and recalled their cycle rides together in the countryside around Bristol. Kitty was an important figure in his life, and he remained so to her; she never married and in later life became reclusive and very reluctant to talk about Gaudier. He had pushed their mutual interest in nature, the

102

woods and flowers and birds into the background while he had been involved in sophisticated London, even though he had spent hours drawing at the zoo and Richmond Park. Most of his energies in London had been engaged in intellectual activities with men whose insight challenged his. He had found the machine age and abstractions that stemmed from concepts like Epstein's *Rock Drill* wholly absorbing, but now in the midst of what was the ultimate machine of war, he returned to his first love, nature.

At Christmas 1914, Karlowska had received a gift of sycamore seeds from Henri and in a letter to Dorothy Pound dated May 20th he wrote, 'I become rather interrupted because of the enemy . . . I tell you they'll end up by wounding me. All I can give you from here is a buttercup, the only flower that grows on the trench (we are in meadows) and not a very nice flower, but it is a souvenir from the hand fights at Neuville.'

From Sophie's diaries it is evident that Henri and Sophie wrote to each other many times when he was at war, but none of his letters to her has survived. It is impossible to know when or indeed why they were destroyed. If she had kept them, it is reasonable to think they would have been found amongst her voluminous papers when she died. Her diary gives a faint insight into their content and into her replies, but that was written after Henri's death, much of it at a time of great anxiety and mental anguish. However, her comments do throw some light on their friendship:

You left for the war – tearing my heart in pieces. The country air, where I had gone, calmed my nerves – your letters from the front reassured – the sun filled me with confidence . . . . All through the winter you wrote me rather scrappy letters, mostly talking of your military exploits. We did not indulge much in affection, I, because I was thrown out by your conduct during much of the previous year.

I thought you did not really love me any more, a little yes and that truly from the depths of your heart, but my candour and the fear I had of realising an ugly truth held me a little on my guard. You did not write to me nearly as often as I wanted and all that gave me great cause for apprehensions more or less precise.

Then as the spring came, your love, sweet dear, renewed itself. You began by sending me letters more often and less cold. And my

heart took fire and as the spring advanced was aroused more and more to a loving and ardent sensibility; I had died so without friends, without lover. I wanted so much to see you again, to press you in my arms and fondle you on my breast, pent up with tenderness so long unspent.

It is tantalising that none of the letters between Henri and Sophie survived when those written during their separations in England did. Did they fall so far short of her ideal that she destroyed them? Were the diary references no more than fantasy? Or maybe the letters were not, in fact lost, but destroyed or removed from the estate after Sophie's death? Their disappearance, under whatever circumstances, is an odd, but perhaps appropriate, end to a very odd relationship.

From Henri's point of view his relationship with Sophie had become ambivalent. They had been brought together by loneliness, their mutual dependence accentuated by straitened circumstances. Their on-off life together was constantly under pressure. Now at a distance, he was powerless to exert any influence on her and he was trying to withdraw as gently as he could. Undoubtedly, he had no illusions about her mental instability. At times, in London, she had made social life impossible for him, and she had alienated many of his friends.

In the two months at the end of his life, Henri had sent eighty letters to people other than Sophie, including twenty to Kitty Smith. One, to Ezra Pound, should be quoted in full, with Pound's comments at the end. It was written on May 3rd, 1915:

Dear Ezra,
I have written to Mrs Shakespear in what a nice place I was. It becomes worse and worse. It is the 10th day we are on the first line, and the 10th day we are getting shells on the cocoanut without truce. Right and left they lead Rosalie to the dance, but we have the ungrateful task to keep to the last under a hellish fire.

Perhaps you ignore what is Rosalie? It's our bayonet, we call it so because we draw it red from fat Saxon bellies. We shall be going to rest sometime soon, and then when we do come back it will be for an attack. It is a gruesome place all strewn with dead, and there's not a day without half a dozen fellows in the company crossing the Styx. We are betting on our mutual chances. Hope all this nasty nightmare will soon come to an end.

What are you writing? Is there anything important or even interesting going on in the world? I mean the 'artistic London'. I read all the 'poetries' in one of the 'Egoists' Mrs Shakespear sent along. Away from this and some stories of Guy de Maupassant . . . I have read nothing, a desert in the head a very inviting place for a boche bullet or a shell, but still it had better not chose this place, and will be received in the calf for instance.

You ask me if I wanted some cash not long ago. No, not here, but as you may imagine things are pretty hard and I should be thankful if you could send what remains to my sister . . .

Have you succeeded with Quinn?

(The Germans are restless, machine-gun crackling ahead, so I must end this in haste.)

Yours ever,

Henri Gaudier

'His premonition of a head wound [wrote Pound] is curious, for this letter was written I believe only two days before his death. His sister tells me that years ago in Paris, when the war was undreamed of, he insisted that he would die in the war.'

*no comment in notes . . on disparity dates . .*

The article Henri had promised Pound was completed in November and he sent it so that it could be published at Christmas. But it did not appear until July 1915 when it was published in the second issue, the 'War Number'. It contained the article, 'Vortex', and the photograph of *Hieratic Head*, as he had wanted. Beneath 'Vortex' appeared the obituary of Henri Gaudier-Brzeska.

**MORT POUR LA PATRIE**
**Henri Gaudier-Brzeska; after**
**months of fighting and two pro-**
**motions for gallantry Henri**
**Gaudier-Brzeska was killed in a**
**charge at Neuville St. Vaast, on**
**June 5th 1915.**

The official report of Henri's death read:

In a single attack by the first and seventh on the village of Neuville St. Vaast, Houses D3 to D12 were captured, taking over also the

left of the main street and the houses bordering on it. This result was achieved by 3.30 p.m. on June 5th 1915. The ninety-five men killed in the action included the Sergeants Rocher, Buisou, Gaudier . . .

Henri was buried in the military cemetery at Neuville St. Vaast where his is one among 15,000 graves.

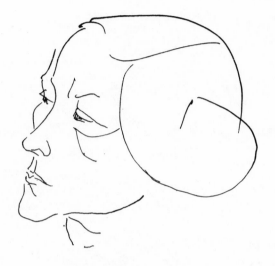

# Sophie

# 1

Sophie had written to Henri at the beginning of June 1914, declaring her love and regretting she had refused his proposal. In his letters he had talked of marriage and she, in reply, had protested their age difference, suggesting that his proposal was an impulse as he was at war. Her letter was a volte-face, and she wrote contritely and with passion. Her change of heart had come too late, however, and her letter was returned with an official notice of Gaudier's death in action.

This sequence of events would be enough to topple the balance of any mind, let alone one as unstable and volatile as Sophie's. From that time she believed herself responsible for his death. God had punished her selfishness; had she been less demanding, more giving, even given herself, Henri would not have been killed. She was haunted by despair and the belief that he had taken stupid risks because of her and which resulted in his death.

Sophie had no close friends; no-one in whom she could confide. She had, though, always kept both a diary and a journal. She now poured out her misery on to sheets of closely lined foolscap paper. The writing was erratic, changing in tense from sentence to sentence with sometimes several languages – Polish, French, German, Greek – in the same paragraph. After Henri's death she referred to the journal as 'Our Work', and addressed it directly to Henri, each entry precisely dated. Her feverish hand could hardly keep pace with the speed of her thoughts. She had always had the habit of speaking out loud when writing, muttering and even shouting the words as she scribbled them down.

Sophie had lived with her neuroses for years and was not unaware of the precarious state of her mind. Over the years the journal became increasingly incoherent, eventually consisting of page on page of joined together loops, like rows of plain knitting. The diaries, journal and her correspondence clearly trace her mental deterioration from the first great shock of Henri's loss until her confinement and death in an asylum.

Chère Memoire July 1915

Little love, everyday that I see you in dreams you are so sad, tired and suffering, what does this mean. You seem to be annoyed with

me in these meetings – why my dear? Haven't you yet forgiven me for my stupidity? and I have said I am sorry, again and again, oh if only I knew how to make you happy.

. . . Dearest darling don't you feel that my sorrow is a great enough burden without you adding your own sorrow to it. All the same I would rather see you sad than not at all, oh, I am desperate. Tell me, tell me my love what must I do to please you, I am prepared to sacrifice my life as long as it will bring you comfort, anything to relieve this ignominious humility.

I haven't even a corner in which I can work, I can't get my thoughts together, I am harassed on every side, at every turn. I live like a hunted beast without a moment free from being molested and fear my mind and body is the pasture for any ravaging brute who wants to exercise his lust. What can I do, how can I be reactive under such conditions, where can I go? I have no passport, I am a prisoner of war, of body and of spirit. As long as I'm surrounded by these visions in my mind it will remain closed to all spiritual healing. Beloved what is the use of all my ardent goodwill, my tireless enthusiasm? Is it to give satisfaction to your spirit, to honour your dear memory? I may well go into fits of dementia and rage, tear out the fibres of my heart, shake my fists at the implacable powers and curse them to Hell – but what is it all to them, what is it to you?

Sophie was writing this journal in the second year of the war. All round her, other women were bereaved, losing their husbands, lovers and sons. Cocooned, she was unaware of anyone else's tragedy. In her life with Henri her self-centredness had caused constraints and problems within their circle of friends; now she isolated herself even more and rejected any consolation that was offered. Nina Hamnett tried to offer help, as did Sidney Schiff, who continued to write to her for the rest of her life.

### August 3rd 1915

I experience such terrible pain at the very idea of telling anyone that you have been taken from me, that I avoid everyone I know for fear that they may ask me for news of you. It seems to me to be an offence against you and a shameful reflection on me to confess to anyone that you are dead, you who I would have willed to be an

immortal God, the one who I thought was so well protected against death by our supreme power.

No, beloved, it is impossible to confess to anyone that you are dead. Today I met a young couple in the street who lived in the same house as we did. They have been very kind to me since you went to the front. Seeing them run towards me, not having seen them for ten months, I didn't have the courage to be abrupt with them or run away. I thought I could brave it out – but the first question they asked was about you, I burst into tears and pleaded with them to go away and leave me alone.

The Jews disgust me as a thoroughly materialistic race and are all the same, the best element in this country of cold calculation and of nothing else. One Jew, Schiff – thinking me entirely destitute of means – offered to come to my aid, I refused but all the same I appreciated the intention. Brodzky, a second Jew, who often shocked us with his greed for money and his sexual demands amongst all these greedy perverts, is the only one who really misses you, he is the only one who has offered me genuine help, not like the others out of politeness – but really hoping I would use him. But really beloved all these people provoke and wound me with their stupid 'goodwill'. They want to prove to me that it is absurd to give way to sorrow! How sickening their ill timed words are. 'Cheer up' or that stupidly banal phrase, so very English, 'you must make the best of it'. I suppose they mean well and it's only because of that that I don't punch their rotten sensual noses in. They have only one way of reasoning, 'so much the worse for those who have gone – we who are left let's profit by life'.

I still hope that sooner or later you'll come back. When I am working in the library if there is any movement which is out of the ordinary it fills me with emotional anticipation, I dare not look towards the door, so that the feeling may continue – expecting you, wanting you to be there.

### August 28th 1915

You frequently used to reproach me for not having felt or shown any passion for you – you used to call my love a sentimental affection. No love could be more perfect than that which fills me now, but it is all too late: I feel that all this will end by my going mad. Is that the worst? No, the worst is already here and if madness will make me forget – then I desire it now.

111

# SOPHIE

I am nothing but an eccentric flower of trouble – an orchid of suffering, a flower which poisons everything without she herself being able to die because she is everlasting . . . For everyone that I have met up to now, except you, the unhappiness of others is nothing but a waste of time. If your friends had an ounce of true feeling they would feel as I feel, instead they listen quietly, politely for a certain amount of time, with some I can observe sorrow, sometimes even sympathy, but it lasts only a short time. I can see, or rather I feel their impatience – their desire to go away and have done with it. If they are not looking at their watches all the time it is only through politeness. Sometimes I even see the movement of the hand caught halfway, I can read their feelings on their faces . . .

I must of course continue to see all these fools from time to time in order to make the right arrangements for the Exhibition of your works, but after each meeting I feel worse and my brain burns. Oh madness, I feel it now so close, ready to carry me away . . . If by some miraculous effort I manage to hold myself together it is only because I must accomplish the work I have set myself to do . . .

She spent many hours wandering about London, revisiting their favourite places. On August 30th, 1915, she wrote:

I was in Richmond Park yesterday, I spent my time weeping and upsetting myself because I did not have the heart either to write or read, my distress even attracted and stupefied the deer and the birds. A great storm came and I sheltered from the rain under a tin roof. I listened to the thunder crashing on top of me, to the right, to the left, since childhood I have had a terrible fear of thunder – yesterday I lost my fear and swore at the Gods . . .

My old superstitious habits haven't yet entirely left me. The storm was nearly over and the sun was already shining in the west. I thought 'if the rainbow comes today it will indicate a peace between God and I', in other words, that my little boy will come back again in spite of all the bad news . . . . Then as if by chance I lifted my eyes and saw a rainbow of the most extraordinary beauty, stretching from the east to the skyline in a splendid semi-circle, spontaneously I rushed out shouting through my sobs 'Oh God what have you done, what have you done – see my despair – give me back my little boy – you can see that I cannot live without him, God, God, if you are not cruel, restore him to me, help me, help me!'

112

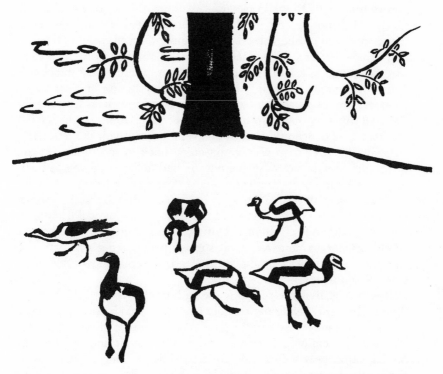

A drawing doubtless inspired by Gaudier's walks with Sophie in Richmond Park.

As the outpourings continued she wished herself dead and discussed suicide, but in the early part of the diary there was always the haunting idea that perhaps, after all, Henri had not been killed. She was so obsessed with this idea that, for days on end, she did not leave her rooms for fear that he might return and she would not be there to greet him. One obsession that Sophie and Henri shared was that the vagaries of the moon and sun had an influence on human life. It was a belief that consumed her for the rest of her life.

Only last May as I sat in Richmond Park I was writing to you about our belief in the sun and discussing how we could best live for this belief when you returned from the War. The sun was about to set and all about me fell his rays, caressingly and I felt that surely in Him was a power which could take the place of the bloody

113

Christianity, which would cleanse out the evil influence of that icy spectre the moon; and at this very moment a whispering came within my breast 'She will take vengeance, she will make you suffer more than ever before.' I looked up to gain comfort from the setting sun, as though to ask of Him protection, and there across the clouds I saw the moon, menacing, horrible, bright shining and then surrounded and obscured by clouds . . . I asked myself in terror 'Will she take my dear boy from me' but at once the God of Light refilled me with confidence and that same evening I sent you the letter . . .

Dear one your own visions too come back to me. It was at the beginning of our love. The evil powers had fallen upon you as birds of prey on carrion – you were almost devoured, filled to the bone. On my beseeching, you went to be looked after by your parents and there you were the victim of the most atrocious hallucinations, appalling dreamless visions. During these convulsive horrors I would appear to you, an awful spectre personifying evil with the waning moon, a diadem above my head. It is only now after three years that this comes back to me.

It was then that the sun took me to himself, warmed me back to life by His light, giving me consolation. And what a consolation, for it was you my beloved one he gave me, a treasure greater than my thought can express. Perhaps God is now punishing me for not having sufficiently valued this, for from His bringing of us together should have arisen the most sparkling beauty. But we made little of it, even profaned it. You darling not contented to have my love, so strong, tender and devoted, struggled to receive my physical love which I could never give you.

This first mention of their physical relationship illuminates their speaking of each other as brother and sister, mother and son, which so confused their friends. It was clearly more than a social convenience.

I, for my part, not satisfied with the sweet devotion which you gave me complained always of our material miseries and of my physical pain. Cohabitation became the murder of our souls and overpowered us; serving only to augment our faults and heighten our egotism. Even so I cannot excuse myself of indifference or ingratitude towards this God whom I adored. On the contrary the more unhappy I became the more I turned to Him with increasing faith in his Justice.

# SOPHIE

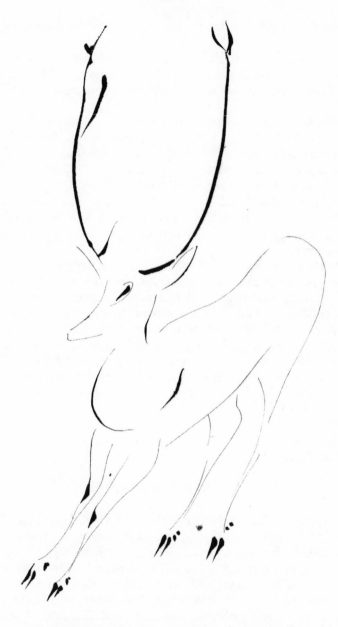

This ink drawing of a stag was included in the memorial
exhibition at the Leicester Galleries in 1918.

She was full of self pity for his loss but also for her entire life.

Is it a crime to love? Every opportunity of love, each moment of tenderness in my life has been dogged by unimaginable sorrow; and the more pure my love is the more I am condemned to suffer in its name.

You left for the war – tearing my heart in pieces. The country air, where I had gone, calmed my nerves – your letters from the Front reassured me – the sun filled me with confidence. Then, in January, She appeared to me again, early in the morning as the sun was rising. She hung there close to him defying me with her false light. I shuddered with fear, but by a force of will which has always made me fight down superstition, I soon forgot this most lugubrious apparition. Today it returns to mock me in line with all its predecessors.

Neither you nor I ever indulged in spiritualistic seances – we never bothered ourselves with astrology, our time being wholly occupied by our search after Beauty. Whence comes then our superstitious aversion for the moon? In me this aversion shows itself in hatred and violent mistrust. You darling, too good to hate, felt fear; a real and naive fear such as children have of ghosts. How often, of an evening when we had been walking in the country you turned sharply with a sudden nervousness. 'Not there, not there, I cannot bear the great glare of the moon full upon me.'

A diary entry around this time put the whole sequence of events dramatically into context.

### August 26th 1915

The more I reflect and enter in upon myself the more clearly do I see, my beloved, that during the weeks before your death I was possessed by devils. I now remember that already while I was in the country and the moon was at its full, I was seized by hideous fits of rancour which harassed and persecuted me without end. If you did not write to me for a little while, I immediately thought you no longer loved me, believed you cruel and heartless. Then often would she foully whisper in my heart that I must be revenged upon your silence by not writing to you for a couple of months. I had

terrific difficulty in clearing myself from these obsessions. At moments I was frantic.

Oh, how clearly these things come back to me, one after the other, to make a martyr of me; to kill me with the most terrible suppositions.

In my unbridled desire to throw a little clarity into my life, I have left no stone unturned, looked everywhere for omens. Thus when you came to tell me of your second departure I shuddered with anxiety. 'Darling (I said) it is the full moon who sends you to this death – don't go beloved – I beseech you. It is September, month of her perfidious harvest, and in these days she is full. Not only my love forbids you to go away, but my conscience, fed by my intuitions, is in revolt, I cannot let you go; vox populi, vox Dei, and you also agree that all your friends say don't go' . . .

Ah, my dear little friend, why oh why did you not listen to me? Had you so great a desire to die?

So often you wrote to me from the trenches of how you would be patrolling under the protection of darkness, feeling yourself free from danger, when suddenly the moon would pierce the clouds and expose you to the enemy fire.

Why did she not get you sooner, why, after so many miraculous escapes, did you perish just when I believed I had saved you through my love? This is what I must find out.

All through the winter you wrote me rather scrappy letters, mostly talking of your military exploits. We did not indulge much in affection, I, because I was thrown out by your departure, and also by your conduct during much of the previous year. I thought you did not really love me any more, a little, yes, and that truly from the depths of your heart, but my candour and the fear I had of realising an ugly truth held me a little on my guard. You did not write to me nearly so often as I wanted and all that gave me great cause for apprehensions more or less precise.

Then as the spring came, your love, sweet dear, renewed itself. You began by sending me letters more often and less cold. And my heart took fire and as the spring advanced was aroused more and more to a loving and ardent sensibility; I had died so without friends, without a lover. I wanted to see you again so much, to press you in my arms and fondle you on my breast, pent up with tenderness so long unspent.

I worried myself with not being able to go to France and to be a

117

little nearer to you; to hear the tongue which we spoke together and which I love so dearly.

One day I got your dear love letter, you were settled in a little wood which was all blossomed with primroses and with lilies of the valley. The nightingales filled your ears with their sweet quavering and your war hardened heart which for ten months had seen only carnage, was moved by Nature's lovely poem. You told me of your deep love, unalterable and passionate, in words so expressive, although so simple, that I was moved to tears, and was so happy, and so grateful to my dear little beloved boy for his faithful affection. True fine love from a noble and generous heart.

Old woman, used up by sorrow as I was, still you gave me your glowing love. I was bewildered, touched to the depths of my heart and I offered thanks to the great sun for having so rewarded all my sufferings.

You asked one question dear, would I when you came back give you the fulness of my love both in body and in spirit. Oh so dear friend, my heart was full of you, I was ready not only to grant your wishes but even to sacrifice my life to you. Why were you not there to take my reply from my living voice? It is one of those rare chapters of my life which leaves me, not only a heartrending memory, but also an unbearable regret, a bitter repentance until the end of life.

I had a letter by me which I had written to you the day before about my stay in England. I complained, I said how exasperated I was not to be able to leave the country, then I discussed at length the supreme value of solitude.

My good spirit, timidly (as always) advised me to follow the good and sincere impulse, to write you a letter, expressive, exuberant, full of tender assurances and of the most sincere reciprocal promises.

Was it again the evil spirit, or was it laziness or madness? I cannot say, but I believe the worst, only one possessed could have acted so contrary to his feelings and intentions.

Wishing to send off the letter quickly (was it that?, how do I know) I added a few sentences of loving assurance − insipid enough no doubt for you were not satisfied, how could you be. And then each day I said 'I really must write all that I feel about this subject to my dear one, I must speak ardently to him, effusively, so that he may feel what I feel, and even if I do not agree with him entirely what does that matter so long as I give him some moments of

## SOPHIE

Sophie in 1912/13.

pleasure, so needed in these perilous times.' I thought, 'My only wish is to console him since at the moment I cannot make him happy.'

Then the friends, robbing me of my memory, made me forget, even by the next day, so important a decision. After that I still promised myself to do it but doubts settled in upon me. 'How can I promise when I do not know if I will be able to hold my promise? Supposing he comes back from this accursed war rough and savage – he seems to enjoy butchering Germans – he may want to ill use me, be harsh to me – no I can't lie to him.' And again in the next letter I only put in a little sisterly love. This doubt, this stupid and ungenerous struggle held me in its infernal claws. Every day I decided to pour out my heart of deep love, even as I would today, but always the evil spirits held me back . . .

Then – oh how I loathe the thought of my brutal egotism! I wrote you a letter full of reproach, a violent letter, asking you to find some means to get me out of this country since it was for you that I had come. I cast your egotism in your teeth – your selfishness in not considering me. At the end of the letter I tried to excuse myself and my wicked character. I said it was the full moon which had irritated me – but that could do nothing, the fact will always remain that this was the last letter you ever had from me and I wrote it knowing that you were in the utmost danger. I moan, I repent, I hate myself – the mere thought of my brutality brings the blood to my temples . . . Perhaps my letter unnerved you – it will certainly have saddened your last moments – perhaps it even . . . Ah, I cannot bear to think of it. During the first days of my distress I wanted to kill myself in order to expiate my crime, what have I imposed upon myself, Life – with its frightful remorse which should goad me on to work. Oh if only I could achieve work worthy to wash out this stain. Dearest – beloved you can have no idea how I suffer . . .

That unfortunate and disagreeable letter was followed at once by others full of affection which arrived too late. No, no, it is enough to drive me mad, if at least I had had a precise idea of my love for you, and here lies the greatest sorrow for it is in this I feel God's injustice. I did not know the strength of my love and . . . so often put my literary aspirations, my ambitious thoughts to the fore. Now you are gone, I have nothing left, ambition, vanity, pride, all are blown out, razed out with the sparkle of your life, which has created all things and extinguished all in going.

## SOPHIE

I see from day to day that I write only to pass the time, to keep myself from madness, from suicide which haunts me as the one end to my impossibly atrocious life.

Her drama increased and she refused all comfort and help.

During the first weeks after your death I clung to life in the name of our work, the work which would reunite us, I forced myself to visit those human jackals who were your friends, besought them to find me some home where I could work in peace, or to get me to France, where I should be nearer to your body. They only lied to me, enticed me with worthless promises . . .

Oh beloved darling, forgive me, I am guilty, more towards you, than towards God. When exasperated by the roughness with which you overwhelmed me, my heinous nature overflowing with poison I would ask Him to punish you, to avenge me by making you suffer, could I ever have reached that cruel extreme of asking Him to kill you? . . .

Just at the moment when you reassured me of your affection and your loyalty I lose you. How can I preserve a belief in God who takes you at such a moment. I may well investigate, contemplate his designs. I arrive at no solution except that I was not sufficiently criminal to have to suffer so monstrous a blow.

What is left to me. In what and in whom can I put my trust and my hope after having been deceived by God. And still I cannot free myself from the illusion that you must return to me − is it from this we derive our ideas of eternal life − of Resurrection?

. . . At night if I hear some chance noise in the street I leap from my bed and strain my eyes against the windows my heart throbbing, it is you, you had lost your memory and now have gained it and they were bringing you back to me. And in the darkness my hearkening ears perceive a stillness and there is no sound on the stair or in the street and I return to my bed and lie wide-eyed in dumb distress.

I see too late how it should be, I see amongst other things that one should always pardon all things when one loves and is loved . . . The love between two souls is so precious a gift, so rare and sublime that all things must be sacrificed to it, for there is nothing which is worth so much . . .

# SOPHIE

## September 1915

The beginnings of madness have haunted me for some time but it is a long time since these feelings have come with such definite precision as in these last days. The night before last – a prey to sleeplessness and filled with the saddest thoughts – for the first time I felt as if I were bursting. I felt swamped by the avalanche of my sorrow, it was the end, I tried to stop the pain changing the directions of my thoughts and slowly the pressure went away . . .

I have written to one of your comrades – Serg't Grand d'Esnou a week ago and I await his reply with a trembling heart – an exasperating tension – mixed with hope. I want to get his reply but I fear the complete ending which it may bring. It must be possible that there was a mistake in the military report if the trench was filled by the enemy after the charge, but if your comrade saw you fall . . . Ah, dear heart I cannot believe it, I cannot conceive that you have been killed – your beautiful head filled with genius, mortally struck, your exuberant life cut off by the bullet of some stinking German thug.

For two nights in succession I have dreamt that a dark young man (but not you) kissed me or tried to kiss me. What is the meaning of this dream? A kiss always signifies separation to me, the departure of a loved one, you no longer exist so why am I so obsessed by such nightmares – there can never be mortal kisses for me again, all that revolts me, I could not even kiss a woman as I used to do with people who called themselves friends . . .

Sweet soul, the last vestige of hope has been torn from me, I have just received the letter so anxiously awaited, the letter from your friend at the front.

There is no more doubt. You were taken by a bullet from a machine gun – they took away your papers. Only yesterday believing that you would come back – I was ready to embrace the whole world – to stretch out my arms to God and even to my stinking enemy the macabre moon . . .

For a number of days I have been absorbed by a biographical study of Nietzsche. I am not excited because it is a subject which satisfies the curiosity, but because it is a serious study which confirms many of my own ideas and feelings. Dearest why did we not meet with such a man in our lives, instead we were surrounded by ignorant morons who did nothing but spoil our best years.

## SOPHIE

I am not sufficiently intelligent to appreciate or even understand the true worth – the outcome of the work of this revolutionary spirit, but I intuitively feel that there is an affinity between Nietzsche and myself. In one of the letters written by Nietzsche to his friend M'lle Mey I have found a passage which delights me enormously. It is the first pleasure I have felt since your death.

Henri's drawing of Sophie reading, 1912.

# 2

From that point on the diary and notebooks gradually changed in emphasis. Sophie became obsessed with the need to commemorate Gaudier's work and create a lasting monument to him. Others had similar aims. In February, 1915 Ezra Pound had written in *New Age*:

And if the accursed Germans succeed in damaging Gaudier Brzeska they will have done more harm to art than they have by the destruction of Rheims Cathedral, for a building once made and recorded can, with some ease, be remade, but the uncreated forms of a man of genius cannot be set forth by another.

But Henri's death, when it came, seemed inevitable, as Pound wrote to his father: 'Brzeska has been killed, which is pretty disgusting, though I suppose it's a marvel that it hasn't happened before.' Pound commemorated this personal loss in the second issue of *Blast*, and it inspired his book about Gaudier's life and work.

When he left for the war, Henri had entrusted friends with various sculptures and drawings on loan or for safe keeping. Sophie was anxious that everything should be together in her charge. She enlisted Pound's help to put pressure on Hulme to return work that he had and demanded that Dorothy and Ezra make a list of what was in their possession, provide a duplicate copy and sign it. Letters between Sophie, Hulme and Pound from August to November 1915 show her determination to gather together Henri's estate. After a number of meetings with Pound, Hulme had still not returned the drawings but felt obliged to offer an explanation. He wrote to Sophie:

I forgot to let you know that I took four drawings out of the parcel – you said Mrs Kibblewhite and I might choose (one of the ducks and one of a man on horseback) and two others which I told you I wished to buy, a small phallic one which could not be exhibited of man and woman and a little design of a love charm which I wondered whether it would be possible to get carried out. If you want these I will return them also. Otherwise the parcel is exactly as it was sent to me.

Equestrian drawing.

Sophie demanded the return of all the drawings, and asked, 'have you written to Mr Gaudier, please let me know if there is anything worth mentioning?'

She was worried that Henri's father, on hearing of his son's death, might decide that an estate of value existed and that the family had a right to it. She also asked him to go to the French Embassy to speak to Mr Morand, the Cultural Attaché, as Pound had been unsuccessful in clarifying her position in French inheritance law. Hulme replied:

I have sent things off to the father, the carriage which I paid in advance was twelve shillings.

I have seen Morand. He wants to see the document left by Gaudier giving total status to you. He wants either you or I to send it to him. He will show it to someone in the Embassy who will advise him as to the legal position under French Law. He thinks that if he wrote to the father as you suggest, it would only make the father suspect that the statues are worth much more than £50. If you don't want to let the document out of your hands will you make copy of it, send both to me, and I will then forward the copy

alone to Morand certifying at the same time that it is an exact copy of the original document.

It is impossible to know what Hulme sent to St Jean de Braye but from the tone of Sophie's letter demanding the return of the drawings it is fair to assume it was not works of art but merely some personal effects. Sophie's reply shows her distrust. She did not disclose the whereabouts of the list, but said it was out of London 'for fear of the Zeppelins'. She then returned to the question of the missing drawings.

> You told me you would keep them for three or four days, you have had them now for weeks and that should be sufficient. If you want to buy drawings you can come to me in four days after they are returned.
>
> Now I am a wilful creature and the more you insist on keeping them the more I want to have them and will have them. I must sell some drawings to assist those that are in need. I understand that those eventual purchasers (foreigners) do not know much about good drawings, so there is an opportunity of pushing out the weak ones. Please leave the necessary instructions so that I may take the drawings on Thursday morning between 11 a.m. and 1 p.m.

When the drawings were returned on December 11th, she took 'thirty animal drawings, five studies of riders on horseback, eighty-four nudes, six drawings for vases, four small drawings, four modern drawings and two other studies' and deposited them with the Westminster and London County Bank in Putney, London. She also left there a quantity of her own writings in a sealed box 'each packet sealed with a double seal', one of a human head, and one of an eagle. She trusted no-one, and when not totally preoccupied with protecting every aspect of Henri's estate she reverted to her memoir and other obsession: her own personal demise brought about by Henri's death.

### December 31st 1915

It is New Year's Eve – I remember the last one – it was as sad as this one except that then I still had hopes – I was waiting for a letter and had feared you were dead – it came three days later with your sweet assuring words:

126

## SOPHIE

'It is certain sweet one that we will be together and in Paris on next New Year's Day'.

You were so certain that we would be together and I believed you.

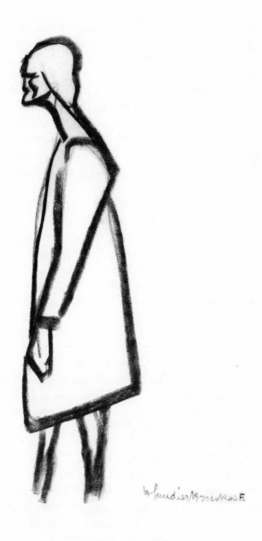

# 3

It is now nearly a year and a half since you left me – nearly eight months have gone since you were killed and my sadness never diminishes. I cannot look at your portrait without tears filling my eyes. I cannot allow my thoughts to wander freely about your memory since I am so rapidly thrown into despair.

I have spent weeks trying to find suitable and worthy places for your work – places where it will be held in esteem, but I can do no more. I am surrounded by shopkeepers who only think of what they can get out of it, at this rate I'll soon become a shopkeeper myself. I must get away and I seem to hear you say 'But leave it all, go and get on with your work'.

While Sophie was busy securing a safe keeping for Henri's sculpture and trying to sell off those pieces she regarded of less artistic merit, Ezra Pound was continuing to promote Gaudier's work both through the memoir he was writing and also through his promotion of modern British painting and sculpture in America. He had met the American lawyer, John Quinn in 1910 and encouraged him to develop his collection of European art. Quinn was to become champion, patron and a major collector of Gaudier's work. A New Yorker of Irish parentage and educated at Harvard, he was a partner in a prominent New York law firm. He had first visited England and Ireland in 1902 when he met the Yeats family, had bought paintings from J.B. Yeats and his son Jack, and had arranged a lecture tour of the States for the poet W.B. Yeats. Later Quinn was instrumental in helping J.B. Yeats at the end of his life to settle in America and subsidised him financially.

When Ezra Pound returned to America in 1910, he used his meeting with W.B. Yeats in London the previous year as an excuse to search out Yeats senior and as a result met John Quinn. He later renewed the acquaintance and Quinn began, on Pound's advice, to purchase work by Epstein, Gaudier and Wyndham Lewis. He was already collecting work by Augustus John and the manuscripts of Joseph Conrad and William

Nov. 7.15.

Dear Madam

I have left instructions here that the torse by Gaudier Brzeska shall be given to you for presentation to the Victoria & Albert Museum. I am willing to waive any claims to commission which we may have in this case since it is very gratifying to me that the torse should find a home in the South Kensington Museum, but you will understand that we regard this as an exception and as not applying to other works by your late adopted brother confided to us for sale. Yrs. faithfully

Roger Fry

Kindly let Mr. Robinson know at this address when you intend to call.

Roger Fry's letter to Sophie agreeing to release a sculpture for presentation to the Victoria & Albert Museum.

Morris. Pound encouraged Quinn to buy as an investment but not to buy up everything; at one point he advised him that 'roughly speaking Brzeska's drawings are all the same, 30, 40 or even 50 ought to be enough for a single collection'. He also told him that 'if the patron buys from an artist who needs money, the patron then makes himself equal to the artist'.

Quinn was a long-time patron of Pound's own work, subsidising magazines prepared to publish his poetry, but Pound was never possessive about patronage and frequently sought it for his friends. When Pound told Quinn of Henri's death, he commissioned Pound to buy everything he could find and promised to underwrite an exhibition of Vorticism in New York, which he did in August 1916. None of Gaudier's work was in the event included, as Sophie refused to co-operate. The exhibition did not find much public favour and Quinn was the main purchaser.

In his lifetime John Quinn assembled a remarkable collection, not only of British art but more than sixty works by Picasso, paintings by Matisse, Derain, Rouault, Redon, Cézanne, Degas, Van Gogh and many others. The collection included the major work, *Le Cirque* by Seurat which Quinn bequeathed to the Louvre, as well as Oriental, African and Polynesian art. In spite of strenuous efforts by many people, including Pound, to keep the collection together, it was split up and sold on Quinn's death in 1924. Many works by Gaudier disappeared from sight in the United States.

Pound arranged the purchase for Quinn of two of Henri's sculptures – *Marble Cat* and *Water Carrier* from the Omega Workshops. The final payment of £42.10s was made on February 7th, 1916 and the sculptures were despatched on the ss *Korea*. Encouraged by this success Pound believed he could act as an intermediary between Quinn and Sophie, but she was having none of it. She suspected him of double dealing. She wrote a forthright letter on January 2nd, 1916, making it quite clear how she expected him to behave in any dealings relating to Henri's estate.

185 Munster Rd
London, S W
Dear Mr Pound,
If you want to continue playing at mystification – find another partner suitable for your game. I am fed up with mystifications – lies and other mean dealings and want an open game. I want facts

plain and substantial. Therefore, I request you to answer as straight as you are able, the following questions: Is Mr J. Quinn of New York going to buy any of Gaudier-Brzeska's sculptures or drawings, both or none? If he be still entertaining his former intentions – what is he going to buy in this domain – when and for how much money?

If you are still his agent for the purchasing of G-B's work, I wish to have the market concluded before the 15th of next month, let me know whether you are prepared to finish up this business by that time.

Owing to your mystifying and tom-foolery (whereas I dealt with you in the utmost sincerity) I cannot rely any longer upon your friendly attitude. As you did not think it fit to give me information for which I asked in matters of importance, I am having to resort to the assistance of an able solicitor. If there should be any agreement to be made with Mr Quinn we would have it done with the aid of my solicitor. In reward for my full reliance and anxiety of not hurting any of Henri's friends' feelings, I am invariably being taken for a fool. Thenceforth I shall have to deal only with strangers and enemies . . .

As you were able to 'rush up' several times to London for your manuscripts, etc. please 'rush up' once more and return all the things I have entrusted to you.

A week or so ago I was told that some of Henri's drawings were on sale at one of the New Bond Street dealers. I went there and found a few of the early ones he left with Rider, others feeble imitations with Henri's signature forged. To prevent such further proceedings of sales, I am going to sign all Henri's drawings with my name and will advertise in French-English-American & Russian papers that only drawings with my signature are genuine, all others coming from fraud or from forgery. Therefore I want to get all the drawings deposited with you in order to sign and put them in order with the rest – so that I should have all my things together.

Please explain it to me why have you written to F. Duveen asking him for Henri's drawings? I have given you a letter of authorization to him, asking plainly for plaster vases.

Thanking you for readiness of assistance in difficulties, I expect a clear answer by Saturday next (29th inst).

Verily & truly,

S S Gaudier-Brzeska

Pound was getting the same treatment as Hulme. To defend himself from such an onslaught, he sent a copy of the letter to Quinn with an explanation; then he wrote to Sophie and visited her. As a result, she wrote direct to Quinn, and he replied on February 14th:

I sent a long letter to Ezra Pound on Saturday February the 12th. I should have written to him long, long ago. But I explained it all to Mr Pound; how I had been dreadfully driven, how in the autumn I had been under the weather, how I had been called to the state of Virginia, and that then when I got back I was almost continuously in court, and each day driven, and each week putting off a full answer to his letters, thinking I would have more time. However I have never failed to respond and often by cable, to any request by him for money. I didn't know that the matter was pressing. I knew that he had paid you £40, £30 for six drawings and £10 on account of other works. I should like at least thirty of the most representative drawings by your brother. I should like as much of his sculpture as I can possibly get. I pledged myself to Pound to keep the collection together as a whole and not to sell it or any part of it.

I got a letter from Ezra Pound this morning, February 14th, undated, and enclosing your letter of January 27th to him, and telling me that he had told you that I would take drawings amounting to £150.

. . . I cabled £120 to Ezra Pound because he had previously advised me that he paid you £30. That makes £150 for drawings. But if Mr Pound will have the goodness to select further drawings that he approves of thus bringing the drawings from £120 that I cabled him for you to £150, I should be glad to take the additional ones.

As to your brother's sculpture, I am anxious to get as much of that as I possibly can. I thought that Mr Pound had made that as plain as possible. I have only been waiting to be advised by him as to what he would have the goodness to secure for me and at what price. In fact in my letter to him I repeated what I had said repeatedly in cables to him, that I was as anxious to get as many representative works by your brother as possible and in my last letter I added the one and only qualification I have ever made, namely, 'provided the prices are not jacked up to an unreasonable point'. I have explained to Mr Pound fully why I have not been able to write to him. But I have cabled him from time to time. He

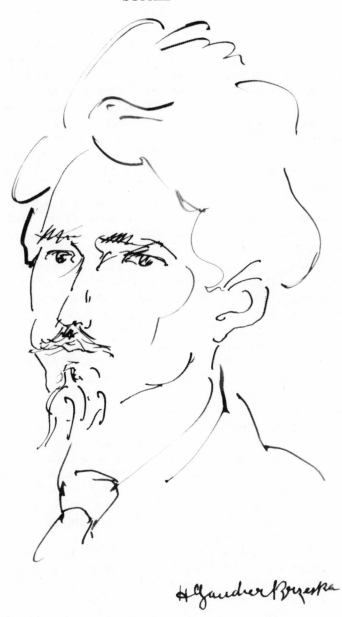

Portrait of Ezra Pound, 1914.

and I have another art matter on together which I considered and now consider quite as pressing as, if not much more pressing than, the matter of your brother's drawings and sculpture, and yet on that matter I was unable to write to Mr Pound until last Saturday. I mention this in order that you may see that keen and interested as I am in your brother's things, some things are physically impossible and that settling this matter in December and January was out of the question for me, as were other personal matters.

But let me repeat that I told Mr Pound to buy all of your brother's sculpture that he approved of, provided the title of it was clear.

There is no necessity of any 'able solicitor being called in for any agreement with me'. All I want to know is (a) what sculpture of your brother I can secure and (b) the price per example or for the collection.

I think you were a little hard on Mr Pound in your letter. I can't help but feel that you wrote in a moment of great exasperation and didn't really mean all that you said, for if you pursue the line of "dealing only with strangers and enemies" you are likely to find yourself coming out at the little end of the horn.

. . . In the first part of your letter to Mr Pound you ask whether I am still entertaining my former intentions of buying your brother's sculpture and then you say 'when and for how much money'. Those two questions are precisely the questions that I should like to have Mr Pound answer, after conferring with you and whoever else may enable him to give me the information. You surely wouldn't expect me to put a price upon your brother's things until I know definitely what I can get. You seem therefore to have put the cart before the horse. While I regret exceedingly that I have not been able to write Ezra Pound fully before I did, there hasn't been a time in the last three months when I would not have cabled him such money as he might have requested. He will tell you that I have always responded to any requests for money.

I hope that you will co-operate with Mr Pound in a proper settlement of the matter and I am writing him a short note telling him that as soon as he, Ezra Pound, after conferring with you and others interested, if any, advises me, to use your own words, what I can get of your brother's sculpture and when, and for how much money, I will give him my decision immediately, by cable, if necessary, and pay at once.

Trusting that the foregoing will completely put matters straight and assuring you of the great pleasure it will be to me to acquire as many of your brother's things as possible, provided they be kept together, always, I am dear Miss Brzeska,
Sincerely yours,
John Quinn

Despite both men's placatory efforts, Sophie's next letter to Pound was no more friendly to him and equally disparaging of Quinn. She was in her most petulant mood, heedless of patronage and determined that she alone would control the future of Henri's work:

Shall greased lightning move me to thundering speed? No. I shall not send the statues to Mr Quinn at present. He was not in haste – nor were you – while I wished to finish up and conclude the matter, feeling uneasy and worn out, uncertain as to the eventual issue of the affair. Now my solicitor has reassured me, lifted up my spirits, and I wish to hold a show of all Henri's work. I don't consider Henri's gift as means of making money. I am indebted to his name and shall do all in my power to give that name its right place in the world of art. After I'll have had a few months' rent I shall thoroughly sound the state of things and see what can be done.

. . . You will no doubt understand that contemplating a memorial exhibition I do not want to send away the best of Henri's work. Neither do I wish to risk it drowned in the ocean. No matter that the statues would be insured, the work of art would disappear and Henri is here no more to replace it. I believe this war will be drawn to an end before next winter and then it will be much more opportune for Mr Q to get the statues. I have already insured them here and arranged for storing. I don't care how much trouble and fatigue I undergo for objects dear to me.

It is possible that I may lose by refusing this hustling offer of Mr Q's. Still I prefer to do – at least endeavour to do – my duty.

Please explain it to Mr Q. I feel certain he will understand my motives.
Truly yours,
S S Gaudier Brzeska
London 27.ii.16

135

# SOPHIE

On April 20th, Sophie was writing at length direct to John Quinn:

Standing as the matters are, I consider it will be more efficacious and more brief, if we deal directly, without the aid of third persons.

... On several occasions last autumn, have I asked Mr P whether he received precise instructions from you concerning the purchase of my brother's sculpture. He invariably answered that he had no definite news as yet, but expected them every day and saying that you were busy editing a new periodical – that you went 'here and there' etc.

The 'Sea-Bird' of which you wish to have a bronze cast was in plaster. I wished to see it in a solid substance, protected from being damaged, the Zeppelins having been hovering at that time over London. I trembled for my brother's works – in danger of destruction. I wished to have them put somewhere into a safe custody, my health physically as well as morally having been shattered. I longed for a rest, in the country. For all those purposes I had no money, although Mr P told me in October that you were to buy £150 worth of drawings and made me understand that he expected the money to arrive shortly. I waited patiently – October passed, then November, in vain expectations.

Towards the end of November Mr P having told me that he had still a reserve of £30 of your money, I asked him to give me that money in exchange for some drawings or a piece of sculpture. He seemed to have agreed, but did not give me the money. At the beginning of December, I again asked Mr P if he could not give me at least some of the money for the casting of the 'Sea-Bird' without his taking any notice of my request. Of course I did not squeal or squeak for money. I did not insist. It was a matter of his fine feeling. At that time also, being utterly worn out with suffering and worry over rascally dealings of so-called friends, I also prepared to have the sculpture shipped there and then. I said so to Mr P but received no answer. I suppose all my utterings were not worth his attention or consideration. A few days before Christmas, Mrs Pound came to see me, telling she and her husband were leaving the next day for the country with the intention of staying away some 2 or 3 weeks. I asked them again if Mr P had a letter from you. Also if the money was coming. The answer was negative. And to my question: 'Do you know whether Mr Q still entertains the intention of buying my brother's sculpture', the answer was: 'I do

not know, I think so'. I proposed her to kindly ask her husband if he has decided to give me money for casting the 'Sea-Bird' – she acquiesced and left.

A month of uncertainty very disagreeably passed without any news from Mr P. I did not even know his country address. Still people have seen him in town. He did not think proper to let me know at what stage was our business. Finally a postcard about my brother's photograph – and not a word about the important matter.

Then to my asking when he would be in town and be able to answer some of my questions, he replied having no intention to return to London for another month.

Mr Pound having had several of my brother's sculpture and many drawings, which I deposited with him, was that a proper way of acting? He never informed me in time of his leaving London or asked whether I wished to dispose of my property left with him. I was quite entitled to the outburst of indignation and accusing of mystification and do not regret in the least having given it free utterance. In fact I needed some of the drawings for an exhibition and was tied up by his lack of consideration.

To make the matter clearer to you, I might as well mention that we were not at all on friendly terms, Mr P and myself during my brother's lifetime. In consequence of that, I refused to see him after my brother's death. I would probably not have seen him again, had he not called on me with your proposal of purchasing the sculpture, which of course I was anxious to place with an appreciative serious collector of modern art.

. . . Now as to the last arrangement made through the intermediary of Mr Pound. I believe it will be just as well or better if we consider it as non-existent and begin it all over again. And that on the following basis: we agreed with Mr P that you were to buy the ten mentioned pieces of sculpture, pay for them directly and lend them for the contemplated memorial exhibition. He never stipulated any conditions or restrictions on my rights of casting the plaster works. We also agreed that I was to have a bronze cast of the 'Red Dancer' which I want to exhibit in Paris. Before leaving for the post-office in order to cable you the list of prices, he asked me whether I wanted the money by cable or mail. I said that if it be more convenient for Mr Quinn to send it by mail I was willing to wait a few weeks longer, Mr P assuring me it would not take more than 2-3 weeks for the cash to arrive.

It was understood that as soon as the money would arrive we would make the transaction, that is from hand to hand: give money and take the sculpture.

After a month has elapsed since the arrangement Mr P came to tell me that you were to take the sculpture only after the exhibition is over. That you are putting forth conditions for me having only one exemplary of each plaster work, the original plaster put in a museum. Further, that according to your opinion, notwithstanding my brother's premature death, his work has not risen in price, etc. etc. He never shows me your letters and I do not know what of it is your opinion and what is lined with his views.

. . . As the matters are at present, the exhibition will probably be postponed until October or even next spring. If you should however care to buy now directly some of the pieces of sculpture, which will not be indispensable for the exhibition or of which duplicates I have, I would be quite prepared to hand them over to Mr P or your shipping agents on the receipt of the arranged sum:

I propose four pieces which are:

|   |   |   |
|---|---|---|
| (1) | The 'Group of Birds' (stone) | £70 |
| (2) | The 'Football Player' (bronze) | £55 |
| (3) | The 'Sea-Bird' (bronze) | £50 |
| (4) | 'Brass paper-weight' | £10 |

I am obliged to charge you £5 more for the 'Football Player' for casting of it will cost much more than I anticipated, the bronze being doubled in price. I am willing to let you have the 'Group of Birds', although it has not been exhibited here, for it is very heavy and difficult to pack and I do not wish to have things dragged here and there, deposited everywhere as before. I wish to put some order in my affairs at last.

Also these 'Birds' are not very likely to be appreciated by the English public or even the world of English artists with few exceptions probably.

If you should consider my proposal, kindly answer by cable for the 'Football Player' must be cast, which requires some two-three weeks to be done. Besides I intend to leave London in four or five weeks.

Thanking you for your appreciation of my brother's work, which appreciation I highly esteem, believe me, dear Mr Quinn.

Very sincerely yours,
S S Gaudier-Brzeska
London, 20 IV.16

While carrying on this frenetic correspondence, Sophie was confiding a very different attitude to her memoir and to Henri.

## March 23rd 1916

I feel myself heavy, dazed, lacking any desire, no definable reason even. Is everything within me burnt up – no exuberance – no hope. I fear, anticipate, a further bout of troubles and disasters – a kind of stillness before a storm. These are all the same things which continue to wound me – when I'm introduced – I'm spoken of everywhere as 'the sister of the noted sculptor', consequently I suffer doubly both for you and myself for I know they cannot appreciate your art and yet your reputation depends on their opinions – for me it's alright, but at my age I would like to be known for myself. I am so insignificant now and inadequate that they have to justify my presence.

It is nearly a year since you died and I still cannot bring myself to read your letters.

Sophie's resentment at not being recognised on her own terms resurfaced three days later.

## March 26th 1916

Your friends only persevere in their efforts to convince me that I am an imbecile, simple and stupid. Hulme, who at first offered to find me a place where I could rest and be quiet, openly mocks me. Pound, less lazy, is willing enough to occupy himself with your affairs, because they are so closely allied with his own interests, but he treats me as an inferior.

I am shocked and horrified when I hear the prices people now offer for your works, works which you left with your 'thought of' friends and which they now sell as theirs. What a monstrous turn of events – we who fought against the blackest misery, your enthusiasm and confidence always being restrained by the impossibility of earning a living – even in the simplest form. No one wanted any of

139

your works and you gave them away to anyone in friendship – they were accepted and now that you can no longer profit by it the money will flow.

I have just received the letter from J G the comrade closest to you at the front. It was he who was at your side at the fatal moment. He says that you were sad and pensive during your last three days, my beloved one, out of character since you had always been full of fight and wishing to attack and to kill – you were disgusted, you no longer wished to fight, nine days of incessant fire had brought you to the end of your tether. Was it a presentiment of your end or was it my dreadful letter which made you so sad?

I can neither live nor die, neither weep nor laugh, where can I go, what is in store for me, nothing anywhere, an endless blank, and to think that all my long interminable sufferings should come to this, to a blank, to zero, and that the work of your dear hands should now be food for parasites . . .

In April and May Sophie corresponded with the Victoria and Albert Museum seeking the safe keeping she cherished for those sculptures she thought important. She was sending them two stone sculptures, *Chanteuse Triste* and *Danseuse,* and six plaster casts – *Sea Bird Swallowing Fish, Portrait of Major Smythies, Portrait of M'lle Borne, Cariatid Vase, Football Player* and *Baptismal Font.* She continued, 'There is a large bas relief in plaster, 'The Wrestlers', at Mr Pound's which I am most anxious to place somewhere and it is difficult to do so on account of its size, some 2 yards long and 1 yard wide. I am waiting for Mr Quinn's answer (our eventual American purchaser) to relieve this cast from Mr Pound's custody. I should be pleased if you could possibly place it with the others – I should then fetch it myself in a taxi.'

Sophie received an immediate acknowledgement for these sculptures from Cecil Smith at the Victoria and Albert Museum. She had delayed sending the work partly because of the possibility of Pound's establishing a definite purchase with Quinn and partly because she was also negotiating with Charles Aitken, Director of the Tate Gallery, for the Contemporary Art Society to purchase the 'Football Player for £100 or with an option of one bronze cast for herself and exclusive rights, £140'. The Contemporary Art Society did not respond. Eric Maclagan at the Victoria and Albert wrote her a personal letter reassuring that the eight originally listed works would be accepted and would be safe in his custody.

In April she had written to Quinn with an indication of what was available and at what prices, and only six days later was writing again.

Quinn's reply, on May 17th, began, 'To say that I am weary of the entire matter is putting it mildly.' In a nine point résumé, he reiterated his interest in Gaudier's work, but not at any price, and dealt sharply with her criticism of his alleged procrastination. The letter concluded:

. . . I cannot deal at long range with two people in regard to the same matter. I am very much indebted to Mr Pound for all the time and trouble and thought that he has given to this matter. If nothing comes of it, I shall be just as much indebted. I don't criticise him for not having closed it last autumn. I was ready and willing, the minute I got the names of the examples and prices, to decide. He felt himself in a responsible position and seemed to be troubled about the question of titles. I respect his punctiliousness in the matter. I am grateful to him. I have nothing to do with your quarrels with him. I have my own personal views of the way you write about it. Ingratitude is I think the right word to use about what you have written about him. But that is between you and him. I have nothing to do with it except to tell you how it seems to me.

I don't want to continue this correspondence. You may regard this as personal, but if so let me tell you that your two letters were highly personal.

I have written my views about the sculpture to Mr Pound. If you don't care to deal with him you can tell him so and that will end this matter. If you would rather deal with a dealer, I am perfectly willing to send my views to a dealer or to have Mr Pound hand my letters to a dealer, and you can deal with a dealer. But I imagine if you deal with a dealer he will mighty soon get out of your mind the idea that I should pay for sculpture not to be delivered until after the war.

If you think that you are going to make me buy all Brzeska's sculpture by selling it to dealers, although it is a breach of your understanding with me, I am not going to try to stop it.

If I had been treating it as a business matter, when Pound suggested about the drawings and cabled that you wanted the money for the drawings, I should have cabled back:

'I will pay the one hundred and fifty pounds for the drawings when the sculpture is settled; not before.'

It is easy enough for you now to assume an injured air with £150 of my money in your pocket for drawings which I have not yet received and have never as yet seen and which I don't care for unless I get the sculpture.
Yours very truly,
John Quinn

Sophie's hysteria was rubbing off onto Quinn, and his growing exasperation led him to appeal to Epstein to intercede.

I should be glad if you will tell her that I am not a dealer nor an over-reached [sic], nor a liar, nor a thief, nor a crook, nor a naive [sic], nor a man who takes advantage of women financially or otherwise and that it is altogether stupid on her part to write to me as though I was one, or some, or any or all the things she imagined I was. There is a great deal of canniness mixed up with her emotionalism.

Meanwhile, Sophie confided to her diary on May 17th, 1916:

At last I hope to be alone for at least a little while – I am leaving this damned hole where I have been tormented beyond belief for the last year. Now I will be able to get on with 'Our Work' – watch over me beloved.
At last I am out of that hell hole at Munster Road. Even when you were with me it was the one road that I absolutely refused to go into – till fate drove me into it, and now I am out of the mess and with Miss W who you knew well. By chance I met her again through some London militants – the other day – one of them accosted me and then she invited me to her house (Miss W) and I'm going to stay here until I find a better place.

From this new address at Fulham Palace Road, Sophie fired off another salvo on May 30th:

To Mr John Quinn
31 Nassau Street, New York, USA
Mr John Quinn of Nassau Street, New York can throw my letter unread into the wastebasket – still I cannot forbear leaving him unanswered.

Herewith I acknowledge having received his highly impertinent letter on May 17th where he accuses me of having out-traded him etc. etc. He also in a most vulgar manner repeatedly affirms having given me 'his' money in advance – which is not true, for I have taken the money only on handing purchased drawings either to Mr Pound or his substitute (Mrs Shakespear). It is perfectly ridiculous of Mr Quinn to say that he paid before having seen the drawings – or that he had done generous or benefactory work buying them.

. . . It is no fault of mine that Mr Quinn does not inhabit England – nor that Mr Pound had not sent the drawings 4–6 or 8 months ago. If Mr Quinn has perfect confidence in Mr Pound's artistic taste and knowledge it seems quite intelligible to me that he should trust and depend upon the latter's judgement.

. . . If Mr Quinn is weary of the transaction so am I and more so, quite exhausted even by it, and ill. If it is dragging on in a slow 'tempo', the fault is by no means on my side – as I was only too conscious and too ready all this time to conclude a clear market.

If Mr Quinn had given me his money I have given him my drawings and the best of them. I gave him each at £5 a piece because he was buying many and also the collection of sculpture. I should not think of selling separately any of those drawings under £10 or more. I have sold many others at £7 and £8 and Mr Quinn is quite entitled to believe it or not. I shall not sell them cheap – even if I should starve.

. . . I conclude, having waited for Mr Quinn's answer over five weeks according to my promise and having lost all hopes for an answer, I have just sent away all the sculpture for safe custody.

Perfectly willing as I was and continue to be to sell the collection to Mr Quinn I do not intend to give away the last breath in order to satisfy his wish immediately. I have waited in this dreary, dirty surroundings for the settlement almost a year, which is more than I can stand, I am going away to the country for at least four months.

If after my return to London, Mr Quinn feels inclined to take up dealing about the sculpture I shall be perhaps able to finish up the matter definitely.

I like to emphasise before closing that Mr Pound proposed in March to buy the whole collection directly and exhibit it in London which was of main importance to me, whereas afterwards he said: Mr Quinn would purchase it only after the exhibition, which of course changed entirely the conditions of proposal.

On my return I shall inform Mr Pound. Mr Quinn can then if he likes to, have a solicitor, notary or whomsoever necessary in such matters.

Lastly I forbid Mr Quinn once and for always to take such a liberty as of charging me with bad will, mean intrigues, out-trading and so forth.
Untruly
S S Gaudier Brzeska

Sophie's impossible temperament, the rudeness of her reply to a very keen patron and her dismissal of Pound all led to Henri's sculptures and drawings not being exhibited as Pound had wished. He had suggested the Vorticist exhibition in New York and when it materialised in August, 1916 it included the work of Lewis, Wadsworth, Etchells and Roberts but, because of Sophie's paranoia, none of Gaudier's work. Quinn purchased thirty two of Lewis' paintings for £375. What else he might have bought, had it been included in the show, is impossible to guess.

Pound, Hulme and many of Henri's other friends became cautious of making any approaches to her and Sophie's isolation grew. She interpreted this as the typical rudeness of the English. As she had predicted earlier in the year, Mrs Westwood's rooms began to feel too restrictive and she decided to leave London for even greater solitude in the country. She searched through several agencies and in late September, just as Pound's *Memoir* was published, she left London for Wotton-under-Edge in Gloucestershire.

*Gaudier-Brzeska: A Memoir* was a strange mixture of reprints of articles written for *Blast, New Age* and *The Egoist* both by Pound and Henri, and Pound's tribute to Henri's achievement and an evaluation of his place in twentieth century art. Much of it Sophie denigrated as inaccurate, annotating the copy given to her by Pound. For example:

*Pound:* Later he went to his parents on the Loire, resumed his painting, came to London and was for three months out of work.

*Sophie:* Never touched the brush but retook modelling when I visited him there. For two months previous he was not allowed by the doctor to do any exerting work whatever on account of his illness, which the fool [Pound] does not mention at all, taken up as he is with advertising his blessed 'Vortex'.

144

Pound's appraisal of Henri is at its best in the Introduction to Chapter XIII. It is the reality behind the book itself.

> There are few things more difficult than to appraise the work of a man dead in his youth; to disentangle 'promise' from achievement; to save him from the sentimentalising which confuses the tragedy of the interruption with the merit of the work actually performed; and on the other hand to steer clear of unfair comparisons with men dead at the end of a long life.

Sophie made no comment on this. The memoir, as she rightly observed, was largely a vehicle for Pound's own ideas and enthusiasms. He, too, was a young man establishing his reputation, but the book was still a most fitting tribute. It was put together in the emotional fervour of the hour and although in later years Pound occasionally reflected on their short relationship, and changed his opinions, the memory of Henri's prematurely wasted life stayed with him; the constant reminder of their association, *Hieratic Head*, the largest carving that Henri had created.

Settled into The Cot at Wotton-under-Edge, after an uneasy start, Sophie was now preoccupied with daily routine. Ill health and sickness induced by neurosis continued to dominate her life and in the diary she constantly complained of being tired and worn out. Her mental state was further strained by the determination to finish 'Our Work' which already ran to almost four hundred pages. Entries in the journal towards the end of 1916 indicate how she recognised her own predicament and was unable to break out of it.

### December 24th 1916

> Perhaps I am calmer because I no longer see the newspapers, that's quite possible and although I am always conscious of how badly things are going, I am no longer upset every day by seeing all the lies and false reports with which the newspapers are filled.

### December 27th 1916

> There are moments, particularly after a sleepless night, when my mind seems to leap from moment to moment, is elated, exasperated, one then the other in quick succession beyond control. I feel a sudden need to burst out and tell everything I feel to

145

anyone and everyone I see, my nervous system is in revolt. I want to run, leap, dance, fly to free myself from the bonds which keep me in this place, trapped, then I crash and am unable to escape, my brain continues to roam like a tiger in a cage, roaring as if it would break through the bars . . . I just go round in circles and only time separates one cycle from another. Others take my need to talk and shout for madness, my needs to communicate my sharing of confidences are seen purely as lies, I can see it in their eyes, they yawn, complain of headaches, anything to get away from me. What humiliation, what a desperate mess I am in.

I cannot bear this society of men or women, I wish I could change myself into a fawn and live in the woods.

Oh my love you did not live in vain, your great spirit which loved life. I would absolve you of all your misdeeds if you hadn't left me in this mess.

### December 31st 1916

Dearest beloved love. It is New Year's Eve here, my distress, in past years, in being alone here has gone up in smoke. I am becoming wiser and see more clearly that my real need is solitude. If I cannot be with you I prefer to be alone. All that I ask of God, our dear protector, for this New Year is the strength and spirit to finish 'Our Work'.

Sophie planned to complete 'Our Work' in 1917 and continue with her Trilogy which had suffered because of the time she had devoted to Henri's estate.

# 4

The solitude that Sophie sought in the country now became an additional burden to her already confused and deranged mind and was the cause of her ultimate breakdown. Old friends continued to write to her. Ezra Pound, despite the way she had behaved, Sidney Schiff and Robert Bevan and others began actively to encourage her to consider a memorial exhibition of Henri's work. John Rodker, a small London publisher as well as poet, wrote seeking her agreement to reproduce a portfolio of Henri's drawings.

But the usual fears filled Sophie's troubled mind and her diaries for January reveal that although there were those who offered her help she was suspicious of everyone, not least the local people. Increasingly these suspicions became obsessive, self indulgent and sexually motivated. At the same time she seemed to be aware of what was happening.

### January 18th 1917

Beloved, inexplicable things are happening in my brain − at one moment I am full of life − exuberant, almost happy and above all I feel an inexhaustible force for the fray − then I am utterly broken with sorrow and despair it is so devastating I wish I could die − life seems so stupid to me. I don't remember ever having been like this before, I long for love, for a devoted lover − one would think of me as the prey to sexual desire − every day the same sufferings torment me followed by the same obsessions.

If the vulgar folk who live around here knew my feelings, heard my sighs, what would they think − filthy ideas of which they themselves are guilty. What is it that prevents me from satisfying these sexual lusts if I feel the need to − in the country one is never denied the opportunity of a lusty man − although I am not young I can still take my choice, each week a new one, they are indefatigable. It isn't a romantic obsession that haunts me, I could easily satisfy that − no country is more perverse than this in indulging in the sentimental. All this feeling makes me feel sick − what I really need − desire, is a kindred spirit who will understand and encourage me − someone to whom I could be a help while at

the same time giving myself to them but I doubt whether I could find such a person here . . . Being alone I fear death because of our artistic heritage – if it were not for that I would welcome death – but 'Our Work' is not ready and apart from that to whom can I turn to confidently secure the safe keeping of your sculpture. There is no one whom I can trust. Mr Schiff is kind and ready to help, but even he has wounded me treating me so protestingly, this is because of his wife, I think, who regards me as very similar to Currie's mistress. This humiliates me and irritates me so I cannot bring myself to leave all your work to his judgement, anyway he dislikes what you did at the end, apart from him I know no one to whom I would trust what I hold most dear . . .

Two months later the fantasies are more disturbed:

## March 20th 1917

Sweet love, I must confess my faults to you, sins which arise as much from my temperament as a writer as that of a woman. To amuse myself a little and perhaps more to help me stay sane in this difficult life, I have been using, quite immorally,what remains of my charms the power of which rapidly decreases every day. Sometimes I have no idea why I do it and am annoyed by own stupidity.

It happens like this. I feel that it is impossible to interest these stupid people in the real purpose of my existence, in fact it is very hard to get them to do anything for me, even for money, they seem to avoid me. So in order to get the moronic male population which squat in their holes around here like pigs, to do anything for me, I am forced to make use of the power of my eyes to electrify them, to make them come nearer to me and get them to believe that they want me. Do my eyes make outrageous promises, I suppose so for that is my intention, I merely try this with the vivacity of my gestures and nervous and breathless speech to interest them in my body – my person, so that they will be kind to me. Can I dare hope that they will like me as a friend without any sexual desire, never, I am not as naive as that. There is of course a mischievous intention behind all this – the more mischievous because those stupid locals get all of a sweat with themselves

charged with animal lust without any feeling or sentiment, and when they realise how they have been led on they show their arrogance at the deception, as if their pretensions had been totally legitimate, they have been trapped and shown up to be the lustful boars they are.

There is no beast, however ugly or repulsive, vulgar or stupid who does not think that my friendly smiles and encouraging words are given with the end in view of promises of encouragement. Do I flirt with them, no truly I don't, I am only friendly and deserving of receiving friendship in return − but not ready or prepared to be taken.

Naturally I only do this kind of thing with the real thugs who may easily respond with gestures or words which are intended to offend. I never go out of my way to meet or contact them or give them any reason or cause for their unsolicited attention. On the contrary I avoid them particularly if I notice that they have been watching me or hanging about my road. Secretly I watch them, study their behaviour and laugh to myself at how easily they are attracted to my traps. In my heart where I hold my imprisoned passion impossible fantasies begin to arise about their real desires for me. I begin to take them seriously − they are in love with me − then I suddenly begin to blame myself for causing them trouble and invent a thousand explanations. It is then that my entertainment becomes a nightmare, I am obsessed and although my heart remains untouched I am tormented by the possible distress I have caused others. I see a man coming towards me, unhappy, his life totally upset and with incomprehensible stupidity I throw myself at him in body and spirit in order to be good enough for discourse in mind or body. Uncertain of offering physical love, I offer friendship, sisterly friendship and the spiritual protection of a devoted companion.

Then gradually I realise that this man who, for a moment, I have regarded as a romantic shepherd, is only a gross, grasping sex maniac. In a word he thinks that 'to get' a blooming foreigner or a French woman of easy virtue at little or no expense is good sport. Once I have realised this and seen through it the man irritates me − I hate him and am disgusted by the impudence of his advances − for certainly I never gave him my consent. Must one be a cow of English respectability in order not to attract the filthy suppositions of lusty men. Shall I ever get away from it?

# SOPHIE

## March 28th 1917

For the last two weeks I've looked everywhere for another cottage, unfurnished so that the rent will be less. Wherever I go the owners send me on to someone else – they regard me with suspicion but God knows what I have done to deserve it. Everyone has some excuse or other to offer – always I come away empty handed and disappointed.

By now, Sophie was frequently barefoot, unwashed and dishevelled, wearing what Sidney Schiff described as a 'rag bag' of clothes. She walked the countryside in all weathers and could be heard muttering to herself in a language which local residents did not understand; they considered her mad and kept out of her way. In fact she was not mad, but had periods of acute depression followed by flights of erotic fantasy all of which led to remorse and further depression. She was trapped in a vortex of developing insanity.

In lucid intervals she could appear quite in control, writing to mutual friends and her more recent acquaintances. She continued with 'Our Work'. But her diary showed increasing signs of self obsession and sexual fantasizing. She was desperately in need of help, but she would accept none, turning instead to Henri in the pages of her diary. The entries alternate between imagining present daily happenings and turning over the past, between sexual obsession and guilt.

Her torment increased. She was living alone and slowly driving herself further towards insanity. She complained that the police harassed her because she told the neighbours to leave her alone, and there are long, completely incomprehensible passages in the diaries. She was, however, still possessed by the idea of making Henri's genius known in the world, and she managed to maintain a dialogue with Robert Bevan without antagonising him. It is likely that Robert Bevan's wife, Karlowska, who had been very close to Henri, was a balancing influence; and Bevan persevered in acting as an intermediary between Sophie and the Leicester Galleries who had agreed to mount a memorial exhibition. Pound, realising that any contact with him would only antagonise Sophie, kept at arm's length.

Quinn, in New York, was getting news of the impending show and renewed his efforts to buy. He wrote directly to the gallery. The letter is of interest in many ways. It shows what he thought of Sophie, reveals his genuine desire to honestly purchase sculpture and exaggerates his claim

150

to friendship with Gaudier, a misrepresentation which others, notably H.S. 'Jim' Ede, were to make over the years in order to try to establish their right to be favourably considered in relation to Henri's estate.

December 3, 1917
Messrs Ernest Brown and Phillips
The Leicester Galleries
Leicester Square
London, W C
England
Dear Sirs

. . . And now there is a matter that you may have that does interest me, and that is, the possibility that your gallery may have an exhibition of the work of H E Gaudier-Brzeska. Mr Ezra Pound would, I daresay, tell you the story. Briefly it is this:

Before Gaudier was killed I was in correspondence with him about purchasing some of his work. It was under discussion and some things promised, and then he was killed. Then Ezra Pound interested himself in the matter. Then followed Pound's book on Gaudier. Then followed long delays because there was no one who apparently had title to sell the things, and there was a possibility that his father might turn up from France to claim title. Then more delay because of inability of Pound to tell me just what could be sold. Finally, we came to an understanding, partly by letter and partly by cable [then follows list of sculptures in various hands which he said Pound had arranged with Sophie to secure for him at prices to be agreed] . . .

That was all settled. I had paid her something on account. Then Pound said that as I was having that number of his works I should have some of his drawings to make the collection complete. That seemed reasonable. I told Pound to make a selection. He selected some twenty-nine or thirty. They came to £150, as I recall it. Then followed a cable from Pound that he had the drawings and she would like the money for them. I cabled. Then with that £150 in her pocket she became very independent about the sculpture. She wasn't going 'to be bossed by Ezra Pound', she wasn't going 'to be gouged by an American', she wasn't going 'to be forced', and God knows what she wasn't going to be or do or suffer. Then I began to wake up. When I finally got the drawings, things that I was charged five and six and ten pounds for were marked on the back for sale

151

£2 and £2.10. She evidently forgot to erase those prices. In short, the prices of the drawings were jacked-up to me two and a half to three and four times.

Then she quarrelled with Pound. Then she made insinuations about me. Then she began to deluge me with letters with all sorts of complaints. She was very like a female Trotsky. Mr Trotsky, who is at present playing the English game, is making all sorts of charges. First, he charges that the United States wanted the war to exhaust Europe, and now that Europe is exhausted that the United States wants peace. Then he threatens the Entente powers. Finally he points to the negotiations for an armistice as proof that he and Mr Lenin with their mouths have 'forced the German war party and the German governing parties and the German General Staff and the Kaiser to treat them'. That is about the way that 'Miss' Brzeska tried to treat me. I finally wrote to her practically accusing her of fraud, of having got £150 out of me for drawings, that by themselves I would not have been interested in, on the pledge and promise that the sculptures would be sold to me, and then going back on her bargain. That ended the matter so far as I was concerned.

I am now told by my friend Ezra Pound that she is likely to have an exhibition at your gallery before the war is over. Her last suggestion was that I pay for the things in advance, but that she keep possession of them and that they be not sent over until the war was over, and mind you that was before unrestricted submarine warfare was begun by the Germans. That suggestion of hers was made at the time when it was perfectly safe to send things over.

I am still interested in Gaudier's things, provided the prices are reasonable and absurd conditions are not made.

I understood that the Dowdeswell Gallery had a show there in June, 1916, of three or four pieces, but that they were not important and were later on removed.

There were five pieces of sculpture which I should like to have if I can get them at reasonable prices and on reasonable terms, namely:

1. Bird Swallowing a Fish, in bronze
2. A Dancer, in Red Stone
3. A Marble Woman, seeming asleep
4. A Group of Birds, upright
5. Elaborate Carving of two Stags.

I understood that these things, except the bronze, had been stored at the Tate Gallery for safekeeping.

I know that 'Miss' Brzeska, or 'Mlle.' Brzeska, is a difficult person to deal with. Ezra Pound did more for Gaudier's memory than anyone by the publication of his book, and yet no sooner was the book out than she pretended to take a violent dislike to him. She is perhaps somewhat mad. But she is not mad when it came to making a good business trade, but quite shrewd, as shown in the way she unloaded the drawings on me and then broke her bargain about the sculpture.

If you are interested in the matter I should be glad to have you make one price for the five things, purchased together. I would have no objection to her having one or two copies made of the 'Bird Swallowing a Fish', and also a copy in bronze of the 'Red Dancer'.

Jacob Epstein wrote me in the summer of 1916 that he was friendly with her and that her desire was to see Gaudier's things worthily placed, and offering to take the matter up with her. But I was so disgusted with the way she had acted that I thanked Epstein for his offer but did nothing.

At that time Epstein wrote me that there were other sculptures of Gaudier's, like the 'Singing Woman' and the 'Football Player', that he did not think should go into my collection. He agreed with me that the five that I have mentioned were the best.

Her letters impressed me as being those of a cunning woman. But she over-played her hand with me. I don't want anything underhand in the matter. I don't ask you to conceal from her that I have written you this letter. The letter, of course, is personal to you, because I have written frankly and in confidence, giving you briefly the story. I am not disposed to have any secrecy about my willingness to purchase the five named. I am willing to have an offer submitted. I am not willing, however, to pay now for works whose delivery is to be postponed until after the war. I lately bought Epstein's marble 'Venus', eight feet high, and his carving in granite 'Mother and Child', and they came over perfectly safely. In fact, hundreds of thousands and millions of dollars worth of art works and old furniture and antiques are being brought over to this side from England and France and Italy and Spain. I was told that by the customs officials quite recently. No big passenger boats are being sunk. At one time I had agreed to pay her for all of the

things named above, provided they were delivered to my nominee and to my custody and out of her custody, so that my payment would be accompanied by an actual delivery out of her possession. I made that condition because that was going a long way. I felt that I had to do that to protect myself legally. I wasn't going to pay her for things and then have her disappear and be unable to trace the things, or run the risk of having them be sold over again or of having conflicting claims or claimants to the same work.

There is the whole story. I have no objection to your telling her that I have written to you; no objection to your telling her anything in this letter, except the one or two personal parts of it. I never met the woman personally. She may be a saint and an angel, for all I know. I have given you the facts and the impressions that I got of her from her letters and her acts.

Yours very truly

John Quinn

In spite of everything, Sophie was still capable at times of reasonable behaviour. Late in 1917 she sent a box of apples to her old landlady, Mrs Westwood, in London. Her reply was generous and benevolent and suggested that the note which accompanied the apples had been coherent and logical.

Three diary entries in November 1917, full of pathos, are the last which make any coherent or legible sense at all. From then on they became the desperate scribblings of increasing insanity.

## November 8th 1917

Oh this war, this war what an infamous monster when oh when will it end. All these years of loneliness and want in the country make me want to break away but I cannot. Trapped here it is only a superhuman effort that enables me to control my desires. I had wished to live to finish 'Our Work', the memory of pure love. It is impossible I am squashed into a great gelateous ball − a huge roll of dung which suffocates me and I cannot escape. It would take very little for me to drag fat Dick into this and give myself to his cruelty, his filthy ugly debauched form, toothless mouth and paunched belly, his grossness draws me to him. What a vicious circle, what misery, how can I get away but where can I go, there is nowhere, trapped, trapped.

## SOPHIE

### November 14th 1917

I struggle to shut out the voice that whispers to me, it tells me, is it you, that the deed is near its end? All my life I've had to fight, now there is no fight, fatigue falls upon me. Light alone nourishes the spirit and I am more and more surrounded by the shadows of darkness.

### November 17th 1917

I have no power left, yesterday I cleaned the house and went out to the forest to find my secret place to lie down in peace. When I was half way there I remembered all the provisions were left and the house unlocked. I had to go back but my legs were hardly strong enough to carry me. I left for the forest again and wished I could make it my grave – any death is better than this damned life, let death come quickly now, now, now!

# 5

B y the New Year, plans for the memorial exhibition at the
Leicester Galleries were well advanced. Sophie had contacted
Mrs Westwood to arrange the collection of some of the carvings
which she had left with her. Mrs Westwood's reply refers yet again to
Sophie's illnesses but suggests that when Sophie goes up to London for
the exhibition she should let her know in good time in order to arrange
lodgings for her. This she did, and Sophie stayed with a Mrs Gilling for
about eight weeks.

Robert Bevan, in his capacity as 'the middle man' for the exhibition,
early in the year advised Sophie that she should not write the preface to
the catalogue: it would appear to be too much 'in the family'. He
suggested that Raymond Drey, critic for *The Westminster Gazette*, or
Pound should be asked. All his most fervent assurances were necessary,
and Bevan wrote that she must not assume 'that everyone is bent on
swindling you'.

As the planning for the exhibition progressed and the work was
assembled, the gallery directors, Oliver Brown and Wilfred and Cecil
Phillips, had a difficult time maintaining equilibrium between all the
factions, and the project more than once came close to foundering.

The gallery replied to Quinn's letter in February, detailing the works
which would now be available for purchase together with the new
prices. They were unable to resist a gentle touch of humour in referring
to Sophie.

Thank you for your letter of the 3rd December which we must
apologise for not answering earlier. Our excuse is that we could not
deal with your letter until we had had an opportunity of consulting
Miss Gaudier-Brzeska.

We have arranged for an exhibition of the work of Gaudier-
Brzeska to take place this summer. It will be an affair of some
importance, partaking of the character of a 'memorial exhibition' of
his works, containing loan exhibits, and exhibits for sale, both
drawings and sculpture. Amongst those that we have agreed to

exhibit are several pieces of sculpture which you mention and they are already in our hands for sale:

1. Bird swallowing a Fish, in bronze    £120.00
2. A Dancer, in Red Stone    £160.00
3. A Marble Woman seeming asleep    £220.00
4. A Group of Birds, upright    £105.00
5. Elaborate Carving of two Stags    £260.00

These prices have been fixed by Miss Gaudier-Brzeska. It is possible, of course, that they may be higher than the prices quoted to you formerly. This, we understand, may be very annoying to you in view of the protracted nature of your negotiations for their purchase, but of course, you will see that we are in no way responsible for this. It seems to us that Miss Gaudier-Brzeska, or anyone else, would be quite justified in charging much higher prices now for this sculpture in view of the artist's increased reputation, due to the publication of the book [Pound's *Memoir*] and the circumstances of his death, and of course the great merit of his work which interests more and more people every year. We, ourselves, anticipate a great success for the coming exhibition.

Your account of the transactions with Miss Gaudier-Brzeska is certainly disturbing but, so far, we have not had much experience of her character and peculiarities. Perhaps her resemblance to Mr Trotsky may be more apparent later on.

In the event of you purchasing the Sculpture, we would ourselves see to its delivery immediately after the exhibition in May provided, of course, war conditions do not make it impossible for us to dispatch them.

At present we believe there is no more difficulty about transport than there was when Epstein's marble and granite groups were sent to you. If you want the works mentioned reserved for you, it would be as well to let us know as soon as possible as when our coming exhibition begins to be discussed, we shall no doubt have other enquiries.

Thanking you for your frank letter and for approaching us in the matter.

At Wotton-under-Edge Sophie's erratic behaviour continued. Apart from visits by Sidney Schiff and Nina Hamnett – both of whom realised

# SOPHIE

*Telegraphic Address :*
*" Vicaleum, London."*

18/2095.

VICTORIA AND ALBERT MUSEUM,
SOUTH KENSINGTON, LONDON, S.W.7.

11 July, 1918.

Dear Madam,

I have much pleasure in accepting the plaster statuette of The Dancer, by your late brother which you have so kindly offered to present to this Museum. I take this opportunity of informing you that we will keep in custody for you until further notice, the stone figures of The Singer and The Dancer, the small alabaster figure of an Imp, and the two plaster figures of The Football Player and The Bird swallowing a fish. As it is your wish, we will put the three first pieces in a bomb-proof store, and the two plaster figures will be stored with the other plaster figures which we are keeping for you. We will also put the four paintings, which you left here in the bomb-proof store. It will be understood that all the above objects are received on our usual conditions, a copy of which is enclosed.

Rules 6.

Yours faithfully,

Miss S.S.Gaudier Brzeska,
3, Wortley Terrace,
Wotton-under-Edge, GLOSTER.

*Cecil H. Smith.*

Sophie donated the sculpture, *The Dancer* to the Victoria & Albert Museum.

her developing insanity – she sank further into isolation. Because of the war anyone at all unusual in any community was regarded with grave suspicion; rumours began circulating that Sophie might be a German spy. Her continued anti-social behaviour and strange appearance were the cause of jokes and abuse in her presence from children and adults, and Sophie now found it impossible to find sanctuary even in her own home.

The Cot was one in a row of cottages and every sound heard through the thin walls was a torment for Sophie, convinced they were made deliberately to torture her. She adopted the habit of 'working' at night, going to bed at three in the morning after cooking her supper, and frequently disturbed her sleeping neighbours. Sometimes, even on cold days, fleeing from her perceived persecution, she would leave carrying a suitcase and dressed as though to go on a journey. The neighbours noticed her departure with relief. She would sit out in a field all day or shelter in a barn and towards dusk, or even after dark, she would slink home, hoping not to be seen. Then there was blissful silence; for hours she would sit and write, without stirring or making any noise. She would steal downstairs to cook herself some supper and, as she wrote in several lucid lines in her diary, 'she would move about in the darkness and suddenly knock over a saucepan or chair'. The neighbours realising her return, would shout 'she's back' and after that there would be no more peace. Sophie wrote an 'ode to the poker' to commemorate her neighbour who she thought was always poking the fire, making an unearthly din to annoy her. One episode she confided to the diary: when she wished to rest in the afternoon, 'little Willie', who lived next door, was sent to play on the stairs close to her bed. 'You make as much noise as you can, my boy', she thought she heard him being told. For the following three nights Sophie, in turn, sang loudly when 'Willie' went to bed, keeping him from sleep, hoping to tire him out for the following day's torment.

It was against this hysterical background that the preparations for the exhibition were being made. Sophie made a gift to the Victoria and Albert Museum of the plaster of *The Dancer*. All the other sculptures which had been left in safe keeping with the Museum were sent to the Leicester Galleries for the memorial exhibition and other work variously deposited was collected, including that with Mrs Westwood and Ezra Pound.

Eventually, Robert Bevan asked Ezra Pound to write the preface to the catalogue. Sophie seems not to have objected and the piece he wrote was characteristically eulogistic. It has stood the test of time.

SOPHIE

## HENRI GAUDIER-BRZESKA

For this preface to the Memorial Exhibition of Gaudier-Brzeska's work I can only recapitulate what I have already said in my Memoir of him. His death in action at Neuville St Vaast is, to my mind, the gravest individual loss which the arts have sustained during the war. When I say this I am not forgetting that Remy de Gourmont, Henry James, and lastly, Claude Debussy must all be counted among war losses, for in each case their lives were indubitably shortened by war-strain; but they, on the other hand, had nearly fulfilled their labour, each was still vigorously productive, but we could in fair measure gauge the quality of what they were likely to do.

Gaudier was at the beginning of his work. The sculpture here shown is but a few years' chiselling. He was killed at the age of twenty four; his work stopped a year before that. The technical proficiency in the Stag drawings must be obvious to the most hurried observer. The volume and scope of the work is, for so young a man, wholly amazing, no less in variety than in the speed of development.

In brief, his sculptural career may be traced as follows: It begins with 'representative' portrait busts in plaster, and with work in more or less the manner of Rodin. Whatever one may think of Rodin, one must grant that he delivered us from the tradition of the Florentine Boy, and the back-parlour sculptural school favoured by the Luxembourg. Gaudier was quickly discontented with the vagueness and washiness of the Rodin decadence and the work of Rodin's lesser imitators. We next find him in search of a style, interested in Epstein, but much more restless and inquisitive. In 'The Singer' we have what may seem an influence from archaic Greek, we have the crossed arms motif, used, however, very differently from the crossed or x'd arms of the splendid Moscophoros. (The anti-Hellenist cannot refrain from a slightly malicious chuckle on observing that the Greeks really had a great master (before Phidias), and that they have carefully forgotten his name. Vide also the consummate inanities in the *Encyclopaedia Britannica* regarding the Moscophoros.) In 'The Singer' we may observe also an elongation possibly ascribable to a temporary admiration of the Gothic.

In 'The Embracers' we find a whole pot-pourri of forces: Egypt

in the delicate flattening of the woman's right arm, Oceanic influence in the rest of it. Note that all great artists are imitative in their early work; their power lies in the rapidity with which they assimilate, digest, get through with, weld into a style of their own, the forces and qualities of their models. Obvious as one or two acquired qualities are in 'The Embracers', it is perhaps the most complete expression of Gaudier's personality that remains to us. It is also intensely original, the stylization into the bent prismatic shape of the whole does not, I think, occur elsewhere. He has shown the 'sense of stone' in the utilisation of this queer-shaped block as Michelangelo showed it in the economy of his 'David' (a block, as you remember, which none of his contemporaries could handle, and which was regarded as spoiled, and useless).

Gaudier denied the Chinese influence in 'Boy with a Coney', a piece more opulent in its curves than 'The Embracers', though perhaps less striking at first sight, because of its greater placidity.

By the time he got to 'The Dancer', Gaudier had worked definitely free from influence. This work is his own throughout. I can but call upon the unfamiliar spectator to consider what it means to have worked free of influence, to have established a personal style at the age of twenty-two. There is no minimising such achievement.

The personality is asserted in 'The Embracers', the style is established and freed from derivativeness in 'The Dancer'. This last is almost a thesis of his ideas upon the use of pure form. We have the triangle and circle asserted, labelled almost, upon the face and right breast. Into these so-called 'abstractions' life flows, the circle moves and elongates into the oval, it increases and takes volume in the sphere, or hemisphere of the breast. The triangle moves toward organism, it becomes a spherical triangle (the central life-form common to both Brzeska and Lewis). These two developed motifs work as themes in a fugue. We have the whole series of spherical triangles, as in the arm over the head, all combining and cul- minating in the great sweep of the back of the shoulders, as fine as any surface in all sculpture. The 'abstract' or mathematical bare- ness of the triangle and circle are fully incarnate, made flesh, full of vitality and of energy. The whole form-series ends, passes into stasis with the circular base or platform.

I am not saying that every statue should be a complete thesis of principles. I simply point out the amazing fact that Gaudier should

so clearly have known his own mind, that he should have been able to make so definite an assertion of his sculptural norm or main urges at the age of but two and twenty.

The quality of his stone animals, his sense of animal life seems too obvious to need note of this preface.

Because our form sense is so atrophied it is necessary to point it out, even to wrangle about it with unbelievers. Again Gaudier's technical power seems too obvious to need explanation, whether it be in cutting of brass, or in the little green charm, or in the splintery alabaster, or in the accomplished ease of the drawings.

If the 'more modern pieces' puzzle the spectator there are various avenues of approach. First, by Gaudier's own manifestos. 'Sculptural feeling is the appreciation of masses in relation. Sculptural ability is the defining of these masses by planes.'

Secondly, by a study of Egyptian, Assyrian, African and Chinese sculpture, and a realisation that Hellenism, neo-Hellenism, neo-Renaissancism and Albert Memorialism do not contain and circumscribe all that it is possible to know on the subject. Only those shut in the blind alley which culminates in the Victorian period have failed to do justice to Gaudier. My praise of him is no longer regarded as an eccentricity.

He is irreplaceable. The great sculptor must combine two qualities: (a) the sense of form (of masses in relation); (b) tremendous physical activeness. The critic may know fine forms when he sees them embodied, he may even be able to construct fine combinations of form in his imagination. This does not make him a sculptor.

The painter may be able to record or set forth fine form-combinations, to 'knock off' a masterpiece in four hours.

The sculptor must add to the power of imagining form-combination the physical energy required to cut this into the unyielding medium. He must have vividness of perception, he must have this untiringness, he must, beyond that, be able to retain his main idea unwaveringly during the time (weeks or months) of the carving. This needs a peculiar equipment. Easily diverted, flittering quickness of mind is small use.

When a man has all these qualities, vividness or insight, poignancy, retentiveness, plus the energy, he has chance of making permanent sculpture. Gaudier had them, even to the superfluous abundance of forging his own chisels.

162

For the rest, circumspice! I can but record the profundity of the cry that came from the Belgian poet, Marcel Wyseur, on first seeing some work of Gaudier-Brzeska's: 'Il a eu grand tort de mourir, cet homme! Il a eu grand tort de mourir.'

Horace Brodzky remembered the opening of the exhibition, with Sophie wandering about amongst the twenty or thirty people at the gallery like a 'wild caged animal'.

Her clothes were begrimed with food and mud – her hair was chopped short as if she had cut it herself with blunt scissors and only when cornered by two or three old friends would she stand still – even then her eyes were darting from wall to ceiling – person to person and her conversation clipped with short sentences interspersed with mutterings and asides in different languages. We were all very sorry for her and for Henri.

The exhibition was well received. *The Times* of May 25th, 1918 reported:

Henri Gaudier-Brzeska was killed in action in 1915 at the age of 24. The memorial exhibition of his works, now being held at the Leicester Galleries, will prove to everyone that he was one of the most remarkable artists of our time. We do not quarrel with Mr Ezra Pound's statement, in his preface to the catalogue, that his death was the gravest loss which the arts have sustained during the war. The latest works shown here were executed when he was 23; and no-one can say what he might have done. He rushed through a whole career in a few years; but it was merely a beginning. The rapidity of his changes, though bewildering, is not alarming, because he happened to be born at a time when the art of sculpture was freeing itself rapidly from a dead past. You see him at first a little drawn towards the theatre against his real nature. His 'Madonna of the Miracle' is a concession to another kind of art, and to a bad example of it. It is vivid, but itself as false as that which it imitates. And his 'Russian Ballet' is not much better. There are busts, too, clever and alert, but not expressions of the artist's nature. He was evidently an artist who could make a good show of anything he was asked to do; but his own gift was for the pure music of form; and he learnt his way to that music from many things in the art of the past.

In spirit he is more Chinese than anything else. He has the Chinese power of making an animal not an imitation of any real animal, but more alive than a real one. What he gives us is the life seen with a sympathy deeper than human, he seems, like the Chinese, to assert that there is a soul common to all. And his human beings are like animals, too, not bestial, but instinctive, unconscious, and spontaneous, as if they had never known a public opinion. You feel that he freed himself of all public opinion in his art and did learn to say what he had to say without any desire to show his accomplishment, like a Chinese poet. His drawings are those of a sculptor, like the drawings of Rodin; they are lyrics in form, not merely projects. Anyone can see their beauty, and from them perhaps the public will learn to see the beauty of his more difficult works in marble. It is certainly there for all to see.

Quinn's purchases from the exhibition made it a financial success. He was invoiced in October for three pieces of sculpture: *Stags*, £260, *Birds Erect*, £100 and *Sleeping Woman*, £200.

After the memorial exhibition Sophie arranged for the Tate Gallery to have custody of some of the sculpture, and also made an offer of some drawings. Unfortunately, her lack of trust made her unable to leave any plan alone, and she created confusion by writing to Charles Aitken, the Director:

Copy of letter sent to the Gallery of Thieves
27.xi.1918                                                    To the Tate Gallery
from Wotton-under-Edge
Dear Mr Aitken
Some strange misunderstanding must have arisen from our correspondence. Sometime in August (I do not remember exact date) I had intimation that the authorities from your Gallery had called at the Leicester Galleries and selected four of my brother's drawings in order to lay them before the Board of this Tate Gallery for further selection. Shortly after I wrote to you saying that you ought to have taken more than four drawings as it is so difficult to choose one or two out of a small number. I said one or two for you mentioned yourself to me that they would not take more, the members of the Board being retrograde in their judgement and tastes of Art and I, not wishing to place my brother's work with individuals or societies who do not appreciate or understand it, agreed to it.

ERNEST BROWN & PHILLIPS

WILFRID L. PHILLIPS
CECIL L. PHILLIPS
OLIVER F. BROWN

Telephone No. 6975 Gerrard.
Telegrams and Cables:
"Ofort, Westrand, London."

The Leicester Galleries,

Leicester Square,

LONDON, W.C.

*[Handwritten list:]*

191

Stags (alabaster) – £. 250 _ _ _ 1 _ 60

Sleeping woman _ " 220 _ _ 2 _ 111

O Red dancer (portland st.) " 165 _

O Seabird – (bronze) " 120 _

Birds erect (stone) " 105 _ _ 3 _ 100

Football player (bronze " 160 _

Nude of man & woman) " (white marble)/ _ 80 _

Head of major S. (plaster " 85 _

Bust of nelle B. " " 60 _ _ 4

Maternité – (stone) " 40 _

Nude of woman (bas rel. stone) 25 _

man's head [(stone] " 25

John Quinn bought *Stags*, *Bird Erect* and *Sleeping Woman* from the memorial exhibition.

To my great surprise – I received to that an answer from you
thanking me for the four drawings which I have never offered.
Some rather 'masquins' hints concerning my 'soit disant' unthank-
fulness terminated the letter.

Being fond of clear matters and logical proceedings I directly
notified you that my intention was and continued to be of offering

165

the Tate Gallery two drawings – I added that if you cared to take one personally, I should offer it for your individually rendered service (sending the Bas relief to Mr Lousada). This (letter) also expressed the wish to having one of the animal drawings returned to the Leicester Galleries.

Not having received any answer to all this last letter to you I notified the Leicester Galleries not to give you but two at the most three of the drawings (the third – if you wished it for yourself). The Leicester Galleries wrote in October telling me that the Tate Gallery called again and took the four selected drawings.

When I reproached them having acted against my wishes and will they answered saying that – a letter of authorisation was produced to them and on its basis they delivered the drawings.

How is that!? I have never written you a letter of authorisation unless it was the note asking for delivery of sculpture sheltered at the Gallery and written last Spring.

I do not wish to draw inferences from this affair – I only know that it is not pleasant to be treated slightly – when one has not any reproach to make oneself for having dealt unfairly.

I do not sell any of the best drawings under £15, good animal drawings £20. So if I give the Tate Gallery £30-40 for the space occupied by my brother's sculpture it will be quite an adequate reward for the hospitality granted. Had it not been that I wished to see it sheltered safely I would have escaped unpleasantness and voluminous correspondence by putting it into a private house where the Stags and many others have been kept.

In expectation that this will make the matter clear and finally ended.

Yours truly,

S S Gaudier Brzeska

Aitken replied in early December, apologising for the misunderstanding and informing Sophie that two drawings, *The Elephant* and *Study of a Youth*, had been returned to the Leicester Galleries. He also pointed out that he felt she would have been willing, implying honoured, for them to have become part of the national collection.

This episode is interesting because nearly ten years later, when the Treasury Solicitor was dealing with Sophie's estate, it was Charles Aitken at the Tate Gallery who was approached about an acquisition. His lack of enthusiasm on that occasion may well have been coloured by

this earlier episode. Sophie scribbled uncomplimentary comments over the reply and did not respond to Aitken's request for details of Henri's life for the Gallery catalogue.

## 1919

The memorial exhibition over and this climax of her object in life past, it would have been reasonable to expect that Sophie would retreat to Wotton-under-Edge and that, with the aftermath of war to occupy the nation, Henri Gaudier would be forgotten. This was not how things turned out.

Not surprisingly, John Rodker had failed to get any reply from Sophie to his request to publish Henri's drawings. He now wrote to inform her that he would go ahead without her as he considered that he had enough drawings belonging to himself and friends for the project. In the spring of 1919 he produced 250 portfolios of reproductions of 20 drawings. The portfolio was priced 15 shillings and contained a representative cross- section of Henri's work between 1910 and 1914. The foreword gave acknowledgement to Ezra Pound, who had loaned all the drawings with the exception of one – a dancing figure, loaned by Nina Hamnett. Each portfolio was numbered by hand and a small wood block cut by Edward Wadsworth used as a decorative motif on the title page.

Dan Rider's bookshop had continued throughout the war as a meeting place for artists and writers. Sophie, even when she had left London, ordered books from him and Nina Hamnett, through her friendship with Dan Rider, had kept in touch with Sophie. The friendship between Sophie and Nina had always been tenuous. Before Henri's death, each had been suspicious of the other's relationship with him and Sophie's postcards and letters to Nina between 1917 and 1918 clearly reflect this. But her deteriorating health and developing insanity led Sophie to confide in Nina intimately at one moment, and curse her as an inconsiderate snob at the next. In her autobiography, *Laughing Torso*, Nina Hamnett describes a visit she made to Wotton-under-Edge.

She was taking a cottage in Gloucestershire and asked me to stay with her. We had a long correspondence, half in English and half in French. I went and stayed for a fortnight. She was certainly very eccentric. She agreed to pay for the food if I would pay for the

drinks – port and sherry she liked. She had a horror of the moon, and if we walked out in the evenings we had to walk either sideways or with our backs to it, as it might cast an evil influence upon us. She objected to the way I spoke and said one should speak like the working classes and not be snobbish. We had long arguments about this. In the evenings we drank our port and sherry and I did drawings of her. I slept in a top attic. There was no furniture except a rather short sofa in which my feet stuck out over the end, and one chair. Leading up to the room was a staircase. There was no door either to the room or at the bottom of the staircase, so at night she would stand at the bottom of the stairs and shout her views on philosophy and art and tell me to avoid looking in the direction of the moon, which came in through the window as there were no blinds. What with the moon and the owls hooting outside, and Sophie's raucous voice holding forth on philosophy, I felt sometimes rather unnerved.

One morning, at about three a.m., Sophie screamed up the staircase, 'If you had the chance would you have gone off with Henri?' And I screamed back, 'Yes!' After a moment's hesitation, during which I felt rather frightened, she went back to bed. She talked extremely well. She suffered a good deal from ill-health and was rather nervous. She wore very old-fashioned clothes that she had had since about 1905, and a small hat. She always reminded me of Cézanne's portraits of

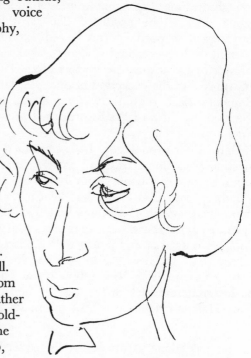

Nina Hamnett, 1913.

his wife. One day she produced a nightdress, also very old-fashioned, it was very elaborate and had real lace on it. She said, 'Would you like this, it might help you to attract men?' I said, 'No, thank you, I can do that quite well without!'

Sophie made pounds and pounds of jam, she had a mania for it. We picked blackberries and bought apples and when she rested in the afternoon I had to sit downstairs and see that it did not burn. Sophie was reading Casanova at that time, and from upstairs would make comments on his disreputable life, shouting down the staircase at me. I only intended to stay there a week, but as there were air-raids every day in London I thought I would stay on. Sophie had obtained from a park-keeper the permission to use an upstairs room in the porter's lodge, belonging to a large estate. This she rested in at the end of her walks. It was very dirty and Sophie would lie on the floor and eat nuts and throw the shells all over the floor. She came there to contemplate, and I was only allowed in on the condition that I would not speak.

Another friend, Mrs Westwood, continued to write to Sophie and give her advice about her future. She was cautious about encouraging her to visit London and equally wary of recommending that she return to Paris which Sophie was hankering to do. The letters were always generous and chatty. Mrs Westwood often copied passages from the newspapers which she thought would interest her. Writing on April 27th, she sent a critique of the London Group exhibition written by Frank Rutter, referring to Fry's portrait of Edith Sitwell, Robert Bevan's ability 'to spring surprises on us' with his horse dealers lithograph and to two 'witty Nina Hamnetts'.

Sidney Schiff, too, kept in touch. Early in January he advised Sophie to write to Otto Gutekunst at Colnaghi and Obachs in Bond Street to whom Schiff had introduced Henri's work and who he now believed might purchase some drawings. He also decided he would buy some for his own collection.

In this connection, I do not know if you remember that I told you that once Henri sent me a mass of these drawings telling me I could give him what I liked for them, but that I sent them back as I could not deal with him on such a basis. I told him that if he would price them I certainly would take some. However he was probably too busy to do so and nothing came of it. I should therefore like to

have a few examples, and if you would select two or three of those which you think best and tell me the price, I should feel very much disposed to purchase them.

In the same letter he commented on Sophie's continuing disagreement with the Leicester Galleries over payment from the memorial exhibition, advising her to press them on this.

It seems he followed this letter with a direct enquiry to the Leicester Galleries, because early in February Sophie received an up-to-date 'Statement of Sales'. This showed that total sales from the exhibition had been £868.5.3d after commission had been deducted. £50 had been paid to Sophie on January 27th, seven days after Schiff's letter to Sophie, leaving £280 still owing to the gallery from purchasers.

Slowness in settling in full by the Leicester Galleries may have been due to the failure by John Quinn to pay for the three sculptures he had purchased. *The Stags* had arrived in New York but were not in the condition Quinn expected:

Two of the items, the marble figure of the 'Seated Woman' and the 'Birds Erect' are satisfactory. 'The Stags' are satisfactory from the point of view of art, but there was not a 'crack' in them, but one of the two heads had been completely broken off and put back on and badly restored. It was a very clumsy job. You will recall the general formation of 'The Stags', the square or nearly square mass, and then the two heads, quite separate. The one head that I have referred to was completely broken off an inch or two above the plane of the mass. It was not, as you had written before, a 'crack'. It was a complete break. The head had been broken off, and, as I have said, very clumsily restored, some colored cement having been used which merely accentuates the break. From an art point of view that break is not vitally objectionable. From a business and monetary point of view, it is a distinct detriment and damage. If I had seen the thing in that condition I doubt whether I should have bought it. If I had known that one of the two heads had been broken off and so restored I do not think I would have paid the agreed price for it. As I have heretofore written to you, I never knew of any 'crack', much less break, and was not told of it even by you until after we had closed on this matter and the exhibition was over.

It took several months of correspondence to agree that Quinn should have the sculpture repaired in New York. Although satisfactorily completed, the repair remains discernible to this day because of the nature of the stone. Although the whole matter was finally settled amicably and there does not seem to be any intention on the part of the gallery to deceive, Quinn in his garrulous way had the last word: 'Your letters refer to sculptures "by Gaudier-Brzeska". You will observe that I refer to sculptures by Gaudier. The man's name was Henri Gaudier. It does seem to me to be a pity to have the good French name of a good Frenchman corrupted by any such hyphenation as Brzeska.'

The instigation of the memorial exhibition and the involvement of the partners of the Leicester Galleries, Cecil Phillips and Oliver Brown, is described from the point of view of the gallery in *Exhibition: The Memoirs of Oliver Brown* published in 1968. Brown recalls how some time after Henri's death,

Robert P Bevan, a well-known member of the Camden Town Group, whose wife was a Polish painter and exhibited under the name of S de Karlekowska [sic], asked me to come and see them in Hampstead and the question of a possible exhibition in his memory was broached. I was introduced to Sophie Brzeska. She paid us several visits at the Galleries, as also did the Bevans.

The difficulty was to find enough pieces of importance, though there were endless drawings by Gaudier. Robert Bevan did his best to help and encourage the plan. He was one of the kindest of men and always tried to help other artists though he had a family and never enjoyed great success himself.

As soon as we had arranged the exhibition we began to find many friends and collectors who had been convinced of his rare talent as soon as they had seen his work, and had managed to buy examples. We were able to assemble about forty-five pieces of sculpture, if we include small objects such as a carved tooth-brush handle, two carved toys in brass and other little pieces which we showed in a glass case.

In his few difficult years in London, Gaudier had been introduced to many kind people in the art world. In addition to his rare sculpture there were a great many drawings on the walls and a big collection in reserve. The exhibition might be called a considerable success, and appealed to collectors modern in outlook and with a sensitive feeling for sculptural form of great promise if not of actual

171

achievement. There were many discerning connoisseurs who took advantage of the occasion to secure one or two of these rare things.

This little exhibition could not claim the popular appeal which even so unusual an artist as Epstein achieved, but it drew the attention of many distinguished collectors and it was impossible for those of discriminating taste not to recognise the great promise it displayed. I wondered at the end of our showing of this small assembly of works whether it was enough in quantity, when distributed, to make a permanent reputation, but now in the 'sixties I realise that they were enough to establish his fame. After all even a genius cannot produce a large amount of sculpture before the age of twenty-three.

I spent much time in the company of his devoted companion, Sophie Brzeska, from the end of 1917, the acquaintance lasting through 1918 and continuing later on her brief visits to London from her cottage in a Gloucestershire village. She was helpful and wise about the planning of the show. She seemed a sad figure and was evidently heart-broken at the loss of her companion. She always spoke of him as 'little brother' and was convinced of his genius. In poor health, she often wrote to say that she could not make the long journey to town because of her nerves. She looked worn and rather poorly dressed and aged greatly after he left her to join the French army. Her letters, however, were practical and businesslike, and she had a satirical sense of humour. When she came first to the Galleries after I had met her with the Bevans I introduced her to my partner, Cecil Phillips. She said on leaving, 'Perhaps I ought to have done my business with that large amiable man, I always get on with those. Now you, are a small cock-sure man!' Unfortunately, she remarked, Phillips did not seem to know much about 'little brother'. I said that he had not yet seen the work and that she would not find me cock-sure, though I was undoubtedly small.

Another time much later – it may have been after the war – she arrived in the Galleries, looking shabbier and more dilapidated than usual, with an enormous brown paper bundle. I put it downstairs in the basement; it was very light and might perhaps have been filled with blankets. She said: 'You look very smart, where are you going?' I said: 'Off to pay a call in the West End. I fear I must go in a few minutes.' She said: 'I will come with you and talk on the way about little brother. Wait a moment,' and she

appeared with the brown paper bundle. We marched along towards the Bond Street neighbourhood, she carrying the nameless bundle. We had not got very far on our journey when she said, 'I should have thought that an English gentleman would carry a lady's parcel for her'. I of course apologised and seized the parcel, but I saw a twinkle in her eye and as I got nearer to my destination she took it from me and waved goodbye. I was afraid she would bring it in when I made my call.

Towards the end of our acquaintance she came into the Galleries one day looking very ill and told me that there were some things in our downstairs showroom which she must destroy because her 'little brother' would have wished it. The work which particularly roused her animosity was a painted plaster of the Madonna in The Miracle played by Maria Carmi (1913). It had been lent for our exhibition and was still in our care, though there may have been another version or a pastel study. She was determined to destroy this because it was religious propaganda and she and her 'little brother' had made up their minds to destroy things of that nature. In spite of her fierceness and the hammer she carried I spent most of the morning trying to stop the work of destruction, and I succeeded. Later still she arrived looking very wild and haggard. She said that she was going to take everything away and leave the country, as she was being persecuted. I said she could not take them away herself because there were several large pieces of sculpture including one or two plasters. She went off with a large portfolio of drawings.

Poor Sophie Brzeska had always seemed to me a clear-headed and intelligent woman, well educated and a very good linguist, but she had become obsessed by her devotion to 'little brother' and she could never recover from his loss. I am told she wrote good verse, but she never showed me any of her own poetry – though she constantly asked me to order new books of French verse for her when they could be obtained in the neighbourhood of Charing Cross or Leicester Square.

Towards the end of the year Ford Madox Hueffer published an article about Henri in *The English Review*. It followed Pound's book, which Sophie had considered a confusion of tributes to Henri and a eulogy of Pound's own ideas on art, philosophy and literature. Hueffer in his memoir also used Henri's death for his own ends, and so by December

1919, only four and a half years after his death, the creation of a Henri Gaudier myth had begun.

## ENGLISH REVIEW – OCTOBER 1919

### HENRI GAUDIER

The Story of a Low Tea-shop by Ford Madox Hueffer

### I

I do not know why it is that, when I rehearse in my ear the cadences of some paragraphs which I wish to be allowed to write concerning our dear Gaudier, the rhythm suggesting itself to my mind should be one of sadness. For there was no one further from sadness than Henri Gaudier – whether in his being or his fate. He had youth, he had grace of person and of physique, he had a great sense of the comic. He had friendships, associates in his work, loves, the hardships that help youth. He had genius and he died a hero. Who could ask for more? Who could have better things?

He comes back to me best as he was at a function of which I remember most, except for Gaudier, disagreeable sensations, embarrassments. It was certainly an 'affair', one or two, financed by a monstrously obese Neutral whom I much disliked. It was in late July, 1914. The Neutral was much concerned to get out of a country and a city which appeared to be in danger. Someone else – several someones were intensely anxious each to get money out of the monstrously fat, monstrously moneyed, disagreeably intelligent coward. And I was ordered to be there. You know, the dinner was a parade. I suppose that, even then, I was regarded as the 'Grandfather of the Vorticists' – just as my grandfather was nicknamed the 'Grandfather of the Pre-Raphaelites'. Anyhow, it was a disagreeable occasion – evil passions, evil people, bad flashy cooking in an underground haunt of pre-'14 smartness. Do you remember, Gringoire?

And I hate to receive hospitality from a person whom I dislike: the food seems to go bad; there is any how a bad taste in the mouth, symbol of a disturbed liver. So the band played in the cave that the place was, and there were nasty foreign waiters, and it was late July, 1914 . . . There were also speeches; and one could not help knowing that the speeches were directed at the Neutral's

breeches pockets. The Neutral leant monstrously sideways, devouring at once with gluttony and nonchalance. It talked about its motor-car, which apparently was at Liverpool or Southampton – somewhere where there were liners, quays, cordage, cranes – all ready to abandon a city which would be doomed should Armageddon become Armageddon. The speeches went on . . .

Then Gaudier rose. It was suddenly like a silence that intervened during a distressing and reiterated noise. I do not know that I had ever noticed him before except as one amongst a crowd of dirty-ish bearded, slouch-hatted individuals like conspirators; but, there, he seemed as if he stood amidst sunlight; as if indeed he floated in a ray of sunlight, like the Dove in Early Italian pictures. In a life during which I have known thousands of people, during which I have grown sick and tired of 'people', so that I prefer the society of cabbages, goats, and the flower of the marrow plant, I have never otherwise known what it was to witness an appearance which symbolised so completely – aloofness. It was like the appearance of Apollo at a creditors' meeting. It was supernatural.

It was just that. One did not rub one's eyes: one was too astounded; only, something within one wondered what the devil he was doing there. If he hadn't seemed so extraordinarily efficient, one would have thought he had strayed from another age, from another world, from some Hesperides. One keeps wanting to say that he was Greek, but he wasn't: he wasn't of a type that strayed; and indeed I seem to feel his poor bones moving in the August dust of Neuville St. Vaast when I – though even only nearly! – apply to him a name that he would have hated. At any rate, it was amazing to see him there, since he seemed so entirely inspired by inward visions that one wondered what he could be after – certainly not the bad dinner, the attentions of the foreign waiters, a tug at the Neutral's money-bag strings. No, he spoke as if his eyes were fixed on a point within himself; and yet with such humour and such good humour – as if he found the whole thing so comic!

One is glad of the comic in his career; it would otherwise have been too much an incident of the Elgin Marbles type . . .

## II

Of his biography I have always had only the haziest of notions. I know that he was the son of a Meridional craftsman, a carpenter

and joiner, who was a good workman, and no man could have a better origin. His father was called Joseph Gaudier so why he called himself B'jesker I do not know. I prefer really to be hazy; because Gaudier will always remain for me something supernatural. He was for me a 'message' at a difficult time of life. His death and the death at the same time of another boy – but quite a commonplace, nice boy – made a rather difficult way quite plain to me.

A message! I will explain.

All my life I have been very much influenced by a Chinese proverb – to the effect that it would be hypocrisy to seek for the person of the Sacred Emperor in a low tea-house. It is a bad proverb, because it is so wise and so enervating. It has ruined my career . . .

That meant that it would be hypocrisy to expect a taste for the Finer Letters in a large public; discernment in critics; honesty in aesthetics or literati; public spirit in law-givers; accuracy in pundits; gratitude in those one has saved from beggary, and so on.

So, when I first noticed Henry Gaudier – which was in an underground restaurant, the worst type of thieves' kitchen – those words rose to my lips. I did not, you understand, believe that he could exist and be so wise, so old, so gentle, so humorous, such a genius. I did not really believe that he had shaved, washed, assumed garments that fitted his great personal beauty.

For he had great personal beauty. If you looked at him casually, you imagined that you were looking at one of those dock-rats of the Marseilles quays, who will carry your baggage for you, pimp for you, garrotte you and throw your body overboard – but who will do it all with an air, an ease, an exquisiteness of manners! They have, you see, the traditions and inherited knowledges of such ancient nations in Marseilles – of Etruscans, Phoenicians, Colonial Greeks, Late Romans, Troubadours, Late French – and that of those who first sang the 'Marseillaise'! And many of them, whilst they are young, have the amazing beauty that Gaudier had. Later, absinthe spoils it – but for the time they are like Arlesiennes.

All those wisdoms, then, looked out of the eyes of Gaudier – and God only knows to what he threw back – to Etruscans or Phoenicians, no doubt, certainly not to the Greeks who colonised Marseilles or the Late Romans who succeeded them. He seemed, then, to have those wisdoms behind his eyes somewhere. And he had, certainly, an astounding erudition.

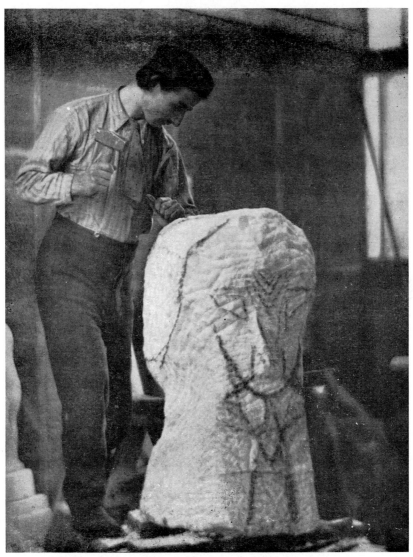

27. Henri working on the massive *Hieratic Head* of Ezra Pound, 1914.

XVII

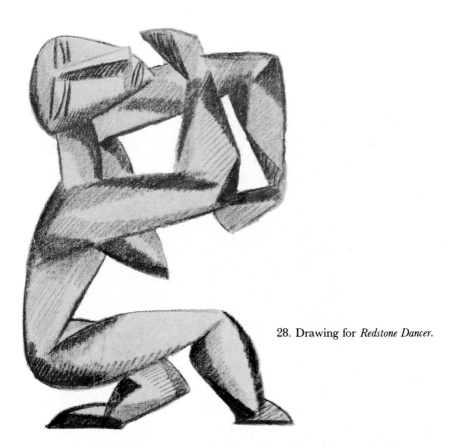

28. Drawing for *Redstone Dancer*.

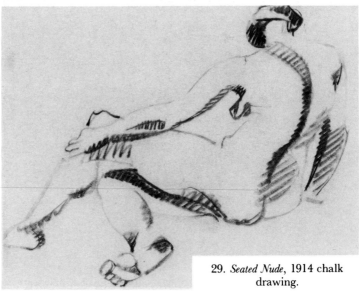

29. *Seated Nude*, 1914 chalk drawing.

XVIII

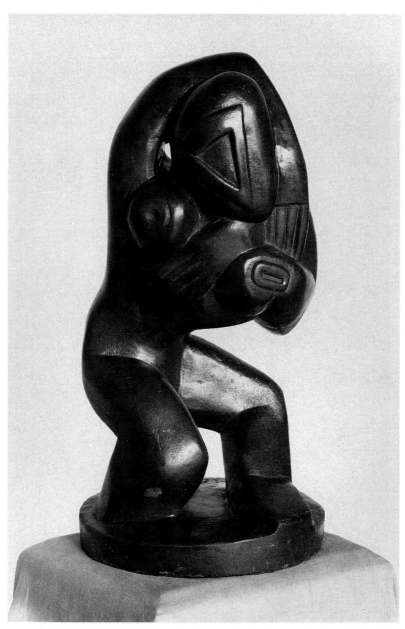

30. *Redstone Dancer*, 1914 extended Henri's language of abstraction further than he had previously dared.

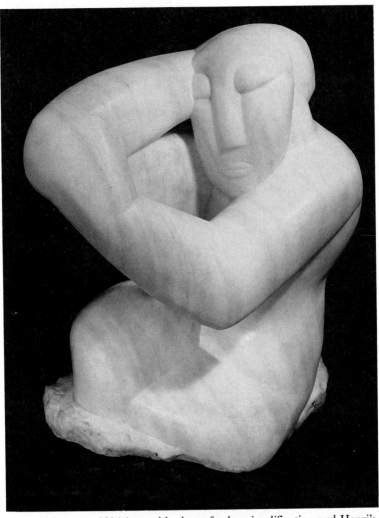

31. *Seated Woman*, 1914 in marble shows further simplification and Henri's
sensitive response to his materials.

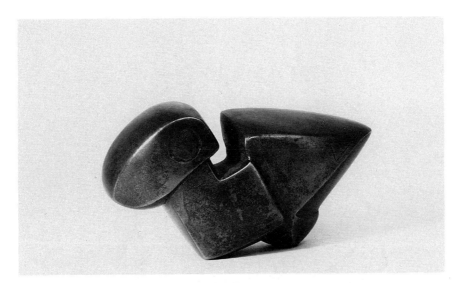

32. *Duck*, 1914 bronze.

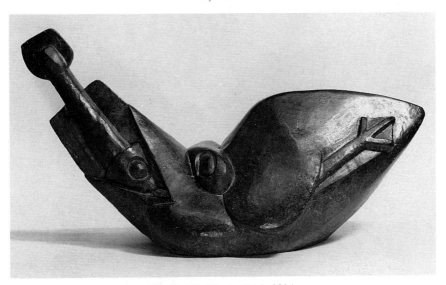

33. *Bird Swallowing Fish*, 1914.

XXI

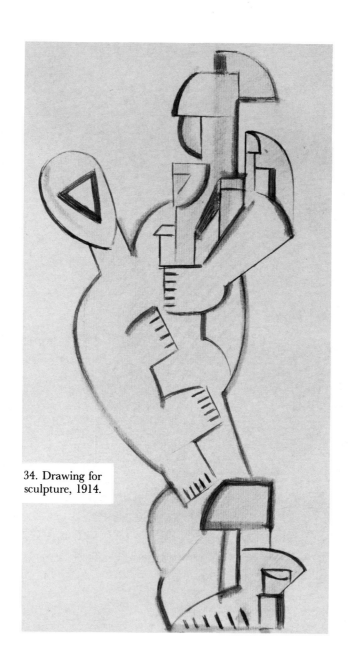

34. Drawing for
sculpture, 1914.

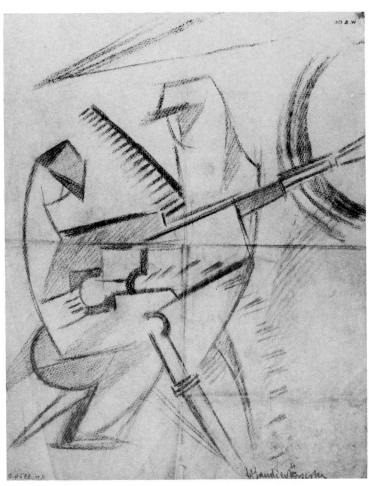

35. Drawing of machine-gunner, sent from the trenches in 1915.

XXIII

36. Henri at the back on the left shortly before his death.

XXIV

# SOPHIE

I don't know where he picked it up – but his conversation was overwhelming – and his little history or sculpture by itself will give you more flashes of inspiration than you will ever, otherwise, gather from the whole of your life. His sculpture itself affected men just as he did. In odd places – the sitting-rooms of untidy and eccentric poets with no particular merits – in appalling exhibitions, in nasty night clubs, in dirty restaurants, one would be stopped for a moment, in the course of a sentence, by the glimpse of a brutal chunk of rock that seemed to have lately fallen unwanted from a slate quarry, or, in the alternative, by a little piece of marble that seemed to have the tightened softness of the haunches of a fawn – of some young creature of the underwoods, an ancient, shyly-peopled thicket.

The brutalities would be the work of Mr Epstein – the others, Gaudier. For Gaudier's work had just his own personal, impossible quality. And one didn't pay much attention to it simply because one did not believe in it. It was too good to be true. Remembering the extraordinary rush that the season of 1914 was, it appears a miserable tragedy but it is not astonishing that one's subliminal mind should whisper to one, every time one caught that glimpse of a line: 'It is hypocrisy to search for the person of the Sacred Emperor in a low tea-house.' It was, of course, the Devil who whispered that. So I never got the sensation I might have got from that line. Because one did not believe in that line. One thought: 'It is just the angle at which one's chair in the restaurant presents to one an accidental surface of one of these young men's larks.'

And then, suddenly, one day, there was no doubt about it. Gaudier was a lance-corporal in the 4th Section, VII Coy., 129th Regt. of Infantry of the Line.

Gaudier was given his three stripes for 'gallantry in face of the enemy'. One read in a letter: 'I am at rest for three weeks in a village; that is, I am undergoing a course of study to be promoted officer when necessary during an offensive.'

Or in another letter: 'Imagine a dull dawn, two lines of trenches, and, in between, explosion on explosion with clouds of black and yellow smoke, a ceaseless noise from the rifles, a few legs and heads flying, and me standing up among all this like mephisto commanding: "Feu par salve a 250 metres – joue – feu!"

'Today is magnificent, a fresh wind, clear sun, and larks singing cheerfully . . .'

177

That was it!

But just because it was so commonplace, so sordid, so within the scope of all our experiences, powers of observation and recording, it still seemed impossible to believe that in that particular low tea-house, there were really Youth, Beauty, Erudition, Fortune, Genius – to believe in the existence of a Gaudier. The Devil still whispered: 'That would be hypocrisy!' For if you wouldn't believe that genius could show itself during the season of 1914, how could you believe that, of itself, inscrutably, noiselessly, it would go out of our discreditable world, where the literati and the aesthetes were sweating harder than they ever did after le mot juste, or the line of beauty, to find excuses that should keep them from the trenches – that, so quietly, the greatest genius of them all would go into that world of misery. For indeed that was a world of misery.

And then I read:

'Mort pour la Patrie.

After ten months of fighting, and two promotions for gallantry on the field, Henri Gaudier-Brzeska, in a charge at Neuville St. Vaast, June 5th, 1915.'

# 6

The remaining years of Sophie's life are shrouded in obscurity. Her further contacts with the Leicester Galleries were simply to demand money from the sale of drawings. She had responded to a request for more drawings by naming a price of £28 each, which the gallery told her was out of the question.

She was still anxious about outstanding payments, and at the end of 1920 Oliver Brown wrote saying that the few pounds owed to her would be paid before the New Year.

To escape the 'persecution' at Wotton-under-Edge, Sophie spent July and early August 1921 in rooms in Margate. She stayed at 41 Marine Parade, fell out with the landlady, accusing her of spying, and moved on to other lodgings. She wanted the sea air but hated the people, and consequently upset other residents with her mutterings and furtive glances. Her sanity fluctuated: when she was at her best she was calm, polite and diffident but this changed 'at a moment'. The Bevans' letters from her, together with the few intelligible lines in her 'Cherè Memoire' show how volatile she was – one minute content with the sunshine, the next cursing the moon, one day walking on the beach dreaming about her 'little brother', the same night imagining that men she had seen from her window were pacing up and down the street lusting after her.

Sophie returned to Wotton, where her violent depressions became more frequent. Late in 1921 letters from old friends such as Mrs Westwood begin with 'It is a long while since I heard from you. I hope nothing is the matter'. There was a great deal the matter but no-one could get close enough to help her. Winter months dragged by and her emotional state became more and more erratic; at one moment she wanted to purge everything, scrub everything, the next she seemed to luxuriate in squalid filth. She had constantly dreamed of a way to 'escape' to France or Poland and on April 13th wrote a second letter to the Polish Consul General in London.

In reply to your letter dated April 7th, I enclose a photograph which is the only one in my possession and which I have been compelled to have taken in spite of my difficult circumstances. I offered this photograph as a souvenir and cannot understand the

179

reason and on what grounds the English authorities are withholding it. Also I cannot see any fundamental reason why I should submit two photographs on demand for the passport.

I am absolutely not guilty in front of anyone, I am of un-blemished honesty which I can prove has been true throughout my life – it's the English – here in the country who illegally have made my life difficult ever since I arrived . . .

So dear Sir, quite openly and for the last time I am telling you that it is your duty to help me to get out of the country (I demand it) before the damned English rob me of the wealth which was left me by my adopted brother – friend.

I curse England and everyone who has committed the crimes of Satan against me. Oh God my God you defended me all this time I pray you will do in the future.

Sophie cannot have known how prophetic her words were. What wealth she had was the residue of her savings and the considerable income she had received from the memorial exhibition. She wrote in the same desperate manner to the Leicester Galleries on August 15th.

I must notify you – that it will be quite impossible for me, for some time to come, to fetch the WORKS OF ART which I left in your custody. This – for the simple reason – that I find myself kept in England as a kind of state prisoner. I went to Southampton last time – but was not allowed to enter on board of the ship and had to come back here again – for how long – God only knows for – it is from this justice – I am awaiting my liberation – suffering as I am for crimes committed by those – who thus dare keep me against my will – though absolutely and completely INNOCENT. I must request you – to continue keeping the above mentioned stores of Art until I am able to take them away.

Her diary reveals how difficult it was for her to be rational about anything. She now felt persecuted and trapped, and like a caged animal saw escape as the only solution, escape anywhere and at any price.

Sidney Schiff kept in touch with Sophie through the years after the memorial exhibition and he and Nina Hamnett and Mrs Westwood remained the only continuing thread from her life with Henri. Schiff frequently sent her books and asked her opinion on them as they shared a taste for European literature. He declared 'we greatly value your

opinion about books'. His letters were considerate and concerned with her situation and he tried to bolster her spirits by keeping her informed and involved. He was possibly not the best correspondent she could have had, as he also was subject to deep depression. His letter of July 1st, 1920 gives an insight into his own current mental state. How much he was aware at this time of her turmoil is unclear but subsequent correspondence enlightened him:

> Lately I have been reading a great deal of Remy de Gourmont's 'Promenades litteraires'. I wonder why I never realised before what a remarkable man Remy de Gourmont was. But there are so many things I seem not to have realised until recently. I have also been reading Mallarmé and Baudelaire. I don't think I have ever heard you say how you regard them. I have also re-read – for about the sixth time – C K Huysmans 'A Rebours'. These morbid sort of people appeal to me in my present mood very much. I am thoroughly morbid myself and I like the society of morbid people. But as I have the society of nobody at all, except the least morbid creature in the world, my own dear wife, it is, perhaps easy to say this. I am convinced, however, that only morbid people understand certain things. I detest so-called healthy minded people, – at least I don't detest them; I detest their minds. The mind that has no disease is a mind that has experienced nothing at all. The mind must get diseased if it has been used. Old age itself is a disease, and a disease we die of. How is the mind to avoid contagion except when it is the one part of the human organism which is not used, – generally the case with the cosmic excretion called mankind.

But as her mind struggled for a way out, her daily routine continued. Sophie's diary in late August degenerated to unintelligible ramblings and her very last coherent entry was in late August. It described how she was cleaning some salad for a meal. As usual she had added a little soda to the water for special cleanliness; as she was doing this she looked out across her garden and out in the lane at the bottom of the garden was her neighbour, a middle-aged man, asleep. He was sitting on a chair, his face covered by a newspaper. Sophie took this opportunity to creep out and empty her slops in the drain by his chair. He awoke suddenly and with the description of his violent anger, Sophie's writings make sense for the last time.

It can perhaps be assumed that after she wrote that account, this

neighbour and others could take no more and were determined to prevent further disturbance. Events were now moving to an inevitable conclusion. Sophie's response to his letter must have alerted Sidney Schiff to her problems, real and imagined, with her neighbours, for he took it upon himself to try to protect her, writing to the Chief Constable of the Gloucestershire Constabulary.

This well meant intervention seems to have led to the involvement of officialdom, already alerted by the immediate neighbours themselves. From then on, the authorities kept a watching brief on Sophie's rapidly deteriorating mental state and the inevitable worsening of her relationship with the inhabitants of Wotton-under-Edge. It was not the persecution that Schiff had been led to believe. Sophie's paranoid state of mind was tragically evident in a letter she wrote on July 11th, 1922.

The Secretary at Home Office
Chief Scoundrel and Ruler of a damned race
Notice 2nd
Mlle Zofia Brzeska
Otherwise known as Mlle S S Gaudier Brzeska hereby gives notice 2nd and last that she wishes and ardently desires to leave this doomed hell of an island and will persist in her wish until she has been let free to leave it without having to undertake any more fruitless journeys. M'lle Zofia Brzeska adhering to the God's Rhythm in pair contrary to the devils Rhythm of impair numbers expects not only to leave this country in August next about the 10th but awaits to have all her journey expenses to Paris paid by the English government as well as £8000 (eight thousand pounds sterling) of damages for lost times injuries sustained etc etc.

In case the English government should fail to let go now and prolongate her stay until October £16.00 (sixteen pounds sterling) of damages will have to be paid for if time means 'moon-ey' for citizens of this country it means real gold for the undersigned. I shall not waste any more of this precious time in sending more curses I have a very 'influential Protector' and He will see to it that Justice (should) be dealt out sooner or later. In case it should be decided to stop the devils game played on me and let me go I require at least a week's notice before my starting for the journey.

The sum to be paid for damages would have to be placed in my name at the Credit Lyonnais in Paris and I notified of the deed accomplished.

All these details are being given at this occasion in order to avoid any further correspondence on the matter, plaintive having already lost too much time in elle correspondence without respondance in journeys most unpleasant etc etc. She understands very well that the devil, chief ruler of England has to be pleased and so on. But it must be meant only for his subjects and faithful adherence to whom the undersigned shall never belong nor be counted to.
Signed: Zofia Brzeska (S S Gaudier-Brzeska)

Mlle Zofia Brzeska protests also with utmost energy against her being considered a state prisoner and her communications with friends and relatives abroad being cut and interrupted. SGB

On November 9th, 1922 she was taken from the cottage and incarcerated as a pauper lunatic in the County Mental Hospital at Gloucester. The officer in charge of the asylum recalled that 'Miss Brzeska was a very bad case indeed – during the three years she was with us we were unable to elicit any reference to her past life.' To them, she was no more than a cursing, violent woman, and yet the pages of her diary, with all her private thoughts and childhood memories, were available to provide an insight into her behaviour. The hospital authorities apparently failed to enquire who Sophie was and why she was in such a dire situation, and when it emerged that she was a woman of property and an Official Receiver was appointed, nothing was done with that money to help her.

Sophie's last known contact with the outside world was a visit the following month from her landlady, who wrote to Sidney Schiff, 'I waited in the hall, when there came our fine young woman, rushing down the stairs, so fast that her two keepers could not keep up with her. She had tied her shawl around her face so I should not know who she was and when she came up to me she started to scream . . .'

Henri Gaudier and Sophie Brzeska had met nearly fifteen years earlier. He had been killed in battle and she had died homeless and insane. Before and after Henri's death Sophie lived only through him, ultimately to the point of obsession. She was a sad, neurotic woman from her earliest days and was perhaps only truly herself in the privacy of her diaries. After Henri's death, she had been unable to trust anyone and had lived out a solitary life of fantasy and despair.

## SOPHIE

Had he survived the war, would Henri Gaudier and Sophie Brzeska have had a life together, and would he have been able to overcome her manic despair? Or would his searing experiences at the Front have made him strong enough to break with her? As with Gaudier's art, it is fascinating, but ultimately fruitless, to speculate on what might have been.

# Savage Messiah

# 1

S ophie Brzeska died at 6.45 p.m. on March 17th, 1925 at the County Mental Hospital, Barnwood Rural District, Gloucester. Her death certificate described her as 'Sophie Suzanne Gaudier Brzeska, occupation Authoress, aged 45 years'. The cause of death was given as 'broncho-pneumonia three days, no post mortem being carried out.' Sophie was in fact 53 when she died. She was given a pauper's funeral and buried in Gloucester City Old Cemetery.

She had been admitted in 1922, and the minutes of the Dursley Board of Guardians for December 1st of that year recorded that:

> The Clerk reported that he had ascertained that the value of the property of Sophie Suzanne Gaudier Brzeska, an inmate of the County Mental Hospital exceeded the limits of the jurisdiction of the County Court and was instructed to make application to the High Court for the appointment of a Receiver.
>
> The Clerk reported that the works of art and papers belonging to the said Sophie Suzanne Gaudier Brezeska [sic] had been removed from the cottage at Wortley Road, by the Relieving Officer assisted by Mr Close, a Guardian for Wotton-under-Edge in the presence of the Police Officer and temporarily deposited in his strong room which was approved.

Later, on December 15th, 1922, 'The Clerk having reported in the case of S.S. Gaudier Brzeska, a lunatic, he was instructed to apply on behalf of the Board of the Master in Lunacy for the appointment of a Receiver of her property.' At the time of Sophie's admission, it had been incumbent on the Board to establish the value of her possessions in order to handle her affairs. The limit of the value of property set within the jurisdiction of the County Court in 1922 was £500 for equity and remained so until 1934. Any estate exceeding that amount had to be referred to the High Court. An affidavit was therefore drafted and sworn by Ellen Meek, the Relieving Officer, 'in support for appointment of Receiver duly appointed by the Guardians to enquire into the affairs of the patient.'

Extracts from the affidavit read:

So far as it is possible to ascertain the patient has no known relatives living. The patient is of the age 40, 45, 50 [handwritten margin note: 'One passport makes her 45, another 50, the reception order says 40 . . . say 50, no doubt correct.']

The patient is now living at the Gloucester Mental County Hospital where she was taken on the 9th day of November 1922 and is at present detained there as a pauper lunatic chargeable to the Guardians of the Dursley Union, Gloucester.

As far as can be ascertained the patient appears to be possessed of some means and the sister by adoption of the late Henri Gaudier, French sculptor of distinction who was killed whilst serving in the French Army in 1915 and the patient is believed to have inherited his works of art. At the time of her removal she lived in a furnished cottage at Wortley Terrace, Wotton-under-Edge, Gloucestershire and as the cottage was entirely unoccupied from the date of her removal to the Asylum the Guardians authorised the transfer of various sealed boxes found there to the strong room of Mr Reginald Penley, solicitor.

A schedule of assets was attached to the affidavit:

## The Schedule Part 1

| | |
|---|---|
| Standing to the patient's credit on deposit account at the London Joint City and Midland Bank Bristol | £660 |
| Ditto Lloyds Bank Wotton-under-Edge | £8.2.0 |
| Fire policies or other memorandum amongst her papers for sculptures, plaster models and drawings on loan at the Victoria and Albert Museum insured for | £1200 |
| A box of drawings formerly at Wotton-under-Edge insured for | £1945 |
| Certain works of art entrusted by the patient to Messrs Ernest Brown & Phillips of Leicester Galleries, Leicester Square, for the purposes of sale value at present unknown. | |
| Clothing and personal effects at Wotton-under-Edge | £5 |
| Cash found on the patient £7.4.7 less 4 months' rent of furnished cottage paid £4 now in the hands of the above mentioned Guardian. | £3.4.7. |

Note. The policies above referred to were found by the applicant's solicitor but have lapsed and he has accordingly arranged for them to be covered in the Sun Insurance Office and seeks reimbursement of the amount paid for their protection. The said Reginald Herbert Penley is also desirous of being relieved of the various boxes in his custody so deposited with him as in Paragraph 6 of this my affidavit is mentioned.

The charge for Sophie's upkeep at the asylum was £56.2.4d. a year and she lived there for a little over two years. Setting this against her considerable assets, it is difficult to see why she was given a pauper's funeral.

The solicitor who was 'desirous of being relieved of the various boxes in his custody' had them transferred to the Official Solicitor's offices in London. Some of these boxes contained various works of Gaudier's stored with Mrs Westwood and those that had been on loan to the Victoria and Albert Museum. Others contained Henri's drawings, sculpture, plasters, books, and papers which were in Sophie's possession when she was taken to the asylum as well as her own personal effects, letters and diaries. The volume of paper and ephemera in the boxes was formidable. None of it was very clean or in any apparent order. Shopping lists were written on the backs of invitations to exhibitions, drawings were muddled up with newspaper cuttings and extracts from magazines. Because so much of it was works of art and 'inherited from Henri Gaudier, the French artist', the Official Solicitor was obliged to appoint an expert to value it.

R.H. Wilenski, the art critic, made a valuation for a fee of two guineas (subsequently increased at his request to ten). He examined and classified the work at the Official Solicitor's office in January 1925, some weeks before Sophie's death. On the valuation report, he described himself as 'Art Critic, author of 'Stanley Spencer' (Contemporary British Artists Series, Benn Bros), etc., formerly Art Critic to the 'Athenaeum', contributor of art articles to 'Observer', 'Nation' and 'Athenaeum', 'New Statesman' 'Evening Standard' 'Studio' etc. Author of 'Contemporary British Artists: Draughtsmen' (Benn Bros). Address 3, Alma Studios, Stratford Road, Kensington, W.'

Prepared as it was by a leading authority apparently well abreast of current trends, the report is startling in its sweeping statements about the artist and in its contradictions. Its particular significance, however, is that it became the yardstick for the evaluations of Sophie's estate after her death.

# REPORT

I have carefully examined and classified the works of the late Henri Gaudier Brzeska collected in the Official Solicitor's office on January 2nd., 3rd., 5th., and 6th., 1925.

They comprise some 13 oil paintings and pastels, 25 pieces of sculpture, 1630 drawings.

The artist who is usually referred to as Gaudier was never popular and never will be. But he had a small following of connoisseurs and after his death in the trenches in 1915 the limited quantity of his work in the market sensibly increased in value. Latterly I understand this value has rather decreased.

The present collection contains many things of negligible market value but many also which are on a level previously acquired by this artist's patrons. The value of the collection on the basis of the average of the prices realised by dealers in the past and the prices probably paid to the artist, is on paper I should imagine about £545. But the selling price of works of art, except in the case of pedigree works by certain Old Masters is always considerably less than their value on paper, particularly when as in this case they enter the market in large quantities. It would be unduly optimistic therefore to expect to realise £545 for this collection. It is unlikely that any one dealer would give even half that sum or that any three dealers could be found to share the collection at £100 each. If offered at public auction the lots would probably fall at purely nominal sums and realise a relatively insignificant total. But if judiciously handled it would nevertheless be possible to realise immediately something approaching £250 from sales effected from this collection in some such categories as I have arranged. It is therefore approximately at that figure that I value the collection for practical purposes at the present time.

The sizes I have indicated and the number of drawings in each category are approximate only.

I have divided the collection into the following categories:

## Class A (1) and (2)

**Paintings and pastels (1)**                                   **Approximate value**

£. s. d.

1. Large cartoon of man with mouse, 48 x 84 in
2. Head of negress 8 x 7 framed

190

3. Portrait of woman profile. Black and white spotted dress (pastel) framed 30 x 20
4. Ditto full face in bonnet framed
5. Ditto. full face blue dress 14 x 25 framed
6. Animal with hump oil 19 x 14 framed
7. Self portrait oil signed 'H.Gaudier peint par lui meme à l'age de 18 ans 16 x 12'
8. Ditto pastel signed monogram 20 x 15 framed
9. 5 Cubist drawings in pastel one framed, one mounted

13 items together        £20.

Note. No 3 not less than £15.

## Class A (3)

**Sculpture**

1. Wrestler Plaster coloured green Height 24 in. Cracked.
2. 'Chanteuse Triste' Marble standing figure with hands behind her back. Height 36 in (Reproduced Pound's 'Gaudier Brzeska', Lane 1916).
3. 'The Dancer' Redstone with triangle face. Reproduced Pound. Height 18 in.
4. 'Imp' marble. Height 15in. Reproduced Pound.
5. Woman's Head on stand. Bronze height 22 in.
6. 'Caritas' stone. Abstract group Ht. 20 in. Reproduced Pound.
7. 'Bird and Fish' bronze Length 21 in.
8. Ditto plaster
9. 'Adam and Eve' marble relief. Length 15 in.
10. 'Three figures embracing' stone. Abstract design Height 8 in.
11. Wrestlers (?) plaster relief 36 x 30 inches.
12. Toy flenite. Abstract design of bird. length 6 in.
13. Toy cut brass. Abstract design length 7 in.
14. 12 other pieces

About 25 items together        £120.0.0

Notes No 2 not less than £40
           3            £15
           5            £10
           6            £15
           7            £15
           8            £20

'Riders in the Park' drawings which Wilenski valued at fifteen shillings [75 pence] each.

## Class B

'Riders in the Park' drawings
some 40 drawings, unsigned, 5 on 3 mounts, the rest unmounted,
depicting riders in Hyde Park.
40 items together                                         £40.0.0
*Note* Average for a single drawing 15/-

## Class C (a)

Signed animal drawings mostly 15 x 10
Five items together                                       £15.0.0
*Note* Average for single drawing £3.0.0.
Drawing of Tiger in frame (reproduced Pound) not less than £5.5.0.

## Class C (b)

Signed figure drawings various sizes
26 items together                                         £40.0.0

## Class C (c)

Signed designs for sculpture various sizes.
Four items together                                       £10.0.0
*Note* Average for single drawing £2.2.0.
The large drawing of man on horse not less than £5.5.0.

## Class C (d)

Miscellaneous signed drawings
24 items together                                         £40.0.0
*Note* Average for single drawings £2.2.0

## Class C (e)

Miscellaneous signed sketches
various media mostly 10 x 7 in
100 items together                                        £30.0.0
*Note* Average for single drawing 12/6

193

## Class D (a)

Unsigned figure drawings
21 items 12in x 8in.
32 ditto 10 x 7 in.
455 do. 15 x 10 in. [later amended in ink from 455 to 800]
Together some 508 items £60.
*Note* Average for single drawing 7/6

## Class D (b)

unsigned figure drawings of various sizes
some framed and mounted.
40 items together £20.0.0

## Class D (d)

Unsigned animal drawings
9 items various sizes mounted and framed together £15.0.0.
*Note* Average for single drawing £2
137 items unmounted together £60.0.0
*Note* Average for single drawing 15/-

## Class E (a)

Miscellaneous unsigned drawing various sizes
37 items £15.0.0
*Note* per drawing 15/6

## Class E (b)

Miscellaneous unsigned drawings and compositions
mostly 15 x 10
90 items together £30.0.0
*Note* Average for single drawings 10/6

## Class E (C.1)

Miscellaneous unsigned drawings in folder
Marked 'Dessins de Pik' 1912

Drawings like these were valued at twelve pence each as a job lot.

25 items together   £2.10.0
*Note* Average for single drawing 2/6

## Class E 9 (C.2)

Miscellaneous unsigned drawings small sizes
220 items together   £15.0.0
*Note* Average single drawing 2/6

## Class E (C.3)

Miscellaneous unsigned drawings mostly
in coloured chalks two on mounts
29 items together   £2.10.0
*Note* Average for single drawing 2/6

## Class E (C.4)

Miscellaneous unsigned drawings
small sizes
200 items together
*Note* Average for single drawing 2/6   £10.0.0

## Class F (a)

Unsigned designs for sculpture mostly cubist in style. Some quite abstract.
large sizes
67 items together   £15.0.0
*Notes*: 'Man and horse' framed (Reproduced Pound)
not less than £3.3.0
'Figures wrestling' (Reproduced Pound)
not less than £3.3.0
Average for other single drawing 15/-

## Class F (b)

Folder containing abstract sketches and studies small sizes
62 items together   £5.0.0
Note Average per drawing 2/6

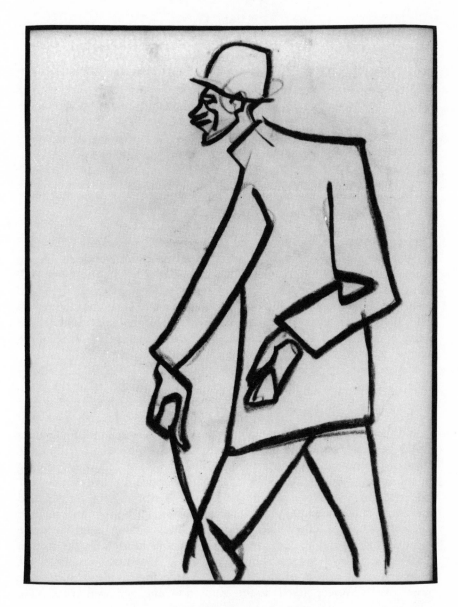

Worth a few pence, according to Wilenski.

## Class G

Pornographic drawings
71 items Value negligible

## Class H (a)

Several sketch books Value negligible

## Class H (b)

Various reproductions, fragments or oriental sculpture and pastel land-
scapes and so on, all by other hands. Value negligible.'

There are contradictions in the values placed on the categories classified
by Wilenski and on single items. In Class A1 & 2, thirteen paintings are
valued at £20, but one of these alone was put at £15. The Class A(3)
group contained the major works of sculpture, but Wilenski adjudged
twelve of them worth less than ten shillings each. Even within the report
itself, there are glaring inconsistencies, with questionable arithmetic and
pieces of sculpture residually valued at substantially less than some of the
named drawings.

The extraordinary feature of this report is that Wilenski had clearly
done his homework, and no doubt checked on the prices at the 1918
memorial exhibition (where *Redstone Dancer* was priced at £160, against
his later valuation of 'not less than £15'). He quite rightly says that
should such a quantity be precipitated onto the market, individual values
would be heavily discounted. It has to be remembered, too, that the
value of the pound fell sharply during the war years, recovering during
the nineteen twenties. Allowing for this, Wilenski's valuation still bore
little relation to the prices paid for Gaudier's work in the market and
was about one twentieth of the amount for which Sophie had insured
the work when in store. The Gloucester affidavit had listed sculpture
and drawings at the V. & A. and other places as insured for the sum of
£5,000 [in today's money about £140,000]. This was work from the
memorial exhibition and one can assume that the insurance value was
based on the prices asked at the exhibition and achieved when sales
were made.

Six days after her death in March, 1925 Sophie was buried in a
pauper's grave. Wilenski's valuation had been made in January. The

Dursley Board of Guardians who were responsible for her burial, had instigated the affidavit three weeks after her incarceration in 1922 and had established that she was a woman of property. There was no reason for her to be buried in an unmarked grave. At the moment of her death all her possessions and papers had in law become the responsibility of the Treasury Solicitor. There was sufficient time for the Board to communicate with his office, as was their duty, and for adequate provision to be made towards the cost of a proper funeral and burial.

# 2

On Sophie's death her estate, worth something over £750 [equivalent to well over £20,000 in the mid-1990s], was transferred from the Official Solicitor to the Treasury Solicitor. One of his duties was to establish whether there were any next of kin or other claimants on the estate. Advertisements to alert any possible beneficiaries were inserted in four newspapers in late 1925, *The News of the World*, *The People*, *The Daily Chronicle* and *The Citizen* in Gloucester.

Although the Treasury Solicitor was handling the estate of a deceased intestate foreigner, the inheritrix of another foreigner's property, these were the only papers in which advertisements were placed. Nothing appeared in any Polish or French newspapers. Not surprisingly no appearances were entered and grant of administration was made on April 20th, 1926.

The Gaudier family in France had had no news of Henri's life in London except from his last letters written from the Front. They had little idea of what was going on until Ezra Pound wrote to Germain Gaudier in 1916, with a copy of his newly published *Memoir*, following it two years later with the catalogue of the memorial exhibition containing his eulogistic preface. These unexpected gifts must have impressed them, while opening up again the grief for their great loss. Here was a splendidly bound and illustrated volume devoted solely to Henri and his work, and an exhibition catalogue of more than a hundred items. They had no idea that he had created so much, nor received so much attention from the art world. They began to ask themselves questions. What had become of all this work? Had some or all of it been sold at the exhibition? If so, who had the money? What was Sophie Brzeska's part in all this? If their son was so famous and successful why had they received only the trunkful of personal effects from England which T.E. Hulme had sent them? Why had no one contacted them about returning Henri's work? Germain Gaudier was furious when he saw the title on the book: Henri Gaudier-Brzeska. He described himself 'as a character so violent that I was unable to reply to Pound with a clear conscience'. Why was their name associated with that of Brzeska? 'My son was never married to that person, that I know.' This was only one of many aspects of the affair that Germain Gaudier refused to accept.

At the end of the First World War, an American sculptor was working in Orléans. John Storrs, born in Chicago in 1885, had travelled to France to study with Rodin and others and had subsequently settled there with his American wife. They had met the Gaudier family and knew about Henri because Père Gaudier had presented the Orléans Museum with some early drawings and the first portrait Henri had made. The bust was of his father, worked during the fateful visit to St Jean de Braye in 1910. Storrs also knew Pound's *Memoir* and the catalogue which Henri's father had proudly shown in the museum. Mrs Storrs wrote to Ezra Pound on behalf of the family. The news that Sophie had inherited all the work and was now dead prompted the family to consult with their avocat, M. Barbier. In May 1925, Barbier wrote to Pound, who was then living in Rapallo, seeking more information. Before contacting a London lawyer, he would need more details: where Madame Brzeska was living at the time of her death; the exact date of her death and whether or not a will existed.

There is no record of Pound's reply, but someone informed Barbier of the newspaper advertisements seeking claimants on Sophie's estate. He wrote to the Treasury Solicitor in January 1926: 'I have read the insertion that you have made in the newspaper that you are looking for a family Gaudier; I believe I am able to give you all the information you would find useful for your research. The family GAUDIER lives in Orléans and are my clients. I would be obliged to you if you would inform me precisely what you wish to receive relating to the inheritance.'

The Treasury Solicitor replied that '. . . very little is known in the Department as to the antecedents of the above named deceased, who is said to have been a spinster, 43 years of age at the time of her death. She was an authoress. It is open to any person claiming to be of kin to her to submit the necessary evidence in support of such claim which should, in the first instance, consist of a pedigree showing the relationship claimed between the person claiming and the person he or she thinks to have been the deceased; together with certificates in support of each maternal marriage and birth shown on such pedigree, and evidence identifying his or her relative with the deceased.'

Nothing came of the family's enquiries. The Treasury Solicitor was interested only in Sophie, and the Gaudiers knew nothing of her background. It was their son's estate they were seeking, and they knew nothing of his having bequeathed it to Sophie. They felt certain there was no marriage certificate, though, and their anxiety persisted.

The Treasury Solicitor's advertisement prompted one further response,

from a Mrs Gilling, by now living in Dursley, Gloucestershire but with whom Sophie stayed in London when making the final arrangements for the memorial exhibition. She wrote on January 7th, 1926:

> I see your advertizing for relatives of Mlle Gaudier Brzeska. As I have been her friend and confidante for several years, I know more about her than anyone. She did tell me that she had a small property about 500 miles from Warsaw but as she had been away from there for about 30 years she supposed it was no longer hers. When she left the place there was an old aunt who she lived with that had the place and she had no doubt that she was dead by now. Mlle was a self made woman and what money she had was earned and she wanted her manuscripts published *in French* as she considered they ranked with the old masters. I suppose you know she was denied the admittance to France owing to trouble with the young sculptor, whom she told me she used her money for his lessons. After discussing the refusal of being allowed in France, she decided she would like all the works of art she possessed put in a museum in Poland with a plaque telling she was the Author of what her writings consisted.
>
> According to her own statement she belonged to the peasantry class. She educated herself and she has no relatives. She was the only child. Her father and mother both died when she was a child. Like herself, she had a cousin who died insane. During the time Mlle was in London exhibiting the Gaudier Brzeska collection at the Leicester Galleries she stopped with me. I think she was with me some weeks nearly 6 or 8, and I feel I ought to be compensated for that time. If you could see a Mrs Westwood of 369 Fulham Palace Road, Fulham she would tell you 'twas through her that I met Mlle: I have considerable correspondence I believe in storage which is impossible to get at! I don't believe it would help to throw any light on what is wanted, further than what I have written. She was negotiating for sales for some sculptory. Mr C Aitken of National Gallery of British Art I believe knows about the works. I could tell if I saw them. This is badly written as I have had to write standing up and using a window-sill. Please let me hear from you.

Mrs Gilling was compensated for the cost of her lodgings at the rate of 2/- per week. More interestingly, her letter provides another insight into Sophie's romanticising about her origins.

# 3

The events which now followed determined the future of Gaudier's estate. This turned on the fact that the person who had been in possession of it was now dead, and had died intestate without any known heirs. The nation was therefore the beneficiary, and sculpture and drawings had to be offered to a national collection. To this end, the Treasury Solicitor contacted the director of the National Gallery, Charles Aitken, in April, 1926. Aitken was unenthusiastic about Henri's work, his attitude no doubt influenced by the earlier confrontation with Sophie Brzeska. He was, however, duty bound to carry out the request of the Treasury Solicitor that the work be shown to the Board of Trustees for their consideration.

On April 27th 1926, five weeks after Sophie's death, the Treasury Solicitor, Dr A.V. Brown, arranged for Messrs. James Bourlet and Sons to collect all the works held at the Official Solicitor's office and deliver them to the National Gallery's Modern Art Department (later to become the Tate). Reflecting a marked lack of urgency on someone's part, it was five months before Aitken confirmed, on October 4th, that the Gaudier estate had arrived at Millbank. Much seemed to be 'mere' personal effects. 'I do not think there is a great deal worth offering to galleries. Most of the stuff is very slight and rather mannered though clever.' He asked Dr Brown to make a special visit to the gallery to examine the collection. Brown failed to appear on either day suggested by Aitken, so Aitken wrote again suggesting other dates and began to get tetchy about the delay. 'As your secretary rang me up about them, I thought the matter was more or less urgent and got them all placed out and as they are out and occupy a good deal of space I think we had better finish the matter off.' Obviously finding the whole business rather tedious, Aitken wrote yet again on October 26th:

My Board meets on Wednesday, October 27. Could you let me know whether I am authorised to offer it any sculptures or drawings by Gaudier Brzeska? (subject to any claimant eventually turning up) I do not think my Trustees are likely to want more than 1 or 2 pieces of sculpture and, perhaps, half a dozen drawings, even if they decide to accept some.

Have Messrs Brown & Phillips decided about an exhibition?

I should be glad if the whole collection could be removed as soon as convenient, as it rather fills up our room.

The Board minutes show that the authority to offer the drawings and sculpture was forthcoming and by October 29th, Aitken had shown his trustees a selection. Much to his surprise, they had decided to accept some and he wrote accordingly:

They were more favourably impressed by the collection than I had anticipated and felt it should be examined at greater leisure than was possible at the Board meeting. They would be obliged there-fore, if you would allow the collection to remain here for the present and they will try to come in and make a selection before our next Board meeting on November 24th.

The Contemporary Art Society is probably meeting here on November 25th and, with your permission, I would also put a selection out of the collection before it for distribution to public galleries.

I discussed the offer made by Messrs Brown & Phillips with some of my Trustees and they thought it should not be accepted at present.

The sale value of such a collection depends, doubtless, a good deal on the skill and work put into disposing of it, but circum-stances having put the collection at the disposal of the nation, my Trustees felt that such a low offer should not be accepted if, as seemed probable to them, a portion of it would be of interest for public galleries. They wished, therefore, to make a more careful and leisurely examination of it before you came to any decision.

The Minutes of the Trustees' November meeting recorded that they had made 'A selection of 3 pieces of sculpture, 'The Singer' (stone), 'The Dancer' (red stone), and 'Imp' (veined alabaster) and seventeen drawings from the late Gaudier-Brzeska as a permanent loan from the intestate estate of the late Miss Gaudier-Brzeska through the Treasury Solicitor.'

Aitken's next letter to Brown, on November 27th, gave the details and proposed a further selection. It shows a considerable shift in Aitken's position from the earlier letter in which he said that he did not think 'there was a great deal worth offering to galleries':

My Board at its meeting on November 24th considered the selection made from the Gaudier Brzeska collection and decided to accept three pieces of sculpture and 17 drawings – 13 unframed and four framed.

My Trustees wished me to express their thanks to the Treasury Solicitor.

I enclose a list with the titles as far as I can give titles.

My Trustees understand that the offer is that of a permanent loan, practically amounting to a gift, if no heir to Miss Brzeska's estate makes a claim, but perhaps you would instruct me as to the exact formula. This will affect the titles put upon those exhibited. Are we to say 'Lent by the Treasury Solicitor'?

The Contemporary Art Society held a meeting, at which Mr Meiklejohn was present, last week in the room where the Gaudier Brzeska Collection was and the Committee expressed its willingness to make a further selection of sculpture, paintings and drawings, which it would be ready to select with a view to lending and eventually presenting to other galleries than the National Gallery.

If you are willing for this to be done, I will ask the C.A. Society to make such a further selection before you remove the rest of the Gaudier Brzeska collection.

From Aitken's earlier letter, of October 29th, it is clear that Messrs Brown and Phillips at the Leicester Galleries had been invited to purchase the entire collection. Having mounted the 1918 memorial exhibition, they were the obvious first choice for the Treasury Solicitor to approach. Their appraisal came in a letter from Oliver Brown to C.L. Stocks at the Treasury on October 19th, 1926:

We have carefully considered the means of disposing of the remaining works of H.Gaudier Brzeska satisfactorily to all concerned. After the careful inspection we made of the drawings and sculpture at the Tate Gallery, we have come to the conclusion that the collection is a very difficult one to handle. We were disappointed to find that the majority of the drawings were unsaleable and almost valueless, and of the few works of sculpture, those which have any interest have been exhibited before and failed to find purchasers.

Your proposal that we should hold an exhibition of the collection as soon as we have a vacancy has had our careful consideration, but the difficulty is that in order to make an attractive and

impressive show, it would be necessary to secure some loans from various sources, as the collection as it stands is not representative of the artist's best work. We might, of course, be able to do this, but it would take time and we are disinclined to commit ourselves definitely at the present time to the date and terms for such an enterprise.

Your second proposal that we should make you the best offer we could for the whole collection has also had our attention, and it might be in the end the most satisfactory way to deal with the question from both our points of view. In mentioning a sum that we would be prepared to give, we have to realise that it is a very small proportion of the work that has a marketable value at all and that black and white drawings at the best are extremely difficult to sell. At auction they bring trifling sums even when lotted in the form of big parcels. Moreover we should have the expense of mounting, framing and cleaning the works, and, if we should ever hold an exhibition of them, some heavy expenses connected with the organization. For these reasons we are prepared to give a sum which may not seem considerable when the quantity of material is considered but which we feel sure is a reasonable one in the circumstances. We are prepared to offer £220 for the whole collection, drawings, sketches and sculpture in bronze, plaster and stone.

In the circumstances, this was a reasonable business offer. It was not far from Wilenski's valuation, and effectively became the valuation on which the Treasury was to base its selling price. The Treasury Solicitor wanted to settle the whole matter as cleanly and quickly as he could. As Oliver Brown offered the lowest figure he considered feasible – and which was uncannily within £30 of the official, flawed valuation – it has to be conjectured that he may have been privy to Wilenski's report. Although he was interested in the artist and had mounted the memorial exhibition, as a dealer he was not eager to put money into a purchase if he could handle the sale on a commission basis.

With the work chosen for the public collections, Aitken doubtless felt he had discharged his responsibilities handsomely and prepared to delegate the detailed arrangements. Aitken's assistant at the National Gallery was H.S. Ede. 'Jim' Ede, as he was better known, had been born in 1895 in Penarth, Glamorgan and christened Harold Stanley. His father, Edward Hornby Ede was a senior partner in a firm of solicitors in Cardiff. Jim began his education at Leys School, Cambridge

and later spent some time at art schools in Newlyn and Edinburgh before the outbreak of the Great War. In 1914 he joined up and was made 2nd Lieutenant (temporary) in the South Wales Borderers, winning promotion to Lieutenant in July 1915. In January 1917 he was again in Cambridge, serving in the Officer Cadet Battalion. He later served in India and spent some time in a military hospital in Egypt. He then spent a year as a student at the Slade School of Art for about a year before being appointed Lecturer at the National Gallery in 1920. His next position was as Assistant to the Director of the Tate Gallery, the post he still occupied in 1927. He had married Helen Schlapp in 1921, the only daughter of the Professor of German at Edinburgh University. They had two daughters, born in 1921 and 1924.

Ede had been privy to the discussions about the Gaudier/Sophie Brzeska estate and the approach to the Leicester Galleries. Four months before his death, Ede recalled: 'Suddenly the Boardroom table was covered with peculiar looking statues and here was Gaudier-Brzeska and nobody wanted to look at him at all.' Aitken gave Ede full responsibility for the correspondence, both in signing letters to the Treasury Solicitor and dealing with the Gallery trustees. He clearly felt the matter had been dealt with as far as policy was concerned and that his assistant was competent to report back to the Treasury and tie up the remaining ends. Ede had other ideas. His letter to the Treasury Solicitor in August, 1927 was the first step in the making of the myth of the 'Savage Messiah':

2.8.27

Dear Sir,

I have thought very considerably about the question of Gaudier-Brzeska's drawings. He was a friend of mine and of several of my friends and I should like if possible to keep his things together until I can place them where they will be appreciated. I should like to buy what remains and would offer £60 (or less if you think satisfactory!). Financially it seems to be a very risky proposition. The Leicester Galleries who are the financial authorities on G.B.'s work won't look at this lot as they say that everything that had any monetary value has been taken by the Tate or the Contemporary Art Society and my colleague here says that list is conclusive.

I arrived at my figure from Mr Wilenski's. He said that if judiciously handled it should be possible to realise £250. On his calculation the saleable value of the things taken by the Tate is

NATIONAL GALLERY,

MILLBANK, S.W.1.

2. 8. 1927

Brzeska

Dear Sir

I have thought very considerably about the question of Gaudier Brzeska's drawings. He was a friend of mine + of several of my friends + I should like if possible to keep his things together until I can place them where they will be appreciated. I should like to buy what remains and would offer £60 (or less if you think satisfactory). Financially

about £120 and by the C.A.S. £100. This leaves a great number of hasty drawings which I fear will only be of interest to G.B's artist friends who can't afford to pay for them and if you put them up for auction they will be sold in bundles at a nominal figure and then perhaps lost. There can be no one much to take them as neither the Leicester Galleries nor the Goupil will consider them.

If you decide to accept my offer I would be grateful if you would allow me to pay this month and next as I can't manage it all at once without borrowing.

Yours sincerely,

H.S. Ede (assistant at the Tate Gallery)

Ede lied about being a friend of the artist's. It would have been an unlikely friendship for the teenage Ede and, indeed, he wrote to the present author in 1968 that 'I never met Gaudier and only first heard of him 10 years after his death.' Ten years after Gaudier's death was more or less the time of his negotiations with the Treasury.

Ede describes his proposal as 'a very risky proposition', adding that the Leicester Galleries 'won't look at this lot'. This is a coloured – not to say distorted – interpretation of Oliver Brown's assessment of the collection's potential. Ede must have hoped that in winding up the estate, the Treasury would look more favourably on the artist's friends. Not that it was Henri's estate that was being settled, but the worldly goods of Sophie Brzeska. The Treasury's duty was to obtain as much from her estate as could possibly be realised. Ede's request for easy terms is an interesting footnote to an audacious correspondence.

There must have been discussions with Charles Aitken over this new turn of events. In spite of his original lack of interest, his mood had changed with the decision of the Trustees to take some of Gaudier's work. As Director of the National Gallery, his agreement was required for the final sale. Complicating the issue, the putative purchaser was his assistant, raising the question of propriety and the possible charge of what would today be known as 'insider dealing'.

The Treasury Solicitor sought clarification from the Treasury as to how to deal with this unusual application.

30th September 1927

Dear Trickett,

We are advertising the estate of one Sophie Suzanne Brzeska who died 17 March 1925 a spinster without known kin and intestate.

The deceased died possessed of a collection of sculpture and drawings by Henri Gaudier-Brzeska which, having regard to the interest from a national point of view, was lodged with the National Gallery Millbank with a view to enabling the Director, if he thought fit, to make a selection there from for the purpose of exhibition in public places.

Portions of the collection were selected by the Trustees of the National Gallery, and a further portion was selected by the C.A.S.

An offer to purchase the residue of the collection for £60 has now been received from Mr H.S. Ede, an assistant at the Tate Gallery, a copy of his letter with regard thereto is sent herewith. This offer the Treasury Solicitor as administrator of the deceased's estate is prepared to accept. In view however of the fact that Mr Ede is a Civil Servant, we should be glad to know that on this ground there will be no objection to the sale to him being proceeded with.

I believe there is a rule regarding Treasury sanctions to sales of government property to civil servants but I cannot believe it to have any application in such a case as this.

Trickett replied on October 10th that 'Treasury sanction is required in such a case and that sanction we are prepared to give, if Mr Aitken confirms that £60 is a fair and reasonable price.'

Ede seems to have got wind of the behind-the-scenes discussions and, perhaps after discussing the matter with his director, he decided to play safe. He wrote to the Treasury Solicitor on October 13th withdrawing his offer:

I hope that this will not inconvenience you in any way as my friend McKnight Kauffer is willing to take up the matter on the same terms.

I had meant to write to you sooner but Mr Kauffer is in Paris and puts off his return from day to day. He is now expected back on Monday and I have asked him to write to you making his offer.

Mr Aitken has now had the works packed so that they can remain here quite conveniently until my return from leave on November 14th if that is alright with you.

Yours faithfully,

H.S. Ede.

210

On the same day a letter was also received from Edward McKnight Kauffer: 'I understand that the Treasury will consider an offer for the purchase of the works by Gaudier Brzeska now stored at the Tate Gallery. I am willing to offer sixty pounds for all that there is there at the present moment and would be grateful if you would let me know your decision.'

Also writing on the day that Ede withdrew his offer, Charles Aitken advised the Treasury Solicitor that, as far as he could judge, '£60 is a fair price for what is left of the Gaudier Brzeska Collection, as most of the drawings are slight, and placing any number on the market would entail trouble and expense. Messrs Brown & Phillips, I believe offered £210 for the whole collection before all the best things were taken for the Gallery and the Contemporary Art Society, so that £60 for what is left seems fair.

'I understand that Mr McKnight Kauffer is prepared to offer £60 for the collection with Mr Ede's approval, and as Mr Kauffer is an outsider, I think it would be better for him to purchase the collection, rather than Mr Ede, who is an official here.

The collection is now packed up and is not in our way so the matter is not as urgent as it was . . .'

Before writing to the Treasury making the offer for his 'friend's', work Ede had discovered that Sophie had died at the Gloucester Mental Hospital and had written to ask whether any papers belonging to her remained there. The deputy medical superintendent replied that there were no papers as everything had been taken charge of by Mrs Ellen Meek, the Receiving Officer. Ede could now be fairly certain that everything belonging to both Henri and Sophie was in his office at the Tate.

He next spoke to the Treasury Solicitor on the telephone, following the conversation with a letter on October 14th in which he outlined, for the first time, his interest in the 'papers' and his purpose in wishing to have them:

With reference to your telephone call this afternoon about Miss Gaudier Brzeska's papers which you had left with me, I am now in a position to make a statement.

There are some 900 pages of closely written French entitled 'A la très chère memoire'. This is a diary of the years 1915–1922. Its interest is chiefly pathological as she was in a very highly strung state after Gaudier's death, and by 1919 was no longer what we

211

NATIONAL GALLERY, MILLBANK, S.W.1.

£ 1283

Sophie Gaudier Brzeska deceased.        October 14th 1927

15 OCT 1927

Dear Sir,

With ref. to your telephone call this afternoon
about Miss Gaudier Brzeska's papers which you had
left with me, I am now in a position to make a
statement.

There are some 900 pages of closely written
French entitled "A la très chère memoire". This
is a diary of the years 1915 - 1922. Its interest
is chiefly pathological as she was in a very
highly strung state after Gaudier Brzeska's death,
and by 1919 was no longer what we call sane. I do
not believe it has any literary value but it retains
an interest as it refers often to incidents in the
life of Gaudier Brzeska.

I am hoping later on to write a life of G.B.
and these papers would be of great value to me in
dating the various movements of his life, and I
had imagined that they would be included in the
"Gaudier Brzeska works now at the Tate".

There are also several short stories in Polish
which I have not read and some in English which have
no value or quality and which she tried in vain
during her life to publish.   There is also a short
note about the years 1911-1915 which would be of
great use to me in compiling a book about G.B.'s
life.

I should like if possible to have these papers
and make what use of them I can.  If there is any
reason against this I would suggest that they should
be burnt, as the bulk of their material deals only
with trivial affairs not worth preservation.

Yours very truly,

H.S. Ede

Ede's request to have Sophie's papers included in the purchase of Gaudier's work by his
nominee, Edward McKnight Kauffer.

212

call sane. I do not believe it has any literary value but it retains an interest as it refers often to incidents in the life of Gaudier Brzeska.

I am hoping later on to write a life of G.B. and these papers would be of great value to me in dating the various movements of his life, and I had imagined that they would be included in the Gaudier-Brzeska works now at the Tate.

There are also several short stories in Polish which I have not read, and some in English which have no value in quality and which she tried in vain during her life to publish. There is also a short note about the years 1911–1915 which would be of great use to me in compiling a book about G.B.'s life.

I should like if possible to have these papers and make what use of them I can. If there is any reason against this I would suggest that they should be burnt, as the bulk of their material deals only with trivial affairs not worth preservation.

Yours very truly,

H.S. Ede, assistant

It is interesting that Ede should recommend that the material which, in his words, would be of great value to a biographer, should be destroyed if he could not get it for nothing. On October 18th, the Treasury Solicitor's office accepted the offer of £60, adding 'I shall raise no objection to the writings referred to in your letter being treated as included in the sale to Mr Kauffer.' At Ede's request, McKnight Kauffer acknowledged this, and sent his cheque for £60.

Ede next wrote an apparently superfluous letter to the Treasury Solicitor. 'I wonder if you can tell me in what Home it was that Miss Brzeska died and at what date. There ought to be a great many more letters but I expect it will be impossible to trace them.' He already had all the information he needed about Sophie's incarceration and death. Did he want to be absolutely certain that he had everything and that no more diaries or journals would appear from other sources? Or was it to cover the fact that he had already made enquiries? An account of these negotiations appeared many years later in *A Way of Life: Kettle's Yard*, which Jim Ede published in 1984:

I think it was 1926 . . . In that same year I first heard of Gaudier-Brzeska. A great quantity of his work was dumped in my office at the Tate: it happened to be the Board Room and the only place

with a large table. It was ten years after Gaudier's death, and all his works had been sent to many experts for their opinion, and London dealers had been asked to buy. It had become the property of the Treasury, and the enlightened Solicitor General thought the nation should acquire it, but no, not even as a gift. In the end I got a friend to buy 'Chanteuse Triste' for the Tate, I subsequently gave three to the Contemporary Art Society, and three more to the Tate. It took some doing to persuade them to accept even this, and the rest, for a song, I bought.

These events had indeed taken place, but in a different sequence. It was not so much an 'enlightened Solicitor General' as normal bureaucratic procedure that brought the offer of Gaudier's work to the Tate. Nor had the final purchase itself been as straightforward as this account suggests. It had taken one or two turns before it was secured to Ede's satisfaction. But that it was indeed accomplished 'for a song' is beyond dispute.

In January, 1929 Ede was again writing from Millbank:

You may remember that in 1927 I was sent the papers belonging to Miss Brzeska & off & on during these last two years I have been sorting these and reading them. I am writing a book about the artist Henri Gaudier-Brzeska & these papers are proving useful. It seems from one reference or another that several papers, bundles of letters & other writings are missing, & I am approaching you to ask if you have any further papers of hers or whether the residue was destroyed. There were a great number of books I know. Also there was a box of sculptor's tools which the Treasury obtained with the things from Chelsea – are these still available?

They were cut & made in a way peculiar to the artist and I would be very interested to have them.

I should be grateful if you could help me in these matters & also if you have any entries could you tell me where these things came from. There were boxes stored in Chelsea, there was her house at Wotton under Edge & there was the Gloucestershire Asylum. Were things collected from all three places?

P.S. I have been saved *hours*, days, weeks of work by that last haul – a list I find, of all Gaudier B's work in order of years made by himself – I could never have found it all out myself – most useful for my book. yrs H.S.E.

*I meant to tell you also that the painting of "Oxen" mentioned in the C.A.S. list was not really chosen by the C.A.S. I put it on the list behind their backs as I thought it a pity the picture should not be preserved.*

*It would really belong to the Kauffer things & would be safer there since no claim could be made on it by possible relatives. Shall we take it off the C.A.S. list?*

Not satisfied with his £60 haul, Ede tried to claim back a painting which had gone to the Contemporary Art Society.

P.T.O. I meant to tell you also that the painting 'Oxen' mentioned in the C.A.S. list was not really chosen by the C.A.S. I put it on the list behind their backs as I thought it a pity the picture should not be preserved. It would really belong to the Kauffer things & would be safer there since no claim could be made on it by possible relatives. Shall we take it off the C.A.S. list?

215

Having public-spiritedly put a painting on the Contemporary Art Society's list 'behind their backs' to save it, Ede was now suggesting it would be safer in private [his own] hands. On the bottom of this letter Ludbrook noted: 'I told Mr Ede over the telephone that the painting could only be dealt with as he suggests if the matter were taken up officially and the necessary sanction obtained.'

The 'song' of which Ede boasted all those years later had indeed secured a formidable quantity of work. When Wilenski had examined the collection at the Treasury it consisted of nearly 1,700 drawings, sculptures, oil paintings and pastels. The Tate Gallery had chosen 17 drawings and three sculptures, the C.A.S. 18 drawings and three sculptures, making a total of 35 drawings and six sculptures. There remained 1,595 drawings, 19 sculptures and 13 oils and pastels. Dismissing 71 pornographic drawings at nil value and taking Wilenski's bottom value of 2/6d per drawing, the total value of this residue was almost £200 for the drawings alone, without taking account of the sculpture, oils and pastels. To these were added the sketchbooks, drawings, notebooks and the entire collection of Sophie's writing, including *Chère Memoire*, which filled three large trunks and five packing cases. Ede was later anxious to have Henri's tools included in the price, and he did indeed acquire them at no extra cost.

A week after his letter of January 23rd Ede wrote to Ludbrook, asking him to 'hand to bearer one box of tools & some note books on account of Mlle Brzeska property made over to Mr McKnight Kauffer'.

With publication in mind, Ede was now preoccupied with the question of ownership and copyright. Kauffer duly wrote to Dr Brown on March 2nd 1929. 'Mr Ede tells me that you have given him permission to use the Gaudier Brzeska letters and manuscripts but I think it might be better that I should purchase the full copyrights from you. Would you therefore be prepared to sell me this for five guineas with a statement that will cover me in case any possible claimant came forward in the future.'

Ede had now become stage manager. Ludbrook wrote to him to query McKnight Kauffer's request. Ede replied on March 5th, to 'Mr Chadbrooke', tying up all the strings:

I thank you for your letter and agree with Mr Kauffer that it would be best that he should purchase the full copyright of the Gaudier-Brzeska papers. They consist of a diary written by Miss Sophie Brzeska, various studies for a story and letters and notes from Henri Gaudier to Sophie Brzeska.

216

I have with the Treasury Solicitor's permission, used all these papers in writing a life of Henri Gaudier-Brzeska but Mr McKnight Kauffer thinks it is best that he should have purchased the copyright before the book is published.

If you need any further details I expect that I can supply them.

Dr Brown then wrote to McKnight Kauffer on March 8th, 1929:

*Sophie Suzanne Gaudier Brzeska, deceased.*

With reference to your letter of the 2nd instant, I understand that the writings in question consist of a diary written by the above named deceased and various studies by her for a story and, also, of letters and notes from Henri Gaudier to the deceased.

With regard to the writings by the deceased the copyright in these would appear to have passed to the Treasury Solicitor as Administrator of her estate, but it is not known whether the copyright in Gaudier's writings was transferred to the deceased although the physical property in the documents no doubt passed to her.

I am, however, prepared to sell and transfer to you such rights as the Crown may have in the copyrights in these writings for the sum of £5.5.0.

McKnight Kauffer continued to act out his part, sending a cheque for five guineas, and receiving in return confirmation from the Treasury Solicitor of the transfer of 'such copyright as the Crown may have in the diary written by [Sophie Brzeska] and the various studies by her for a story, and also in the letters and notes from Henri Gaudier to the deceased'. On July 30th, 1929, he assigned these rights to Ede.

John Rodker, owner of the Ovid Press and publisher of Ezra Pound's early work, who had written to Sophie about reproducing drawings in a portfolio, had also been on the trail. On December 21st 1926, he was asking the Treasury Solicitor about sculptures and, like Ede, claiming friendship with the dead artist:

With reference to the Estate of the late Madame Gaudier-Brzeska, I shall be glad to know if her effects have yet been sold. I am particularly interested in a piece of sculpture [this was *The Singer*] by the late Henri Gaudier-Brzeska, and you will no doubt find in the files relating to that matter a letter from myself to the Official Solicitor offering a certain sum for that piece of sculpture.

217

# SAVAGE MESSIAH

Letters should be addressed to—

THE TREASURY SOLICITOR,

*and the following reference quoted on the cover and in the letter:*

B.V.325.

*Telephone No.:* VICTORIA 8220. Extn.55.
*Telegraphic Address:* "PROCTOREX, LONDON."
*Code used:* A.B.C. 6TH EDN., 5 letter.

STOREY'S GATE,
ST. JAMES'S PARK,
LONDON, S.W. 1.

22nd April, 1929.

Sir,

### Sophie Suzanne Gaudier Brzeska, deceased.

I have to acknowledge the receipt of your letter of the 18th instant enclosing cheque for £5.5.0, and in consideration thereof hereby assign and transfer to you all such copyright as the Crown may have in the diary written by the above-named deceased and the various studies by her for a story, and also in the letters and notes from Henri Gaudier to the deceased.

I am,
Sir,
Your obedient Servant,

*July 30-1929.*
*I hereby assign all the rights pertaining to the ... described) to*
*E.M. ...*

A.W. Brown

Assistant Treasury Solicitor.

39 & 40 Vic. Cap. 18 Sec. 3 Administrator of the estate of Sophie Suzanne Gaudier Brzeska.

E. McKnight Kauffer, Esq.,
17 John Street,
Adelphi,
W.C.2.

The Treasurer Solicitor's assignment of the copyrights in Sophie's diaries, which McKnight Kauffer duly passed on to Jim Ede.

Ede, meanwhile, had persuaded another of his acquaintances to pay for the works which the Tate had selected for the collection. In a memorandum dated 28.5.30 Ludbrook noted that 'Mr Ede called, discussed offer from Mr Stoop of £150 to purchase the works at the Tate Gallery and the Contemporary Art Society and to leave all the works on permanent loan.' The Treasury Solicitor was willing to accept

£160, as that sum, with McKnight Kauffer's £60, would make £220: the figure suggested as a fair sum by the Leicester Galleries, and not far from the Wilenski valuation. Jim Ede wrote to Aitken from home on May 31st, 1930 [he had been on sick leave for much of the past year] saying he had 'fixed up the negotiations about the Gaudier-Brzeskas':

Mr Stoop has bought them all and will give them to the National Gallery for the C.A. It's awfully nice of him, I had rather a difficulty with the Treasury Solicitor and thought that all my negotiations would fail, had to be very slippy and tactful and had it not been that Dr Brown was himself friendly to it all I would not have managed it. However all that is private, and on paper they have done all they can be expected to do in the finding of a purchaser and have got a reasonable price. Mr Stoop has given £160.

The Leicester Galleries quoted £800 the other day as the present value of the 'The Singer' [valued by Wilenski at 'not less than £40' five years earlier] and the other two things are worth about £400 or £500.

I have had many people lately refer to 'The Singer' as the finest piece of sculpture in the Tate, and even Epstein the other day said Gaudier was about the most interesting sculptor who had worked in England – so he's coming into his own at last.

I am so glad you are having a good time. I've found out about the intricate ins and outs of my own case and all that seems to be straightening out and a new assistant asked for who will be junior to me.

The matter had now been concluded very neatly. The nation had been offered first choice of Gaudier's work from Sophie's estate: the Tate, as the modern art department of the National Gallery, had selected 17 drawings and three sculptures, and the Contemporary Art Society, 18 drawings and three sculptures. These had been paid for by a generous benefactor and made available on permanent loan, and an apparently disinterested member of the public, McKnight Kauffer, had made an arm's length purchase of the balance for £60. The aggregate sum of £220 was the exact figure the Leicester Galleries had been prepared to offer for 'the whole collection, drawings, sketches and sculpture in bronze, plaster and stone'.

With the subsequent sale of the full copyright for £5.5.0. the Revenue

could be said to have more than fulfilled its obligations. In the process, a substantial amount of Gaudier's life's work – as well as, thrown in for nothing, all the extant writings of his and Sophie Brzeska's – had been transferred, for just £60, into the private ownership of H.S. Ede. Included in Ede's 'parcel' were 19 of the 25 items of sculpture listed by Wilenski, as well as the items under Class H(b): 'various other reproductions, fragments or oriental sculpture'. These latter should not be underestimated, as Wilenski had shown that he was not truly conversant with Gaudier's work. There was at least one significant sculpture in this miscellaneous grouping: the relief head of Horace Brodzky which the author found in the early 1970s in a shed at Kettle's Yard. Wilenski had not listed it as a separate work, and although it appears in Henri's original list of sculpture published at the end of *Life of Gaudier-Brzeska*, it was disregarded until brought to Jim Ede's attention nearly fifty years later.

# 4

It is interesting to speculate when Jim Ede conceived the idea of writing the life of a foreign sculptor little known outside a circle of artists and collectors. Was it when 'the boardroom table was covered with peculiar looking statues' and he first saw Gaudier's work? Or when Sophie's papers were deposited at the Tate, apparently about a year later? Although he was an assistant curator of modern art, Ede does not appear to have made a critical appraisal of the work. He was more interested in the boxes of papers. Wilenski had not been given these as part of his valuation, and therefore they did not feature in his report. His brief was to value Henri's work. Sophie's papers were of no financial account, and the only interest in a pauper lunatic lay in her connections with the dead artist. And yet, without Sophie's diaries and the letters between Henri and Sophie, there would have been no *Savage Messiah*.

Ede had acquired everything he could lay his hands on: sculpture, drawings, diaries, manuscripts and letters – even Henri's tools – and, finally, the copyrights. The purchase of the copyrights was more than an after thought. It was a precaution to protect himself in the event of anyone appearing and claiming ownership, although the Treasury had to their own satisfaction established that there was no claimant.

He now had two big tasks: to collate the correspondence, and translate and edit it, and secondly to contact everyone who had known Henri and Sophie. His first letter was to Germain Gaudier, Henri's father, making general enquiries about his son. In his second letter, on November 21st, 1928, Ede asked for more details of Henri's school career. M. Gaudier provided information about the scholarships and where Henri had lodgings in England, and how after his stays in Bristol and Cardiff he had returned to France, stayed a year, but found that London 'drew him back'. He described how studious his son was and how he liked drawing but had the bad habit of destroying his drawings. 'When I told him to keep them, he replied, I have made them that's enough, if I keep them I will be tempted to redo them and that will soon harm me.'

The replies led to further lines of enquiry and the undertaking gathered momentum. Ede discovered that each person he contacted led

him to another and the picture that was building up of the strange pair began to take over his life. His preoccupation began to take its toll on both work and family. Within six months the state of affairs had come to the attention of his employers. Ede was still working full time at the Tate, but at the end of April, 1929, according to a Director's report to the gallery trustees, 'he had stated that he was unable to continue his work owing to sleeplessness and the state of his nerves'. Two doctors had reported that he was suffering from nerve strain and required a rest of from one to three months. The report continued that 'Mr Ede had been away for two months but did not appear to be much better . . . as his work had not been at all excessive for a normal person, he was probably suffering from constitutional neurasthenia.' The trustees agreed that he should be examined by the Treasury doctor 'and that the doctor should consult the Treasury with a view to finding work of a less predominantly administrative character at another gallery.' At the end of November, the Civil Service medical referee considered that Ede was then incapable of sustained work, that the probability of his ever rendering efficient service was remote and that recovery would be a matter of a very long time.

The minutes of that month's board meeting recorded that the Director had considered the medical report to be 'unduly pessimistic, in view of Mr Ede having worked eight years at the gallery, and that Mr Craig [of the Treasury] had sanctioned further sick leave up to the maximum period of six months, so that the effect of curative treatment might be tried before a final decision as to Mr Ede's returning or being invalided out of the service was come to. The Board expressed its sympathy to Mr Ede, and suggested that some post might be found for him of a librarian nature, as more suited to his capacities and condition.'

Jim Ede's health improved, and he was back at work in the Spring of 1930, having been away for about a year.

He had written to Gaudier's father again in December asking for more information. Gaudier supplied this and naively promised to send the drawings the family had kept. He added that Ezra Pound had written to him when the 'Memoir' was published, and at that time he was very rude to Pound. 'Being of a violent character I wrote some indecent remarks without thought, if I could I would now ask pardon of M. Pound. Please tell him if you know him that the Gaudier family thank him sincerely for the friendship he bore Henri.' He went on: 'But now we ask ourselves why M. Pound has associated our name with that of Brzeska. My son had never been married to this person, that I know.

222

I knew she withdrew into herself after the death of my son, she even had the audacity to ask us to address her as Madame Gaudier. I protest with all my energy against the association of my name of Gaudier with that of Brzeska.' Clearly M. Gaudier had forgotten nothing of the disastrous last visit to St Jean de Braye.

In his next letter, on July 25th, 1930 Germain Gaudier thanked Ede for the information he had sent about his son's life in London and continued:

Mlle Breska [sic] left only an unpleasant memory with me and if I had known what was to happen in London I would not have hesitated to stop it; and now more than ever; the scandal that she created here appears to me to be part of your oeuvre. We heard through the intermediary, the sculptor, Mr Storr of the death of this person. I have never been able to fathom what has become of the work left by my son, I would like to believe that you will tell me.

When he was in the sector at Craonne he wrote me a letter in which he said 'Father I ask your forgiveness for the worries that I have caused, but if I am not killed, I will return to you and my mother and never leave again.'

By October Germain Gaudier was asking Ede to 'please have the goodness' to return the drawings he had sent. In his previous letter, he had written:

You tell me in your letter that Mlle B. was alone in the world (I do not know what to think). Mlle B. told me many times that she had two brothers. One who was a captain in the Austrian army, the second a doctor of medicine (married with a small daughter). She also told me that she did not get on well with her brother, the doctor, who also lived in Austria.

She showed me a paper prepared in Paris by the Austrian Consul, so for my part she was Austrian. She probably had some reason to hide her true identity under a pseudonym. When she wrote to me telling me of the death of my son she asked and insisted that I reply to her under the name of Mlle Gaudier.

I find in all this things which are unclear, I have nothing else to say to you.

This letter suggests that Ede had not responded to Germain Gaudier's chief concern . . . 'I have never been able to fathom what has become of the work left by my son, I would like to believe that you will tell me.' Germain Gaudier was not to be enlightened by Ede, who realised he had pressed Henri's father as far as he dare without antagonizing him and without precipitating questions about his interest in his son. He left the question unanswered. This omission was to haunt him for twenty five years.

Germain Gaudier supplied a great deal of the information that Ede wanted but it was not sentimental in the way he may have hoped. Ede next approached Dr Uhlemayr. The doctor had lost all touch with Henri after his abortive attempt to visit him on the eve of the outbreak of war and his rapid return home from London. In reply to Ede's enquiries, he told him about the time Henri had spent with the family on his scholarship, how he had learnt German and was fluent in an amazingly short time:

After a mere fourteen days, he understood everything. He also spoke fluently, so that one could discuss everything with him in German. We were surprised by his linguistic talent, but his extra-ordinary talent and intellectual maturity soon revealed itself. I discussed cultural and artistic problems with him and found he had an amazing understanding. He obviously felt he was making new discoveries in his conversations with me and it seems as if basic concepts like soul, culture and things of that nature were becoming clear to him. He took in my views greedily, without becoming slavish; on the contrary he worked in his own way and used them as elements of his own 'Welsanshaung'.

I believe I understood him well, and because of this did not disapprove of his friendship with Miss Brzeska. He got that wrong. The only reason I did not write to him more often was my work load.

Uhlemayr sent Ede another group of letters and cards from Henri and six drawings, one a self-portrait, as well as four photographs of sculptures which he asked should be returned once it had 'served its purpose'.

Ede wrote to numerous other friends and acquaintances of Henri's, telling them of the book project, and asking the same questions. Had they anything written, drawn or made by Henri? Any letters or

224

reminiscences? One of the first to respond, on July 14th, 1929, was Enid Bagnold:

> I have written what I remember of Gaudier. I was tempted when writing it, to start an essay on the whole of the group, Ralph Hodgson, Lovat and all of them. I must do it some day. I want you – I say, rather with the attitude of Mussolini – to publish this as it stands, and not to alter it . . . Another thing – do you think it very cowardly of me to ask to see all the references to me in your book? I promise you I shall not easily take exception to anything, for I, also, am pretty detached, but for my own piece of mind, I would like to know just what I'm in for.
>
> I feel tremendously excited about your book . . . I long for you to intertwine the whole story of poor Sophie up to her death in an asylum. Poor gaunt old devil. I was just as bad as Katherine Mansfield. I never took her in except as a comic figure.

Almost simultaneously, and before Ede had a chance to write, Horace Brodzky contacted him at the Tate Gallery to offer him some Gaudier drawings for sale 'because of a financial embarrassment'. Brodzky's letter continued, 'I also understand that you are writing a book on Gaudier-Brzeska, a task that I commenced some time ago, but laid aside. However, I am continuing the work at the request of several friends, including Epstein. Mine, however, will not be critical but will be more a pen portrait, with records of conversations which have a bearing upon his art, and the way he would go. It will be profusely illustrated.' Brodzky was the one man who had known Henri really intimately. Sophie's 'little dog' description endorses this, yet Ede showed little interest in their relationship. Brodzky's close friendship with Henri did not suit the romantic theme he was set on developing. When it was published, Brodzky was so angered by Ede's version that he completed his own account, which Faber & Faber published in 1933. It painted a very different picture of Henri and Sophie's relationship.

Edward Marsh had also befriended Henri, and become his patron. Marsh had by now moved from the Admiralty to the Treasury and was a considerable figure in London society, a cultivated, urbane, handsome man. As well as approaching him for personal recollections, Ede asked if Marsh would edit his translations of the letters and diaries from the French. Marsh replied, 'It is certainly a very interesting and unusual book and if you get the translation right it will be a very good one.'

Marsh wrote again, two weeks later. 'I have at last had time to go into your difficult passages – and very difficult some of them are. I am not satisfied with my attempts, but hope you may find them useful – especially the long one of "j'observe beaucoup . . ." which I think you had got quite wrong. He expressed himself very loosely, but I'm sure you will agree he is much more likely to have meant what I think – than what you thought.' A week later, 'I told you what I think is an exact idiomatic equivalent of "si sage et si mignonne", either "so good and such a darling" or "such a good little darling"; and you are not going to coax me into saying that I think anything else better! If you won't have it, 'so well behaved and so pretty' is inoffensive, but *not* a translation . . . when a Frenchman calls a little girl a mignonne he means exactly what an Englishman means when he calls her a darling, there is no difficulty at all. "Such a precious" sounds awful to me.'

Characteristically, Marsh was generous with his help, with idiomatic French as well as assessing the text and the interpretation Ede was putting on the material. 'You can't simply wallow, you must wallow in something! . . . In Dodford I've corrected this sort of thing several times. Surely you know one says in London, Paris, Berlin, etc., but at smaller places! . . . Is this correctly transcribed? . . . "J'usqu'a l'indigestion d'esprit" is hardly French, whatever it means, what an ass that woman must have been!' Of one letter, he exclaimed: 'Of course I am against publishing it. The fact that men want to have women is usually taken for granted in good society, like the fact they want to piss or shit – and there is nothing else in the letter. If you do publish it I should translate pissier, "possess" – not very good, – but you can't put fuck or roger! I should translate putain "whore".'

Reservations were also expressed by Enid Bagnold's husband to whom, as requested, Ede sent proofs for approval. On March 24th 1930 Enid Bagnold was writing, 'I read the extracts to my husband and he thought that some of them must be changed.' Enid's husband, Sir Roderick Jones, was head of Reuters and he was concerned about his wife's reputation, which he considered rather racy before her marriage and now wished to protect. The proofs were returned to Ede liberally marked in red ink. The corrections were sent back to Sir Roderick and he returned them initialled, but still requested two further revisions before he would agree to the script being printed.

Others who might have been expected to have particular insight into the Gaudier-Brzeska lives offered little. Wyndham Lewis replied 'I don't know much but will be glad to see you and to tell you a little.' This

probably suited Ede's scheme of things well enough, as he was not especially interested in exploring Lewis' relationship with Henri and his involvement with Pound and *Blast*. Raymond Drey in turn wrote, 'I shall be very happy to see you and to have a talk about Gaudier, who I knew well and was one of the most remarkable men I have ever met . . . brim full of genius and most loveable. I have never ceased to regret him. I wish I had known at the time how poverty stricken he was – I might have done more.'

One of Henri's earliest English friends, to whom he wrote frequently in his last months at the Front, was Kitty Smith of Bristol. Kitty met Jim Ede early in 1928 and showed him the letters and photographs she had received from Henri, as well as a watercolour which he had given her on July 9th, 1909 with a note saying 'You can keep that wreck of a drawing and burn it rather than send it to me. I do not want it as I am compelled to give a lot away because I have too many.'

Ede borrowed a number of things from Kitty. It was only on returning them in 1932, not having used any in his now published book, that Ede made an enquiry about Sophie. Kitty replied, 'He only wrote two letters, I think, to me after he had met her, thinking that I should hardly be understanding, as that time I should only be 13-15 and my people might not have altogether appreciated the position.' Both Germain Gaudier and Brodzky had told Ede about Kitty's friendship with Henri, but he chose to ignore her memories of the young man with whom, as a girl, she had fallen in love, and because of whom, the family believed, she had never married. He chose to ignore the relationship because it did not fit the story. Their letters, spanning the years from Bristol until Henri's death, reveal an innocent companionship which was in some ways more romantic than the one about which he was writing. In concentrating on the Sophie relationship in the 'Life', Ede eliminated one of Henri's closest female confidantes.

# 5

As early as September 1928 Ede approached David Garnett who, with Vera and Francis Meynell, was an owner of the Nonesuch Press, inviting him to read the manuscript and in due course publish it. Garnett replied that he thought the memoir good as far as it went. 'But what I should like to have seen added were a few preliminary pages about Gaudier-Brzeska's youth, ancestry, and early environment. Who were his people? How did he become a sculptor? We are told nothing. Secondly the Memoir leaves one in the dark about *his place* as an original creative force? I see his ideas on art are fluctuating; but whence did he derive his ideas? and technique?'

The following January, Garnett wrote to Ede again: 'I have made a rough survey of your Gaudier-Brzeska and have a definite feeling that you ought to quote Miss B. more and tell less in your own words. My wife has also read it very carefully and her opinion coincides with mine . . . I can assure you that my wife was as fascinated by the story as I was and am. It will be a delightful book and almost all my criticisms are questions of language, grammar, etc.'

It seems from this letter that Garnett had agreed to publish the book, for he concludes, 'I am sending G.B. to be typed'. In spite of Garnett's implicit agreement to publish, Ede was impatient. Early in April, Garnett was writing again, 'by all means sound Harper but you are not quite fair on us. We can't make an offer or send a contract by return which would be any good without knowing further details . . . PS. I think you will get more out of us than you would from Harpers, and that you will like the result better.'

Ede was on sick leave from the Tate Gallery for some of the time that these negotiations were taking place. He had begun to press for publication in the grand manner: a limited, leather-bound de luxe edition. Garnett wrote on September 19th, 1929:

I am really very glad about most of your letter – I am delighted that so many people have liked the Gaudier book, and you know how much I think of it. (Of course quarrelling with your words here and there is nothing) I am as enthusiastic about it as anyone. But the financial part of your letter leaves me sceptical.

Your friends say the book should be done just as you want at
£3.3.0; that, I fancy, will be hellishly difficult anyway, probably
impossible. To do it giving you 20% would be absolutely impossible
for us. If another publisher can do it, we don't know how. I reckon
your book will cost just about 40% of its selling price to produce
decently. The bookseller gets 25%; if you were to get 20% there
would be 15% to cover advertising, overheads and publishing
profits – indeed, the only way I know to give an author 20% or
25% on an expensive limited edition is when the price of the book
is made artificially too high, i.e., when the book isn't good value.
That can be done when you are selling a signed edition of a great
writer such as George Moore, because you give the value in
another form – a signature.

But here we would want to put as much value as possible into
the book, and to keep the price down as low as possible. For the
unlimited edition, we would, of course offer 15%, but I don't make
any promise about selling 5,000; it seems unlikely. So about all we
can say is: Go and prosper and good luck. If you have a publisher
who will produce it really well at £3.3.0 or £5.5.0 and give you
20%, fix it up with him.

Please understand that all this isn't written in a disappointed or
annoyed state of mind. I am glad you brought the book to me,
because I enjoyed seeing it in process of formation, and in talking
about it with you. If anything goes wrong, or if I can be of any help
with it, let me know.

This is a very generous letter under the circumstances. Garnett had
spent a lot of effort and time in making suggestions about the balance
and content of the book only to find that, having incorporated most of
Garnett's ideas, Ede had gone elsewhere for what he thought would be a
better deal. In November, a terse letter from Ede asked for the return of
Sophie's diary. Garnett replied that he had already sent it back. Ede
could not remember ever having received it. The relationship was
showing signs of strain and Garnett was beginning to feel he had been
used.

Still holding the Nonesuch Press in reserve, Ede had been speaking to
John & Edward Bumpus Ltd., and to Heinemann. By means of an
introduction from Edward McKnight Kauffer, he had also been inviting
involvement by Alfred A. Knopf of New York for an American edition.
Eventually it was agreed that the edition in England would be published

by Heinemann. There would be 350 copies; the first ten, printed on hand-made paper and bound in full leather, would be signed by the author and contain an original Gaudier drawing. The remaining 340 would be published as a de-luxe edition printed on hand-made paper and numbered 11-350. The book was to be a large volume measuring 13¾ × 10½ inches with 67 collotype reproductions of drawings as well as 16 illustrations in the text. Bumpus agreed to hold 'An exhibition of the Drawings and Statues reproduced in Henri Gaudier Brzeska by H.S. Ede' to mark publication. This took place from April 27th to May 23rd 1931 at the Old Court House in Oxford Street. There were 23 drawings, six sketchbooks, and 12 'statues' in the catalogue, on the reverse of which was an advertisement for Ede's book.

Ede suggested that a special single volume with the originals of the drawings that had been reproduced in the de-luxe version should be offered for sale as a 'collector's item' for one thousand guineas. The man who had acquired nearly 1,700 items of work by Gaudier for £60 now valued a fraction of the collection at £1,100. Bumpus, who thought they might have a potential client, considered the figure inflated. They wrote to Ede that 'it sounds a lot of money'. Not surprisingly, the sale failed to materialise. Ede was nevertheless determined to realise as much from his investment as he possibly could in order to ensure his own future. He was still seeking financial and contractual advice all round, and one author he approached, Arnold Bennett, advised him to press for a 20 per cent royalty. This was given short shrift by the American publishing house. 'Very many thanks for your extremely kind letter of January 8th,' wrote Alfred A. Knopf, 'I do hope we will be able to get together over the book because you certainly do not underestimate in any way our own keen personal interest in it. At the same time, I have not been able to comply with Mr Bennett's request that we raise the royalty to twenty per cent after four thousand copies. A twenty per cent royalty, while I have no doubt Mr Bennett has been in the habit of getting it for himself and some of his friends from some publishers, simply wipes out any chance of profit for us and much as I like this book, and much as I want to do business with you, I really do not feel that we ought to be asked to do our work for nothing. It is true that we would be able to make a small profit on the first four thousand copies but this might be wiped out in whole by the guarantee I have had to agree to give Evans for his expensive edition.'

'On the whole,' he went on, 'as those who know me will I think tell you, I am not a trader – I usually make my best offer to begin with and

I really felt what I was making you that day was very handsome – certainly one that could not be regarded even by as severe a merchant as Bennett as anything short of fair. I am inclined to believe that it would be a great mistake to serialize any of the book in this country – I am by no means certain that one could serialize it, but even so I think it better not to. The title is, of course, extremely important, but I am sure you will hit on a satisfactory one . . . I have written fully to Ted Kauffer so that he is kept informed.'

Up to this point the projected publication with Knopf had been progressing satisfactorily, and they had asked Ede to suggest a title for the book. The English edition was called simply 'Henri Gaudier-Brzeska'. After a number of suggestions, Knopf became very enthusiastic about 'Savage Messiah'; and that was the title adopted for the American edition in 1931. He wrote again:

I think there is a chance of interesting one of the larger book clubs in 'Savage Messiah', but I can do nothing about it on the basis of the present clause in our contract. In the first place it calls for a division of the proceeds from the book club sale of seventy-five per cent to you and twenty-five per cent to us. It is true that I suggested these terms myself and you are in no way to blame for them, but experience in the past year has indicated that a publisher literally cannot afford to sell a book to a book club on such a basis and we have got to revert to the customary division of the proceeds of such a sale of fifty per cent to the publisher and fifty per cent to the author. We had hoped to be able to treat the author more generously but this has proved not to work out in practice, more particularly as the membership of the book clubs has decreased quite a bit of late and the original club, the Book of the Month Club, now buy book club rights on the same basis as the Literary Guild, i.e. a payment to the publisher of an outright sum for them. That sum at the present time seems to be somewhere between twelve and fourteen thousand dollars so that in the happy event of a sale of 'Savage Messiah' to one of these clubs, I do not think your share would be less than five thousand dollars, although I cannot, at this stage of negotiations guarantee it. To our clause, you or Arnold Bennett added the following, 'If any such sale to a book club is made without the consent and against the wish of the author, then he shall receive from the publishers the full regular royalty of fifteen per cent.' Unless you waive this addition, a book

club sale is practically out of the question as business of this kind must be closed instantly the club decides it wants the book, and there is never any time to transmit the details of the offer or any other details to an author who is abroad.

I am sending Postgate a copy of this letter and asking him to get in touch with you immediately so that if, as I hope very much indeed will be the case, you will cooperate with us so that we may make our best efforts to secure a book club sale for you, all this can be embodied in a night letter cable, for time is of the essence.

Ede's letters to New York became increasingly anxious about quality and estimated sales. His letter of January 18th 1931 reveals frankly his motivation. The publication of the English edition the previous year had obviously not brought adequate revenue on its own:

I was so pleased to see you and Mrs Knopf yesterday & I do hope that she will soon be quite well. I am glad that the book is getting a move on (a little too quick now I feel) & I hope it will be a great success – there seems no reason why it should not be since I believe that everyone who has read it has been enticed by it even as I was. The success will of course mean far more to me than to you since it is my all & could be the means of making me independent of the Tate.

Have you any idea what numbers we may look to sell – or is it indiscreet to ask that of your experience. What size edition are you bringing out? I confess I was surprised to hear that the book was almost ready & disturbed too, now that I have had time to think it over, for I have no idea just how all the Sir Roderick Jones [Enid Bagnold's husband] business was left & I can't risk a law suit with him – also two or three other points. I have always counted on seeing galley and page proofs – it is particularly agreed in the contract that I should (d. of second clause 'The Publisher agrees') – & I felt that this would give me the few moments for a final decision. I don't even know whether you have set up the book from the galleys I sent you marked 'correct' or from the 'page form' proofs sent later. It seems strange too that a book should go out under my name which I have never seen & could surely have helped you in the choice of illustrations – their order etc.

Knopf replied that it was extremely difficult and not a little dangerous to anticipate in advance of publication what the sale of a book would be at that time. However he did say that 'I have every hope for "Savage Messiah" and it would not surprise me to see the book sell 10,000 or 20,000 copies.' The first copies were ready in the second week in February, 1931 and on March 17th Ede received his first payment of $2,000 as an advance on royalties. Ede agreed on the telephone to divide the proceeds from the sale to the Literary Guild of New York on the basis of 50/50 with Knopf if the figure was under $14,000 and his share would not be less than $5,000 and the publication less than 40,000 copies. Otherwise he wanted 60%. In the event they telephoned to say they had been successful in settling for $13,500.

In May Ede wrote to Knopf saying that it appeared that Mr. Salzberg in their London office had not passed on the agreement made on the telephone about the 50/50 share clearly. This came up again because Mr Doran, in New York, wrote to tell him that over 55,000 copies had been issued by the Literary Guild. In the week following the sale to the Literary Guild Ede had received a cheque for $6,750, his share less 5% U.S. tax. In answer to Ede's queries Salzberg wrote on June 10th that 'the print run was sixty thousand copies but this had been nothing to do with the share out from the proceeds from the sale . . . the main question as far as we are concerned was how much money was the Guild to pay us . . . I understand from our New York office that from the sales point of view that for the Guild and Alfred Knopf, the book has been a failure.' To that date under 3,000 copies had sold and he thought Ede and Knopf should consider themselves lucky in having secured the Literary Guild deal.

To promote the book, Knopf was attempting to arrange a lecture tour for Ede in America but without success, and in writing to tell him that he could find no lecture venues he added the disappointing news that 'nothing will ever explain to me the poor selling of "Savage Messiah", certainly general conditions have a lot to do with it but I begin to believe that we all, yourself included, greatly exaggerated Gaudier's fame in this country. I am afraid he is really hardly known at all.'

Faced with the disappointment of what he considered the poor sales of the book in America and slow sales in England, Ede had to accept the possibility that the book would not secure his future. He then received a true bolt from the blue from his close friend, Edward McKnight Kauffer, the man who had fronted for him in his purchase of Gaudier's work.

January 26th 1931
Dear Jim,
I saw a copy of the Gaudier book last night at Alfred Knopf's. I
must ask you to do something about my name in the acknowl-
edgements. Why didn't you tell me or show me, at least ask me if
what you were going to say would be alright or not. I simply
cannot let this through for it suggests that I own the Gaudier
material – this isn't fair or true and I am really deeply concerned –
something *must be done* about it before the book is published.

You can't shift the responsibility like this, particularly since I
acted only as an intermediary to help you. I have too many people
whose opinion and friendship I have a regard for to think that I
have in *any* way pillaged the Gaudier material. And as the
statement stands it has this appearance. It is too ambiguous. Also I
think you should not suggest in the title page that you have written
the life – you really collected and compiled. All this would have
been avoided if you had shown me what you were saying. Please let
me *know* that you will do something about it.

The passage which so upset Kauffer appeared in the preface. It is potent
both in what it implies and in what it leaves out:

Several works by Henri Gaudier Brzeska and Miss Brzeska's papers
passed at her death to the Treasury. These, with some exceptions
which have since become the property of the National Gallery,
Millbank and the Contemporary Art Society, were purchased by
Mr McKnight Kauffer from whom I in turn obtained them.

It was too late for anything to be done. The book was already published,
as was the Literary Guild edition. It was not until the Knopf reprinting,
ten years later, that the spurious provenance was deleted. The dust
cover of that edition carried a blurb which read, 'The story of Henri
Gaudier's turbulent life with Sophie Brzeska is one of the strangest and
most deeply moving of our time – a story of bitterness and struggle, yet
full of keen intellectual and aesthetic enjoyment.'

# 6

A decade after his death many people were beginning to show an interest in Gaudier's work. The first London exhibition after that originated by Sophie was held in the spring of 1926 at the Brook Street Gallery. It consisted solely of drawings and there is no record of who may have instigated it or been the source of the work. The *Evening Standard* reported on April 14th 1926:

## GAUDIER-BRZESKA

At the Brook Street Gallery there is an exhibition of some drawings by the sculptor Gaudier-Brzeska, who, although he lived and worked in England, was in fact a Frenchman, killed in the war.

Gaudier's work is much valued by admirers of modern sculpture. It is now quite rare, because he was only twenty-four when he was killed and everything that remained in his studio became the property of Miss Brzeska, who has only recently died. Gaudier was always desperately poor. He used to forge the tools he made for carving from steel spindles given him by a friend.

Four years earlier, an exhibition had been mounted at the Sculptors' Gallery, 152, East 40th Street, New York, of work on loan from John Quinn's collection. The exhibition, entitled 'Modern English Sculpture, Decorations, Paintings', opened on March 2nd, 1922. As well as Henri, the artists included Jacob Epstein, Eric Gill, J.D. Innes, Augustus and Gwen John, and Wyndham Lewis. With 14 drawings, there were six sculptures by Gaudier: *Seated Figure, 1914*, *Stags*, *Birds Erect*, *The Water Carrier*, *Dog* and *Cat*. Of these, *Stags* and *Birds Erect* are now in the collections of major American museums.

In London, Anton Zwemmer mounted an exhibition at the Zwemmer Gallery in November, 1930 in which Gaudier's work was shown alongside that of the most important contemporary British sculptors: Epstein, Dobson and Moore. Zwemmer, a Dutchman who had come to England as a young man after starting his career as a bookseller in Haarlem, went into partnership in 1923 in a bookshop in Charing Cross Road. Under his direction the shop became a mecca for

artists and art lovers. He stocked a comprehensive list of foreign art books and co-published many himself. In 1929 he opened a gallery for contemporary art in Litchfield Street, immediately round the corner from the bookshop. From the beginning, the gallery was a focal point in London's modern art scene showing British, French and other Continental artists. The gallery bookshop retained its pull, presided over by Anton Zwemmer – a quiet, cultivated, erudite man – until his death in 1979.

Ironically, the catalogue introduction for the Zwemmer exhibition was written by R.H.Wilenski. In five years his opinion of Gaudier had changed radically:

Most of the drawings and sculpture by Gaudier, which form the major part of the exhibition, come from the collection of Mrs Haldane Macfall, and they include two brilliant drawings of her late husband who was a friend of Gaudier's and acquired his collection in the artist's life time. The drawings are typical of Gaudier's calligraphic technique – so unusual in England when he was working here twenty to fifteen years ago; they reveal his acutely intelligent observation and bear witness to the enthusiasm for the pulse of life which animated his early years before he became immersed in a new concentration on abstract form in line and mass.

Of the sculpture from his hand here shown I would signal especially the bronze head called 'The Idiot', an early work still in the Rodin tradition; this bronze has a front view that is almost painful in its pathetic intensity, and in the two profiles I fancy I discern the outline of the sculptor's own features, which impressed all his friends by their exceptional delicacy and sensibility. Sculpture lost much when Gaudier was killed in France in 1915 at the age of twenty-four.

It was a happy thought of Mr Zwemmer's to contrast the calligraphic drawings by Gaudier with the brilliant romantic drawings by Jacob Epstein, now at the height of his astonishing powers and supremely master of his vision of sentient life; and to contrast Epstein's drawings with those of Frank Dobson, who is concerned with the plastic play and interplay of subtly defined masses, and to complete the exhibition with examples of the monumental vision of Henry Moore.

This little exhibition demonstrates that in spite of Academic

obstruction the sculptural attitude can still gain a footing and develop in this land.

In the Spring of 1936 Anton Zwemmer held a second exhibition of work by Gaudier. For the first time only pen and ink drawings were shown.

# 7

In 1936, six years after the launch of his book, Ede finally managed to leave his job at the Tate Gallery which he had held for fourteen years. Over the years he had received substantial financial support from his father, although he had not approved of Jim's career. Now that Ede was comfortable financially, with the funds accumulated from his publications in England and America, he and his wife, Helen, left England to live in Tangier. 'Whitestone', a stylish house overlooking the sea, had large airy rooms where he could hang his collection of paintings, many of which he had been lucky enough to acquire for a few shillings apiece. Ede always had an eye for a bargain – a frequent refrain in his memoir *A Way of Life: Kettle's Yard* – and he had been one of the handful of collectors who 'discovered' Alfred Wallis, the St Ives primitive artist, before his work became widely known.

In *A Way of Life*, Ede recalled that 'except for the years of the war, we lived in Tangier, where we enjoyed making a garden along a ridge of highland and using our home as a holiday place for soldiers cooped up in Gibraltar'. At this time his two daughters, in their mid teens, were at school in Britain. Later the elder, Elizabeth, studied medicine at the University of Edinburgh and Mary read agriculture at London University. At the outbreak of war, Ede and his wife left Tangier and stayed with his aunt in New York, who was married to Frederick Mortimer, some time director of the Frick Collection. Once the war was over they returned to their idyllic life in Tangier. Then they made the decision to move to France. Ede gave the reason for the move in his account of that time: 'in 1952, in order to be nearer our two daughters in Scotland, we decided to try to find somewhere in Northern France'. The property they found was 'Les Charlottières', a farm at Chailles between Blois and Amboise in the Loire Valley. There was 'a little avenue of pollarded limes . . . then a great gate opening onto a long courtyard – tumbledown fifteenth-century outhouses and at the end a separate large kitchen with a seventeenth-century house beyond. There was quite a bit of land and two woods; many fruit trees and a tiny vineyard.' There was also an original small twelfth-century house attached to the main building. They had lived in Tangier for ten years in considerable style and comfort; money could be spun out easily in

North Africa. In France, their mode of life, if anything, seems to have improved. Relatives who visited 'Les Charlottières' recall its beauty and tranquillity, and Ede himself wrote that 'there was a richness of quality in that French life, a quick beauty in the home and a reality in the land so annealing after the strangeness of Africa.'

The effort put into 'Les Charlottières' suggests it was with the intention of making it a lasting haven in which Ede and Helen, now in their late fifties, would live out their lives. As well as comfort and ease, the house provided Ede's much-loved seclusion at comparatively little expense. 'It was a dream world and for the next three years we worked with pleasant artisans to bring it into standing order and to give it life . . . There was time to think, to read, and to enjoy it all. Helen hoped Heaven would be like that.' Jim had written his book on Gaudier and Sophie and his 'life's work' appeared now to be the creation of a personal enclosed world. He entertained and corresponded with friends, many of them artists from his Tate days, but there was no overwhelming interest in the work of Henri Gaudier-Brzeska. Most of this had been left with members of his family in England before the war, some in London and some in Cardiff. On the face of it, Gaudier was a closed book. And yet Jim and Helen now decided to uproot themselves from this idyll and return to England. According to Ede's memoir, 'It was while we were still abroad in 1954 [in France, where they were restoring Les Charlottières] that I found myself dreaming of the idea of somehow creating a living place where works of art could be enjoyed, inherent to the domestic setting, where young people could be at home unhampered by the greater austerity of the museum or public art gallery, and where an informality might infuse an underlying formality.'

There may have been less altruistic motives for the move. 1954 was also the year that Ede received two devastating letters from Henri's sister Renée, acting on behalf of the family. She wanted to know where her brother's possessions were and how the family could obtain the personal papers and mementoes of their 'lost son'. Père Gaudier had been dead for some years but their mother was alive and still grieving over her son's death. Two letters passed between them and Ede. The second letter from St Jean de Braye, dated July 5th, began 'We read your letter to Mother and she was furious'. Ede had ignored the central issue of the first letter and had suggested that Henri be commended by him for the Legion d'Honneur. The family insisted that he took no such action and minded his own business, and returned to the question of ownership which they had raised in the first letter and which Ede had also

sidestepped over a quarter of a century earlier. Ede now replied promptly that 'all Gaudier's possessions were sold before death or given to Miss Brzeska or *left* to her by registered will. She was sole inheritrix.'

Six months later, Ede wrote a very different letter to the Treasury Solicitor. It was virtually thirty years since he had corresponded from the Tate as Assistant Curator about the estate, and he felt the need to begin at the beginning and explain the circumstances in detail. He referred to McKnight Kauffer's role as the purchaser of Sophie's estate, without mentioning that McKnight Kauffer had acted as his nominee, and cast himself in the minor role of Tate Gallery assistant.

5.1.55 Les Charlottières, Chailles, Loire et Cher, France.
Dear Sir,
I am writing to you in reference to a sale of works by H. Gaudier-Brzeska, & writings by Miss Brzeska made by the Treasury in 1927 to Mr McKnight Kauffer. These matters passed through the hands of the Treasury Solicitor, Dr A.V. Brown and the Director of the Tate Gallery, Mr Charles Aitken and myself who was then an assistant to the Tate Gallery.

The works in question were presumably the property of Miss Brzeska who died intestate in the Barnwood Mental Hospital. Miss Brzeska was the companion of H. Gaudier-Brzeska sculptor – French – who was killed at the Front in 1915.

At long last a relative of Miss Brzeska (a sister) has turned up & is repeatedly asking at the Redfern Gallery (Mr Nan Kivell, 20, Cork Street, W1) for particulars as to how Miss Brzeska's estate was dispersed. Redfern Gallery write to me saying they have applied to your office & that the reply was that nothing was known!

At the same time H. Gaudier Brzeska begins to be heard of here in France (he is one of France's important sculptors in the history of their sculpture – but they have not yet heard of him) & questions of copyright & possession (under Napoleonic law) will crop up with his family – (mother & sister). So far as I know there is no official will leaving all his possessions to Miss Brzeska – though morally they obviously belonged to her since morally she was his wife. His family had cast him off. Anyhow I can see that there may in time be questions which only the Treasury can answer & I personally would like to know where I stand – for I eventually purchased the Gaudier Brzeska material from Mr McKnight Kauffer to whom the Treasury sold it.

For your guidance I send a list of correspondence.

Would you very kindly instruct Mr Nan Kivell of Redfern Gallery (above) to whom he should tell the late Miss Brzeska's sister to apply at the Treasury for information. And I should be glad to know how the matter rests officially re Treasury & possible claimants, sincerely,

H.S. Ede.

The identity of this 'sister' is intriguing. Sophie had claimed to be an only daughter. It is perhaps more likely that Rex Nan Kivell was confused and that this was in fact Henri's sister, Renée who was certainly hot on the trail. Assailed by letters and now a personal intervention, Ede was a worried man, not to say in a state of near-panic. His reference to 'Napoleonic law' suggests he felt vulnerable to pressure from the Gaudier family, and thought he might be on safer ground back in England.

Ede wrote to the Treasury Solicitor again on February 8th:

ref BU 3225/RKP of 28 Jan. 1955

. . . if Miss Brzeska asks again I will refer her to you with the above ref. number. For the other matter (your last para) it is *not because* the occasion is already arising that I wrote to you, for I want to know where I am. By making this artist known in France I am inviting these questions – indeed they are already asked me, both by family and museums, & I had wanted to know what my position was before I got in too deeply. Only *you* could tell me this & so I wrote. I wish to proceed entirely in the cause of ART; but obviously must not if my position is in any way equivocal. yours sincerely, H.S. Ede.

The Treasurer Solicitor's reply, dated March 15th, 1955, was brief and to the point. 'I duly received your postcard dated 28.1. last. You will, I am sure, appreciate that the Treasury solicitor is not permitted to advise you as to your own legal position. If you are in any doubt as to how you should proceed I can only suggest that you should consult your own legal adviser.'

There are some extraordinary elements in this exchange of letters. Ede claimed ignorance of the existence of an 'official will leaving all [Gaudier's] possessions to Miss Brzeska'. He was in fact well acquainted with the 'will' and the previous year had assured the Gaudier family that

everything had properly gone to Sophie. Also questionable is Ede's claimed dedication to the 'cause of Art', as there is no evidence that he had done anything at this time to promote Gaudier's work or that he was 'making this artist known in France'. It was about now – a quarter of a century after publishing *Savage Messiah* – that Ede seems to have remembered that 'it has seemed my task to get Gaudier established in the rightful position he would have achieved had he lived into the present time'. His gift of a sculpture, a substantial quantity of drawings and Henri's tools to the Musée des Beaux Arts in Orléans – Henri's birthplace – was not made until 1956. On the face of it, this was a move designed to mollify the family, rather than the cause of their quickening interest in the fate of Henri's possessions.

This group of work was augmented by a loan by Ede of 14 sculptures to form an exhibition at the museum in March, 1956. Later that same year, a larger exhibition of 31 sculptures and 78 drawings was lent to the Arts Council in London, and other exhibitions followed between 1957 and 1964 in Milan, Miami and London, culminating with the gift that enabled the Salle Gaudier-Brzeska to be dedicated at the Musée National d'Art Moderne in Paris in June 1965. Whatever precisely had triggered this hectic activity, Jim Ede could now justifiably claim to have played a major role in establishing Gaudier's reputation in his home country and on an international stage.

The die had been cast in 1954, and less than three years after moving to Les Charlottières, Ede found himself making plans to return to England to live. He began a search for a property that would allow him to create a second 'Les Charlottières'. It would not be easy. A similar paradise deep in the English countryside was an unrealisable dream. At length, 'prompted by the President of the Cambridge Preservation Society', he determined on three tiny condemned cottages on the edge of Cambridge which were called Kettle's Yard. The Kettle family had lived on the site since the tenth century and were known as 'The Merchants of Cambridge'. A theatre had been built there in the eighteenth century by Joseph Kettle which the Commons ordered be demolished 'since its proximity to the University was considered harmful to the morals of Undergraduates.' As a result Kettle had been made bankrupt, the property fell into disrepair and eventually became derelict.

The choice of Cambridge is interesting. Cambridge had been a town of some importance to the Ede family. Three generations had been graduates of the university. Ede was the first of the family not to have been a student there, and this had been a great disappointment to his

father. The acquisition of the cottages suggested a way not only to make his mark in the world but to make it in the rarefied arena of Cambridge in a unique, unequivocal style. He could house there the collection of work that he had assembled through friends and friends of friends – Ben Nicholson, Winifred Nicholson, Christopher Wood and Alfred Wallis – and open the house to undergraduates. His intention was to re-create an oasis of calm and beauty as a home, but this time it would become a positive part of University life, open for two hours each afternoon to all comers. It would 'heighten the awareness and value of art' among the young students of Cambridge and be a haven, as his Tangier house had been for soldiers on leave from Gibraltar. Ede and Helen returned to England, the cottages were renovated and they set up home there 'towards the end of 1957'. Ede's preoccupation now was the dream that his collection should become part of a permanent art centre.

# 8

E de's dream would need considerable funding. His dedication to the task echoed that he had displayed in acquiring Sophie's estate. Jim recalled, in a memorandum to the author, the sequence of events that followed his migration to Cambridge and his efforts to raise the endowment money:

1. I think my first move was made in 1954 to ask Lord Crawford if he had a house in national trust which they would like to devote to an art centre if I brought my collection or left it.
2. Then I wrote to the Fitzwilliam and offered them the whole collection which then included the Brancusi if they could find a house for it – in which I could live as curator for 10 years and then hand it all over to them, also offered £5,000 for adapting the house. They wrote that they couldn't see that anyone would want my collection or words to that effect – I've lost the letter.
3. Offered on same terms to Jesus College & then Kings – both refused.
4. In 1958 or 59 offered Kettle's Yard and collection then housed in it to Magdalene and also gave them the house in Dec. 1963. They refused the collection and kept the lease of the house.
5. I then offered it to the University – Magdalene being prepared to sell them the remainder of the lease on K.Y. This offer was accepted subject to certain difficulties being cleared up in August 1964 subject to solicitors' agreement and good opinion of the Tate Gallery.
   . . . At the same time I put the matter before Philip Jones who wrote that it would entail a capital of approx. £150,000 and he would try to interest the Gulbenkian Foundation.
   There seemed no suitable site available but that the university were interested in the extended idea if they could find the money or the site became available – all the property touching our house – the value being £30–40,000, I believe. I alerted the people responsible and they said they would put it all before Gulbenkian.

Jim's diary entries show his determination to succeed. He took stock of his own position. After selling 'Les Charlottières' and purchasing the

Cambridge cottages, only the works of art remained. They were needed as the core of the Kettle's Yard collection, but the bulk of Gaudier's work was mainly intact. This, the residue of Sophie's estate, still consisted of 1,000 drawings and 27 sculptures. These would have to be used to produce the seed corn for the funding.

The papers and diaries had served their purpose and had secured his independence and an agreeable life in Tangier and France. He saw no reason for them to be part of the Cambridge endowment and believed they would be more highly prized by one of the new universities. He made a gift of them to the University of Essex. In making this gift, Jim Ede split a unique archive. His 1927 purchase had consisted of the bulk of Gaudier's work, all Sophie's writing, Gaudier's tools and photographs and notebooks. Its subsequent dispersal had been made without anything being documented. Today, a catalogue would have stood as a matchless testament to a genius who was given only three years to realise his creative potential.

Ede now needed to marshal his resources to best effect. To sell off work piecemeal would produce some money, but a better plan would be one in which the artist's reputation would also be enhanced. He realised that he could not do this alone. He decided that he should mount exhibitions with the most prestigious London galleries that he could interest in Gaudier's work. There were more than enough drawings – even allowing for the removal of the weakest – to underpin a sustained promotion of the artist over a long period of time. But Gaudier had declared himself a sculptor and the amount of surviving carvings and plasters was limited, especially when Ede realised that successful marketing was more likely if Gaudier were represented in major museum collections in both England and France. He needed more disposable sculpture. If all the pieces he had purchased were sold or given away, the work central to his art collection would not be adequately represented. According to Ede's own record, the programme was put into action in 1963. The first step was to have casts made of the Gaudier sculptures he held and to seek out other sculptures for his putative gallery.

The first exhibition Ede arranged of Gaudier's drawings was held in 1964 at the Folio Society in London. In the following year, he co-operated with the Marlborough Gallery in mounting another exhibition of drawings, which had some small financial success. Another show – this time at Victor Waddington's gallery in Cork Street – followed in 1966. Waddington had been a dealer in Dublin for thirty years when he

came to London in 1957 to open his new gallery. He was a much respected figure in both Dublin and London.

A key element in Ede's programme was to make editions from the plasters or stones that he had and to sell the casts, retaining the originals in the collection or presenting them to museums. He conceived the idea of a set of twelve sculptures to be placed in auction as a single group. Victor Waddington dissuaded him from this approach for commercial and artistic reasons.

With the drawings, Ede counted what remained and balanced them qualitatively, permutating the methods by which he might realize the not inconsiderable sums he sought. He calculated that he could sell them singly, in bulk or as an entire collection, retaining the best for Kettle's Yard. He varied the price according to the method and the discount he felt was appropriate. He also looked for single benefactors to endow the collection and asked Victor Waddington if he thought Australia, Japan, Switzerland and Germany might be interested in receiving exhibitions. Much to Waddington's horror, he even played with the idea of exhibiting Gaudier's work in department stores in the United States. Ede discussed the possibilities of fund-raising and sponsorship with Waddington and together they approached Shell and the Peter Stuyvesant and Gulbenkian foundations. All expressed interest but were not inclined to endow large sums, preferring the possibility of making purchases to enhance the collection in the event of its becoming part of the University.

In the course of arranging the exhibition at the Waddington Gallery, Ede corresponded with Victor Waddington at great length. These letters, over a two-year period, were involved with details of Ede's various schemes. Eventually, the correspondence became fraught, Ede obviously stretching Waddington's very considerable patience to the limit. One letter sums up the tensions:

Dear Jim Ede,
Thank you for your letter and I answer the PS. first. 'You always make me feel that you think that I am going back on my word. I have never knowingly done so.'

I am aware that you do not go back on your word knowingly, otherwise I would have had nothing to do with you, but you do continually change your mind and I have written to you fully on this before and pointed out that I have accepted much of this as coming from your anxiety to get your Kettles Yard going and to sell drawings.

246

Ede replied, 'Dear Victor, Your saying that "I continually change my mind" has forced me into going back over past correspondence – for I feel I have only changed my mind at your request and in your favour.' He then detailed a number of past letters, continuing 'I could go into many other details but as I said don't want to – it is only painful & serves no useful purpose – but I cannot find an instance of changing my mind except to accommodate you.'

Victor made a number of visits to Cambridge, as well as exchanging letters and giving advice and, although an ailing man, devoted much time and energy to the project.

As a result of the Waddington exhibition, and the casting of sculptures in editions during 1964 and 1965, Ede was able to raise sufficient funds to satisfy the University Board that the project was potentially viable. Some of the bronzes were sold individually to private collectors for fairly modest amounts, but in 1969 Ede, acting in his capacity of Honorary Curator of Kettle's Yard, persuaded Sotheby's to underwrite, prior to selling at auction, the bulk of the sculpture and the residue of the drawings not kept for the collection. The auction house guaranteed to pay the University of Cambridge the sum of £124,650.

In June, 1969 Ede received a cheque for £40,050 as the initial payment, the remainder to be paid between 1970 and 1974 with a second amount of £24,600 on January 1st, 1970 and subsequent payments of £15,000 on the same date for the following four years. The work included more than 600 drawings, 40 pastels, 160 designs, an oil painting and a large group of casts, some in bronze and others in simulated stone.

During this time, Ede had been endeavouring to establish Gaudier's reputation in his homeland. The Salle Gaudier-Brzeska at the Musée National d'Art Moderne in Paris was opened in 1965 and 'devoted to the work of Henri Gaudier'. The gift was thirty-two drawings and pastels, the original sculpture of *Seated Woman* and a selection of sculpture casts. Other work was donated to the Museum by Ezra Pound, and Ede rightly felt that he had secured permanent recognition in France for Gaudier's work. He also recalled that this was the fulfilment of a dream of Gaudier's: Henri had presciently written to Sophie that 'I dreamed last night that I visited Paris and I came to a room where my name was written in letters of gold over the door. I went in and there found all my works, so you see Sosik I will one day be a great sculptor.'

The gift to establish the Salle Gaudier-Brzeska was substantial, but a considerable collection of drawings remained at Kettle's Yard together

with the casts. Ede recalled in *A Way of Life* that in the attic, which was also dedicated to Gaudier, work had to be stacked three deep round the walls, 'Somehow all in all there were quite a few over 400 up in this attic, 50 being readily available for visitors; the rest could be rummaged for.'

Forty years after his shrewd deal while working at the Tate, Jim Ede had pulled off a second, more breathtaking coup. In the autumn of his life, he had created his own art centre from the sale of the sculpture and drawings which, all those years earlier, he had acquired 'for a song'. Kettle's Yard was the combination of home, museum and gallery for which he is remembered with great affection. Thousands of visitors annually are drawn to Cambridge to enjoy and draw inspiration from a remarkable collection of art housed in a uniquely serene setting.

At one point, discussing the sale of Gaudier's work in a letter to Victor Waddington, Ede wrote that 'I was going to put in the provenance of the drawings – but it may be better not, for who knows where Miss Brzeska's 'property' should have legally gone. Or indeed whose it was – the Treasury just took it.' By seizing the chance to acquire that property himself, Ede had made his name, acquired a priceless collection and ultimately created a living work of art.

In the process, he had taken the story of two lonely people, whom he had never known, and from selected diary extracts and letters had created a myth which made the wider public aware of the man, but left them knowing little of his work. If anything, Ede had obscured Gaudier's achievement with his partial story about a romantic young artist and his relationship with an older woman.

Henri Gaudier's genius would have been recognised without the publication of *Savage Messiah*. At the time of his death, much of his work had already passed into collectors' hands. The 1918 memorial exhibition had been a critical success and by the time Sophie died much, including Ezra Pound's memoir, had been written. Henri Gaudier was already well on the way to becoming a significant twentieth-century figure.

# VORTEX.

# GAUDIER BRZESKA.

---

Sculptural energy is the mountain.

Sculptural feeling is the appreciation of masses in relation.

Sculptural ability is the defining of these masses by planes.

The PALEOLITHIC VORTEX resulted in the decoration of the Dordogne caverns.

Early stone-age man disputed the earth with animals.

His livelihood depended on the hazards of the hunt—his greatest victory the domestication of a few species.

Out of the minds primordially preoccupied with animals Fonts-de-Gaume gained its procession of horses carved in the rock. The driving power was life in the absolute—the plastic expression the fruitful sphere.

The sphere is thrown through space, it is the soul and object of the vortex—

The intensity of existence had revealed to man a truth of form—his manhood was strained to the highest potential—his energy brutal—HIS OPULENT MATURITY WAS CONVEX.

The acute fight subsided at the birth of the three primary civilizations. It always retained more intensity East.

The HAMITE VORTEX of Egypt, the land of plenty—

Man succeeded in his far reaching speculations—Honour to the divinity !

Religion pushed him to the use of the VERTICAL which inspires awe. His gods were self made, he built them in his image, and RETAINED AS MUCH OF THE SPHERE AS COULD ROUND THE SHARPNESS OF THE PARALLELOGRAM.

He prfeerred the pyramid to the mastaba.

The fair Greek felt this influence across the middle sea.

249

# APPENDIX

The fair Greek saw himself only. HE petrified his own semblance.

HIS SCULPTURE WAS DERIVATIVE his feeling for form secondary. The absence of direct energy lasted for a thousand years.

The Indians felt the hamitie influence through Greek spectacles. Their extreme temperament inclined towards asceticism, admiration of non-desire as a balance against abuse produced a kind of sculpture without new form perception—and which is the result of the peculiar

VORTEX OF BLACKNESS AND SILENCE.

PLASTIC SOUL IS INTENSITY OF LIFE BURSTING THE PLANE.

The Germanic barbarians were verily whirled by the mysterious need of acquiring new arable lands. They moved restlessly, like strong oxen stampeding.

The SEMITIC VORTEX was the lust of war. The men of Elam, of Assur, of Bebel and the Kheta, the men Armenia and those of Canaan had to slay each other crully for the possession of fertile valleys. Their gods sent them the vertical direction, the earth, the SPHERE.

They elevated the sphere in a splendid squatness and created the HORIZONTAL.

From Sargon to Amir-nasir-pal men built man-headed bulls in horizontal flight-walk. Men flayed their their captives alive and erected howling lions : THE ELONGATED HORIZONTAL SPHERE BUTTRESSED ON FOUR COLUMNS, and their kingdoms disappeared.

Christ flourished and perished in Yudah.

Christianity gained Africa, and from the seaports of the Mediterranean it won the Roman Empire.

The stampeding Franks came into violent contact with it as well as with the Groeco-Roman tradition.

They were swamped by the remote reflections of the two vortices of the West.

Gothic sculpture was but a faint echo of the HAMITO-SEMITIC energies through Roman traditions, and it lasted half a thousand years, and it wilfully divagated again into the Greek derivation from the land of Amen-Ra.

VORTEX OF A VORTEX!!

VORTEX IS THE POINT ONE AND INDIVISIBLE!

VORTEX IS ENERGY! and it gave forth SOLID EXCREMENTS in the quattro é cinquo cento, LIQUID until the seventeenth century, GASES whistle till now. THIS is the history of form value in the West until the FALL OF IMPRESSIONISM.

250

The black-haired men who wandered through the pass of Khotan into the valley of the YELLOW RIVER lived peacefully tilling their lands, and they grew prosperous.

Their paleolithic feeling was intensified. As gods they had themselves in the persons of their human ancestors—and of the spirits of the horse and of the land and the grain.

THE SPHERE SWAYED.

THE VORTEX WAS ABSOLUTE.

The Shang and Chow dynasties produced the convex bronze vases.

The features of Tao-t'ie were inscribed inside of the square with the rounded corners—the centuple spherical frog presided over the inverted truncated cone that is the bronze war drum.

THE VORTEX WAS INTENSE MATURITY.   Maturity is fecunditty—they grew numerous and it lasted for six thousand years.

The force relapsed and they accumlated wealth, forsook their work, and after losing their form-understanding through the Han and T'ang dynasties, they founded the Ming and found artistic ruin and sterility.

THE SPHERE LOST SIGNIFICANCE AND THEY ADMIRED THEMSELVES.

During their great period off-shoots from their race had landed on another continent.—After many wanderings some tribes settled on the highlands of Yukatan and Mexico.

When the Ming were losing their conception, these nel-Mongols had a flourishing state.   Through the strain of warfare they submitted the Chinese sphere to horizontal treatment much as the Semites had done.   Their cruel nature and temperament supplied them with a stimulant: THE VORTEX OF DESTRUC-TION.

Besides these highly developed peoples there lived on the world other races inhabiting Africa and the Ocean islands.

When we first knew them they were very near the paleolithic stage.   Though they were not so much dependent upon animals their expenditure of energy was wide, for they began to till the land and practice crafts rationally, and they fell into con-templation before their sex : the site of their great energy : THEIR CONVEX MATURITY.

They pulled the sphere lengthways and made the cylinder, this is the VORTEX OF FECUNLITY, and it has left us the masterpieces that are knowns as love charms.

The soil was hard, material difficult to win from nature, storms frequent, as also fevers and other epidemics. They got frightened : This is the VORTEX OF FEAR, its mass is the POINTED CONE, its masterpieces the fetishes.

And WE the moderns : Epstein, Brancusi, Archipenko, Dunikowski, Modigliani, and myself, through the incessant struggle in the complex city, have likewise to spend much energy.

The knowledge of our civilisation embraces the world, we have mastered the elements.

We have been influenced by what we liked most, each according to his own individuality, we have crystallized the sphere into the cube, we have made a combination of all the possible shaped masses—concentrating them to express our abstract thoughts of conscious superiority.

Will and consciousness are our

# VORTEX.

# Long Live the Vortex!

Long live the great art vortex sprung up in the centre of this town !

We stand for the Reality of the Present—not for the sentimental Future, or the sacripant Past.

We want to leave Nature and Men alone.

We do not want to make people wear Futurist Patches, or fuss men to take to pink and sky-blue trousers.

We are not their wives or tailors.

The only way Humanity can help artists is to remain independent and work unconsciously.

WE NEED THE UNCONSCIOUSNESS OF HUMANITY—their stupidity, animalism and dreams.

We believe in no perfectibility except our own.

Intrinsic beauty is in the Interpreter and Seer, not in the object or content.

We do not want to change the appearance of the world, because we are not Naturalists, Impressionists or Futurists (the latest form of Impressionism), and do not depend on the appearance of the world for our art.

WE ONLY WANT THE WORLD TO LIVE, and to feel it's crude energy flowing through us.

It may be said that great artists in England are always revolutionary, just as in France any really fine artist had a strong traditional vein.

Blast sets out to be an avenue for all those vivid and violent ideas that could reach the Public in no other way.

Blast will be popular, essentially. It will not appeal to any particular class, but to the fundamental and popular instincts in every class and description of people, TO THE INDIVIDUAL. The moment a man feels or realizes himself as an artist, he ceases to belong to any milieu or time. Blast is created for this timeless, fundamental Artist that exists in everybody.

The Man in the Street and the Gentleman are equally ignored.

Popular art does not mean the art of the poor people, as it is usually supposed to. It means the art of the individuals.

Education (art education and general education) tends to destroy the creative instinct. Therefore it is in times when education has been non-existant that art chiefly flourished.

But it is nothing to do with " the People."

It is a mere accident that that is the most favourable time for the individual to appear.

To make the rich of the community shed their education skin, to destroy polite-ness, standardization and academic, that is civilized, vision, is the task we have set ourselves.

253

I SHALL DERIVE MY EMOTIONS SOLELY FROM THE ARRANGE-MENT OF SURFACES, I shall present my emotions by the ARRANGEMENT OF MY SURFACES, THE PLANES AND LINES BY WHICH THEY ARE DEFINED.

Just as this hill where the Germans are solidly entrenched, gives me a nasty feeling, solely because its gentle slopes are broken up by earth-works, which throw long shadows at sunset. Just so shall I get feeling, of whatsoever definition, from a statue ACCORDING TO ITS SLOPES, varied to infinity.

I have made an experiment. Two days ago I pinched from an enemy a mauser rifle. Its heavy unwieldy shape swamped me with a powerful IMAGE of brutality.

I was in doubt for a long time whether it pleased or displeased me.

I found that I did not like it.

I broke the butt off and with my knife I carved in it a design, through which I tried to express a gentler order of feeling, which I preferred.

BUT I WILL EMPHASIZE that MY DESIGN got its effect (just as the gun had) FROM A VERY SIMPLE COMPOSITION OF LINES AND PLANES.

GAUDIER-BRZESKA.

---

# MORT POUR LA PATRIE.

Henri Gaudier-Brzeska: after months of fighting and two promotions for gallantry Henri Gaudier-Brzeska was killed in a charge at Neuville St. Vaast, on June 5th, 1915.

254

# LIST OF ILLUSTRATIONS

Many of Gaudier-Brzeska's sculptures were later cast in editions, and copies are held in private and public collections; sculpture and drawings privately owned change hands from time to time. The references in square brackets acknowledge the source of photographs and do not necessarily indicate the present, or only, whereabouts of the work in question.

*Between pages 96 and 97:*

1 & 2. Henri's birthplace, St Jean de Braye.
3. *Self Portrait*, 1909 oil on panel.
4. *Bristol Cathedral*, 1908 drawing.
5. *Barge*, 1908 drawing. [Mercury Gallery]
6. *Study of Heron*, 1908 ink drawing. [Collection: Réunion Des Musées Nationaux, France]
7. *Head of Germain Gaudier*, 1910 dry clay painted bronze.
8. Enid Bagnold.
9. Bust of Enid Bagnold, 1912.
10. Claude Lovat Fraser.
11. Horace Brodzky.
12. Edward Marsh in 1912.
13. *Ornamental Mask*, plaster relief created for Lovat Fraser, 1912.
14. Relief stone carving of Horace Brodzky, 1913. [National Museum of Wales]
15. *Firebird*, 1912 bronze. [Mercury Gallery]
16. *Head of Brodzky*, 1913 bronze. [Bristol City Museums & Art Gallery]
17. *Head of an Idiot*, 1912 bronze.
18. *Alfred Wolmark*, 1913 bronze. [Southampton Art Gallery]
19. *Sophie*, 1913 pastel. [Southampton Art Gallery]
20. *Self Portrait*, 1913 pastel [Southampton Art Gallery]
21. *Horace Brodzky*, 1913 pastel.

# LIST OF ILLUSTRATIONS

# INDEX

# INDEX

no
Fraser!

# INDEX

# INDEX

261

# INDEX

# INDEX